198

IMAGES
of America

SUTHERLIN

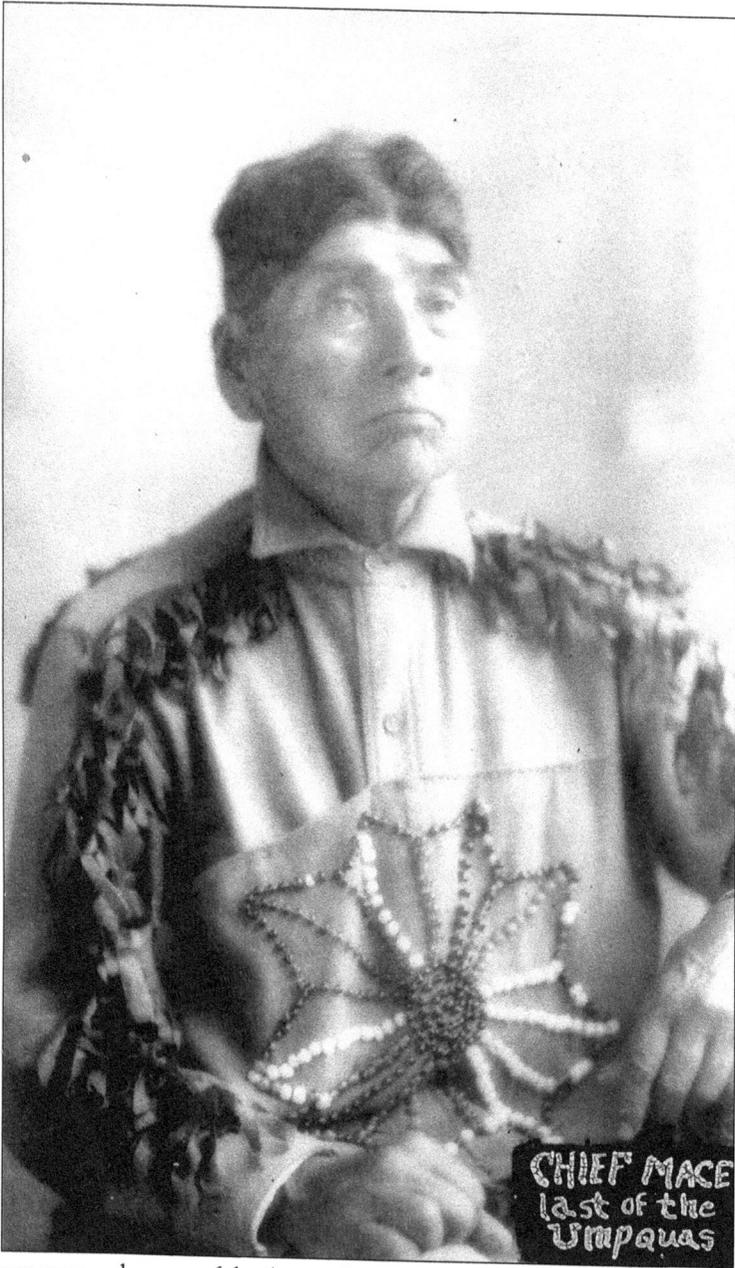

CHIEF MACE
last of the
Umpquas

The Umpquas were a shy, peaceful tribe, preferring to keep to themselves; they did not make war with the whites nor make friends with them. Fishing, hunting, and plant harvesting were the sources of their sustenance. They also traded with their coastal brethren. Chief Mace, the last of the Umpquas, lived for over 100 years and had a ranch on the rim of Mount Scott. (Gail Hodapp.)

ON THE COVER: The 1949 Timber Days Log Rolling Contest has just been won. The unknown winner's name will be announced, and a hard-won trophy will be presented. Once again, the annual Timber Days contest was held at the L and H Lumber Company's log pond (between what is now Allen's Carburetor and the railroad, encompassing the current Techbuilt Incorporated). (Mickey Thompson.)

IMAGES
of America

SUTHERLIN

Tricia Dias with the Sutherlin 100 Committee
and the Douglas County Museum

ARCADIA
PUBLISHING

Published by Arcadia Publishing
Charleston, South Carolina

Library of Congress Control Number: 2010935475

For all general information, please contact Arcadia Publishing:
Telephone 843-853-2070
Fax 843-853-0044
E-mail sales@arcadiapublishing.com
For customer service and orders:
Toll-Free 1-888-313-2665

Visit us on the Internet at www.arcadiapublishing.com

To the people of Sutherlin: past, present, and future

CONTENTS

ACKNOWLEDGMENTS

The Sutherlin 100 Committee has been working since 2010 to make the 2011 Sutherlin Centennial a truly wonderful event. The Research and Historical Committee is an integral part of this effort, especially Pauline Wells Holley, the cochairperson whose personal research collection started me off; Carol Swesso, who helped me with the tedious task of obtaining photographs from various outside sources and sorting all the images into files for us to choose the very best and organize the chapters; and Rick De Young, whose columns in the *Douglas County News* helped identify some of the vintage photographs.

The Douglas County Museum's research and photograph librarians, Karen Bratton and Jena Mitchell, as well as the director, Gardener Chappell, allowed me access to a treasure trove of vintage photographs and research material. Jena did a terrific job scanning and rescanning the images to Arcadia's specifications. The volunteers who also helped scan the pictures, provide the descriptions, and assist in maintaining the collections cannot be praised enough.

Unless noted otherwise, all images appearing in this book were graciously provided by the Sutherlin 100 Committee (S100) or the Douglas County Museum (DCM).

INTRODUCTION

She carefully leaves the forest and scampers down the hill to the water below. She looks, listens, and scents the air. Deciding that it's safe, she signals her fawns to join her at the edge of the spring thaw–swollen creek (now known as Cooper Creek County Park). After drinking their fill, they swim to the other side and climb to the crest of the next hill. Looking down on the blue-flowered swale and meadows below and sensing no danger, they slowly descend.

The hunter watches them from his ambush. Seeing that the fawns were still nursing, he lowers his bow and returns his arrow to its holder. It would not be good to kill the mother and leave the young to starve. Tomorrow is another day, and there's plenty of game.

Returning to his village with the generous bounty his hunt has already produced, he thanks the Great Spirit for the riches that he and his people have been given. This is a peaceful valley full of game, fruits, nuts, berries, and camas bulbs. The creeks teem with fish. During the summer, the swale full of camas will dry up. His woman and the other women of the valley will tend and harvest their own part of the field. The storehouse was already beginning to fill with spring herbs and roots. His village will not go hungry this winter.

Little did the hunter know that his way of life was coming to an end. In the south, cattlemen were driving out the Paiutes to make room for their cattle on the virgin grazing land. In the north, pioneers were making the 2,000-mile trek to the new promised land. Broken treaties and reservations lay ahead for the natives. A new era was beginning.

Camas Swale, located in a long narrow valley, was first settled in the eastern end, close to old-growth forests, Nonpareil's mercury and nickel mines, and the swale where the Fair Oaks community would blossom.

John Franklin Sutherlin and his eldest son, Fendel, were the largest landowners and the heaviest taxpayers in Umpqua County. According to Bureau of Land Management records, in addition to his original claim settled in Camas Swale on March 1, 1851, John acquired 16 more Donation Land Claims (DLC) from 1865 through 1885; Fendel, 35 DLCs from 1864 through 1884; his other children, Sarah, Thomas, John S., Clinton, James, and Jane each held a 640-acre DLC. Although John and sons Clinton, John, and Thomas settled their claims in 1851, Fendel, who had been in Oregon since 1847, didn't register his claim until 1853. Even though John got the land under government regulations, he also paid the local Indians their price for his claim to their camas fields: three suits of underwear. Sampson, John's son, was too young to qualify for free land, so he bought the rights to 320 acres.

After his death, Fendel's daughter, Anne, lobbied to have the town's name changed to honor her father. Soon Camas Swale and the valley were renamed Sutherlin.

The original pioneers came by wagon train, but the new settlers arrived by a different train—the iron horse. For the most part, they had never seen the land they had bought, having purchased it from newspaper ads placed by the various land development companies of the time.

A gap in the hills provided a natural pass to Oakland's markets. After the railroad came, residents took the train to Roseburg to do their shopping, and a two-block business district grew

within the area east of the newly constructed railroad station.

The brickyard established in the Whitmore (now Union) Gap made all the bricks used in local buildings. The Deady quarry on the southern border of Fendel Sutherlin's land supplied the stone for Sutherlin's historic State Street Bank and the State Capitol in Salem.

There was a large Chinese community in the same area. Originally brought in to work on the railroad, and later in the mines, the Sutherlins hired them to drain the swale, creating Sutherlin Creek. There is no longer any trace of their settlement. Farther west, oil was prospected.

Sutherlin was considered a wet, wide-open town, causing the people of Oakland to look down on their upstart, uncouth neighbor to the south. Lumberjacks released a lot of tension on their days off, and some teachers even wore guns to school.

With the advent of the steam engine, the cutting of timber became a profitable venture. World War II created a huge need for lumber. Because of its huge timber industry, Sutherlin proclaimed itself the "Timber Town." Housing was almost nonexistent, tent cities arose, and a government housing project was erected behind what are now the Rife and Goodwill stores. These were originally the development's administration building, and the parking lot was a huge lawn.

In 1948, the centennial of Oregon's territorial status, the first Timber Days celebration was held over the four-day Fourth of July holiday. Within a decade, the event had been shortened to a weekend in August; however, it was still one of the biggest and best of the town's annual events. The 50th and last Timber Days was held in 1997. By then, Sutherlin was no longer a boomtown, and the timber industry had declined due to the spotted owl controversy.

The valley had its share of visionaries and industrious people doing their jobs, regardless of the roadblocks put in their way. They survived fires and floods and hung on to what they had. They built their schools, churches, service organizations, and a library. Although the timber industry was no longer king, businesses came and went, and there was wholesale unemployment, the town continued to survive. From the pages of old newspapers, we learn about the first council members, floods, fires, and how the town came back after a 1989 shutdown of the city, when there was no money to pay the salaries of the police, firefighters, and other city workers. These are hardy people, and survival is in their blood. Maybe that's what appeals to the newer senior citizens who, in greater and greater numbers, are retiring to Sutherlin.

In more modern times, timber has given way to tourism. Sutherlin has shed its former title of Timber Town to become The City of Flags. The flags can be seen flying from poles lining Sutherlin's business district from sunup to sundown on any holiday.

Sutherlin is the gateway to the southern Oregon wine industry, where prize-winning premium wines are produced and wine tours and tastings are easily arranged. It is the eastern terminus of the newly created Umpqua River Scenic Byway and just an hour away from both the ocean and ski resorts.

The valley abounds with recreational facilities. The Sutherlin Valley has seasons on deer, cougar, bobcat, grey and red foxes, wild turkey (fall and spring), and many other wild birds and animals. For fishermen, there are two well-stocked reservoirs, three creeks, the largest stocked log pond in Douglas County, and, last but not least, fly fishing along the Umpqua River.

One

IN THE VALLEY

OF CAMAS SWALE

The first settlers of the area were the Umpqua Indians of Athapascan origin. The tribe's language relates them to the Navajos and Aztecs. It is presumed that they traveled west in search of food when a drought occurred in their original lands. By the time Fendel Sutherlin arrived in Oregon in November 1847, not many Indians were left in the valley of blue camas.

Fendel joined the other 49ers in their rush to the gold fields but became seriously ill with mountain fever and returned to Portland. On his way north, he came across a valley all decked out in blue camas and wrote to his father about it.

In 1850, John Franklin Sutherlin started west with his wife, Sarah Carmichael, and their remaining nine children: Sarah Sutherlin Levins, Thomas (who sold his holding some time during the late 1800s and moved to the Willamette Valley), John S. (who married Polly Brown and died during an epidemic), Clinton (who moved away), James, Melinda Sutherlin Crouch, Sampson, Serena (Irena) Sutherlin Adams, and Jane Sutherlin Ferguson. For the westward journey, John F. cleverly hid his savings (gold coins) in the false bottoms of the flour barrels.

Fendel met his family in the Blue Mountains of eastern Oregon Territory and accompanied them to Camas Swale in the spring of 1851. The majority of their Donation Land Claims (DLC) were in the eastern end of the valley (covering Nonpariel and Fair Oaks). The claims of Fendel and his brother Thomas extended westward into what is now the city of Sutherlin proper. By 1860, there were quite a few settlers in the valley.

Schools were built. A two-block business district blossomed in Camas Swale between the road through Whitmore Gap and the railroad station.

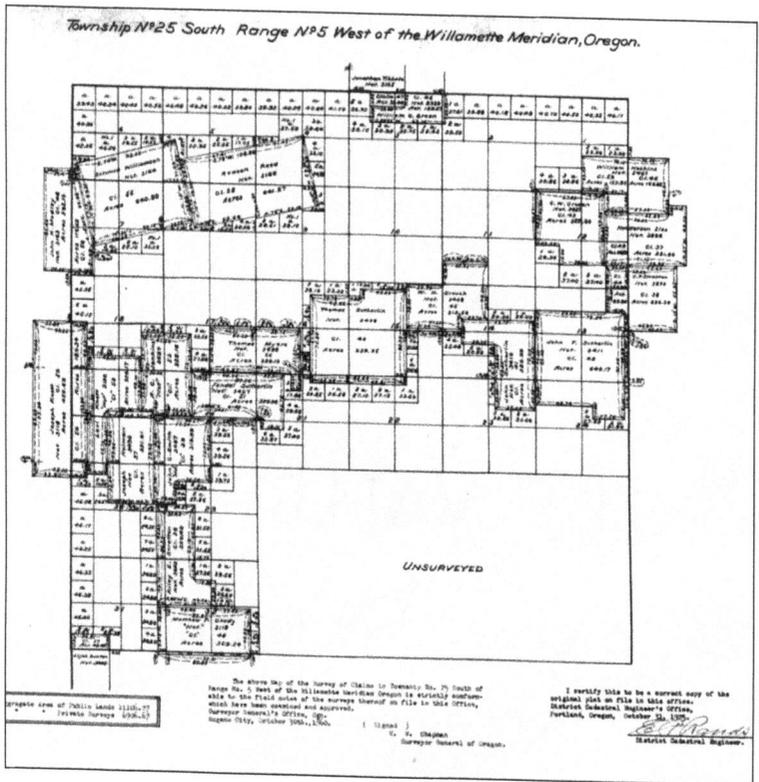

Township Nº 25 South Range Nº 5 West of the Willamette Meridian, Oregon.

These were the recorded Donation Land Claims in the Sutherlin Valley as of 1860. It usually took a minimum of a year between the time a family arrived on their land and when the claim was settled (evaluated for compliance and registered). This map does not show the pending claims. (Douglas County Surveyor Department.)

Umpqua County was carved from Benton County and authorized by the territorial government on January 24, 1851. On January 7, 1852, Douglas County was created from the section east of Umpqua County's Coastal Range. The population of Umpqua County decreased, and in 1862, it was absorbed into Douglas County and ceased to exist. Several annexations and boundary adjustments since then have created present-day Douglas County. (DCM.)

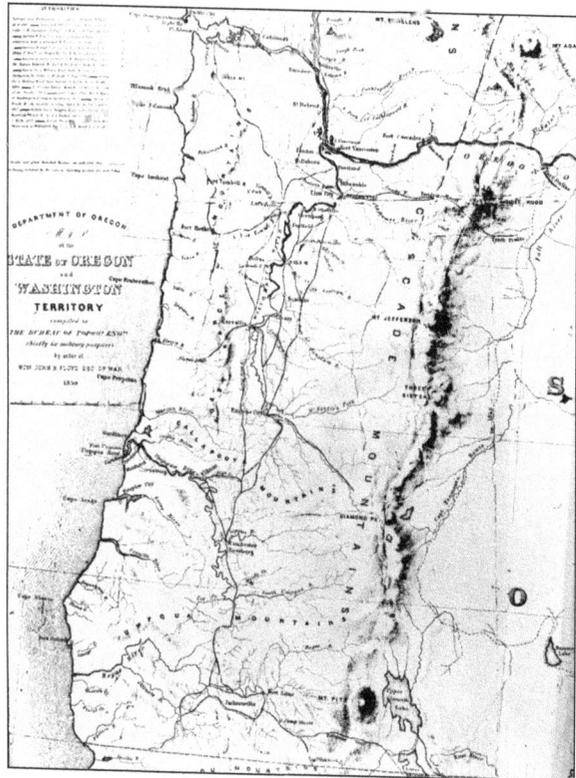

In 1850, John Franklin and Sarah Carmichael Sutherlin emigrated from Greencastle, Indiana. Their eldest son, Fendel, met them in the Blue Mountains and, in 1851, led them to the Camas-filled valley that he had discovered. In addition to several thousand dollars in coins hidden in the false-bottomed flour barrels, John Franklin brought with him the first flock of turkeys in the Oregon Territory. (DCM.)

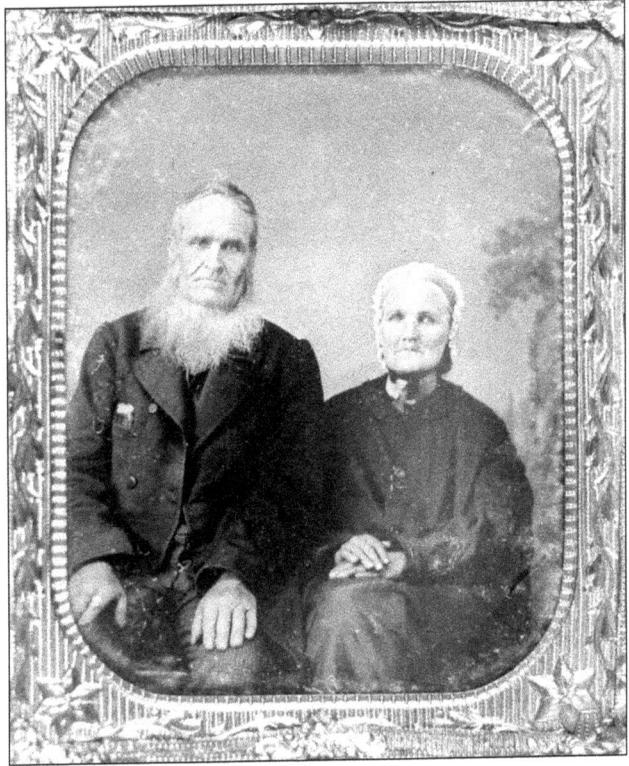

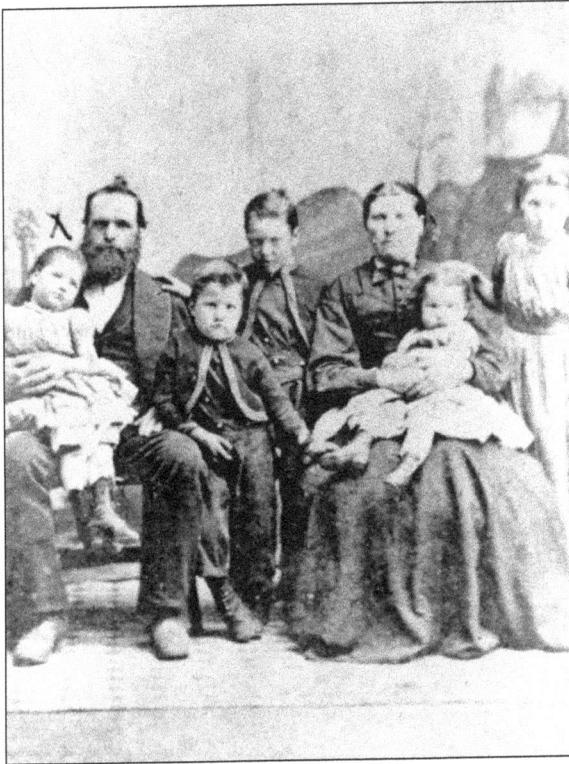

Too young to be eligible for a DLC, Sampson Sutherlin, son of John Franklin and Sarah Sutherlin, and family (a wife and five children) owned various farms in the valley and, for a time, ran a general store where the Fair Oaks Grange now stands. In 1978, several grandchildren still resided in the community. Sampson died in 1914 and is buried in the family cemetery. (DCM.)

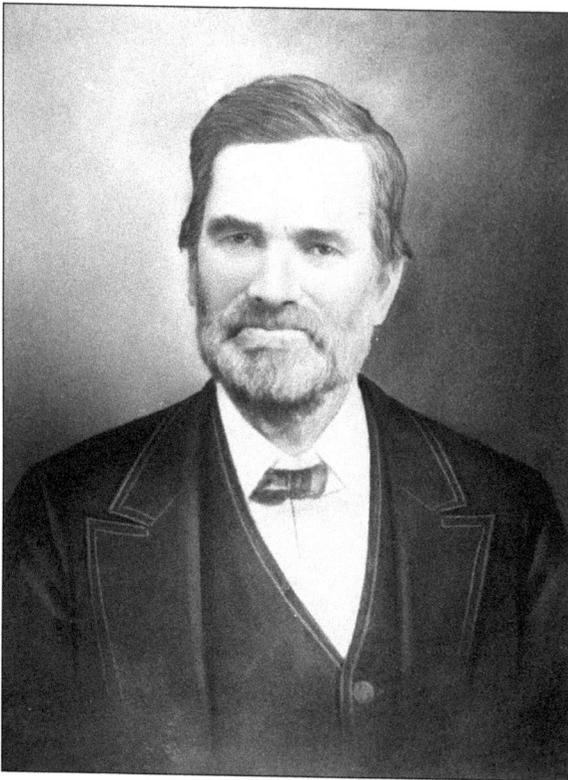

Fendel Sutherlin was the oldest son of John Franklin. He was already living in Oregon when his parents started west from Indiana with their nine children and the child of their eldest daughter, Lucy Mashon, who had married and died in Indiana. Fendel Sutherlin is credited with the early development of Oregon's fruit industry. (DCM.)

In 1854, Fendel Sutherlin married a widow, Lucy Richardson Brown, who had ridden her blooded racing mare named Kentucky Belle over the plains to Oregon when she came west. They had three daughters and two sons: Frances, Annie, Kate, John R., and Stonewall J. (S. J.). Kate and S. J. Sutherlin are buried in Cedar Hills Cemetery, formerly the Independent Order of Odd Fellows Cemetery, in Oakland. (DCM.)

James P. Sutherlin, son of John Franklin, was born in either 1846 or 1847 and died near Oakland while still a young man. A daughter and well-known artist, Maude Hollister, died in Portland in the early 1970s. James was buried in the Masonic Cemetery in Oakland. (DCM.)

Fendel's sister, Melinda Sutherlin Crouch, married Capt. Washington H. Crouch. She lived alone for many years at the family home in Oakland after her husband's death. She passed away in the early 1970s. The building was still standing in 1978 but had been sold previously. (DCM.)

John and Sarah Argabrite Hunt purchased land 2 miles east of Nonpariel from Thomas Jefferies in 1871. Sometime after that, John's nephew, Giles Hunt, occupied this ranch with his brother, Walter. There was good timber on this land, which they were careful to sell when the price was right. Giles was thrifty, to say the least, but he did give the money for what is now the C. Giles Hunt Memorial Library. He also taught French-Canadians who had settled near the Hunt land to read using English and French Bibles as texts. The Fair Oaks Cemetery was originally the Hunt family cemetery. A church at Nonpareil was another contribution of the Hunts. In the photograph below, taken about 1895, John M. Hunt (listed by the museum as a Camas Swale pioneer) is shown weaving a basket. (Both DCM.)

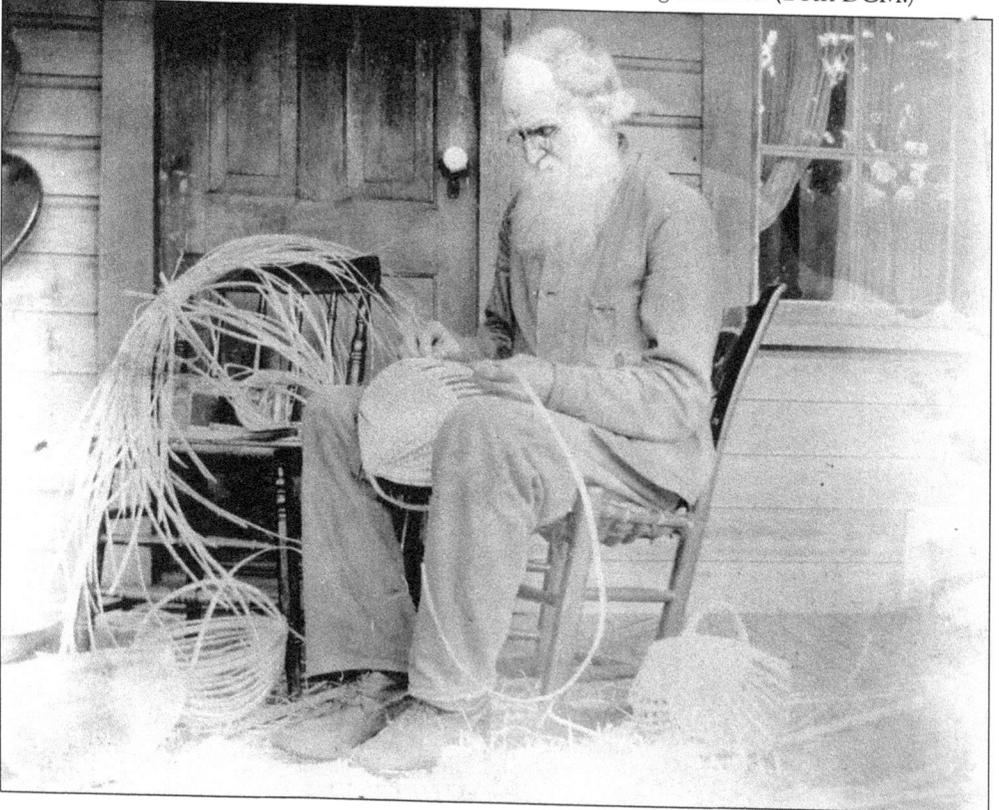

Two

WHEN FARMING WASN'T A HOBBY

John Franklin loved his land. It needed little, if any, cultivation. Crops yielded within two to three years from one planting because of the natural reseeding by the grain lost in harvesting. In an 1858 letter to his brother, Owen, John Franklin delighted in the fact that his entire family was settled within 25 miles of his home. He owned and leased a sawmill and a gristmill; had 10 acres of land planted with 500 apple, 200 peach, 25 pear, 25 cherry, and 30 plum trees; owned 100 head of cattle and 12 to 15 horses; and sold his apples for $1.50 a dozen in the valley and 75¢ a pound at the mines.

In addition to their original 640-acre Donation Land Claims, John Franklin and his son Fendel owned thousands of acres of land, much of which were planted in vineyards and orchards. Hired help earned a minimum of $400 a year plus board. It was to provide water for his fruit trees that Fendel hired a crew of Chinese laborers. Plans to bring water to the valley from the Calapooia were never completed because Fendel died of tuberculosis at his home on August 29, 1901, before any progress could be made.

The first school in the area was an unfinished large two-story frame building built by John Smith on his DLC. It was later bought by Fendel Sutherlin. This is where the Sutherlin children learned the alphabet. A second school was later located east of Cemetery Hill in what is now Fair Oaks.

Advances were being made in agricultural machinery, especially steam-driven ones. This was the advent of the power tool.

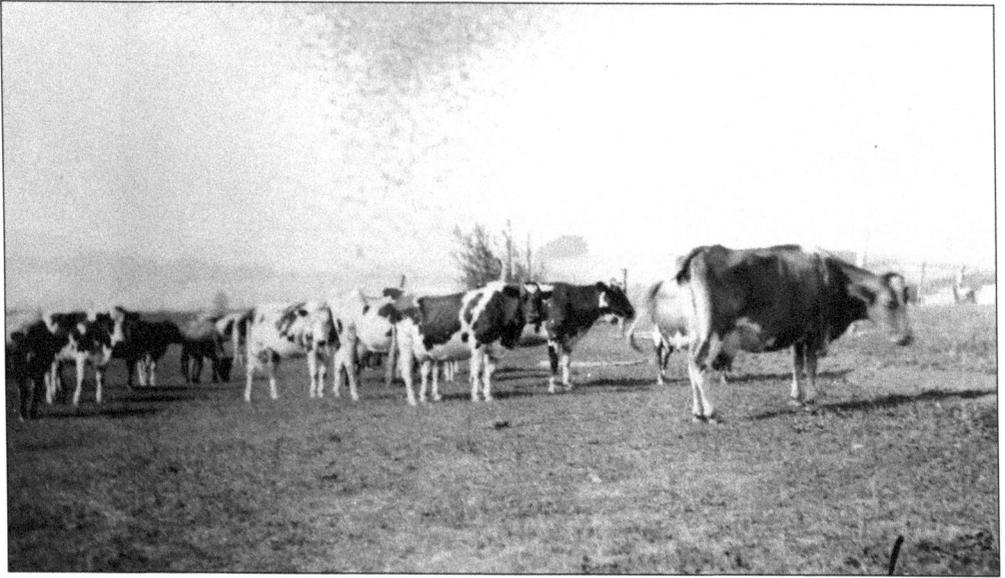

The Cobb cattle ranch was located near Kellogg. Shown here is the herd, composed of Ayershires and a single Jersey, which supplied milk for the Cobb Brothers Cheese Factory in Sutherlin. These milk cows were part of Goff's Dairy in Sutherlin Valley. (Above, DCM; below, Dana Culver.)

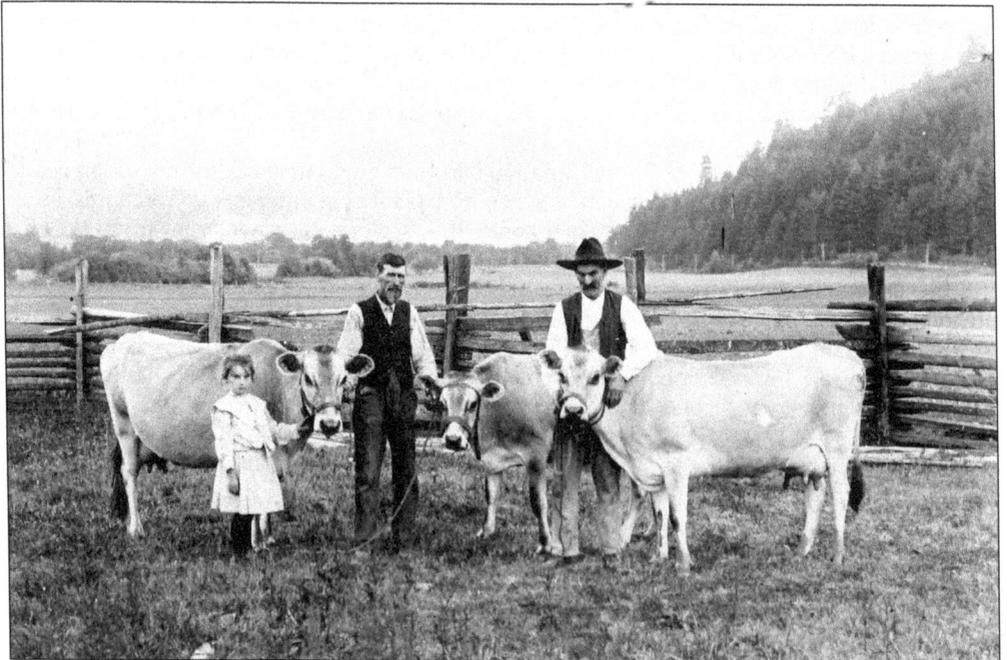

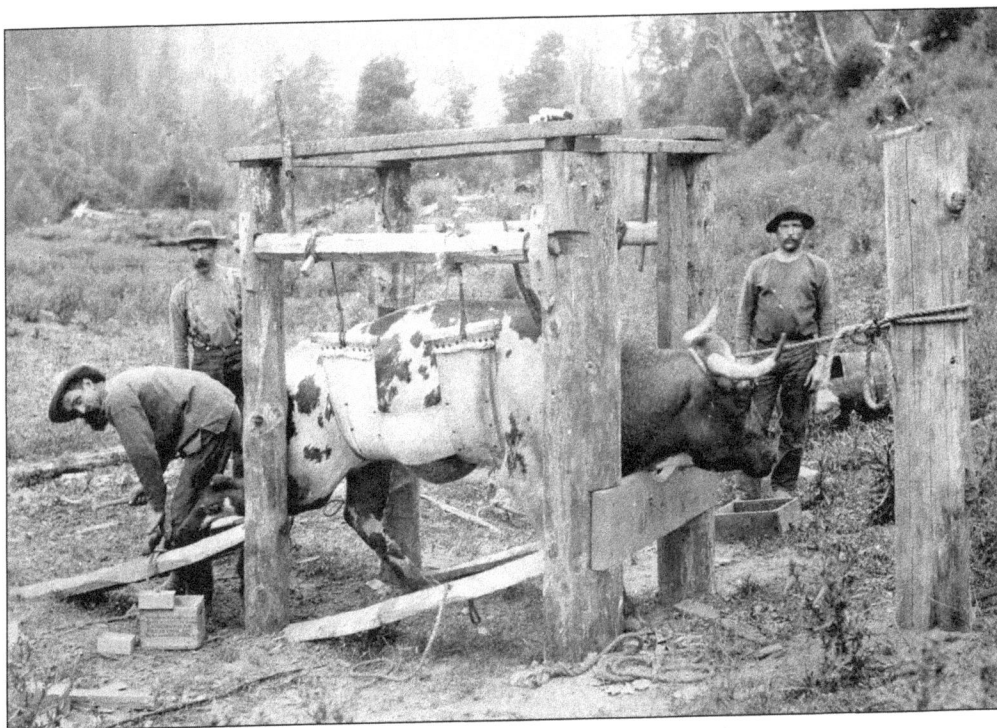

The 1890 photograph above shows W. W. Gage shoeing oxen for drafting and plow work. Below is the Rochester gristmill on the Calapooia, an example of the ones used during this time. (Both DCM.)

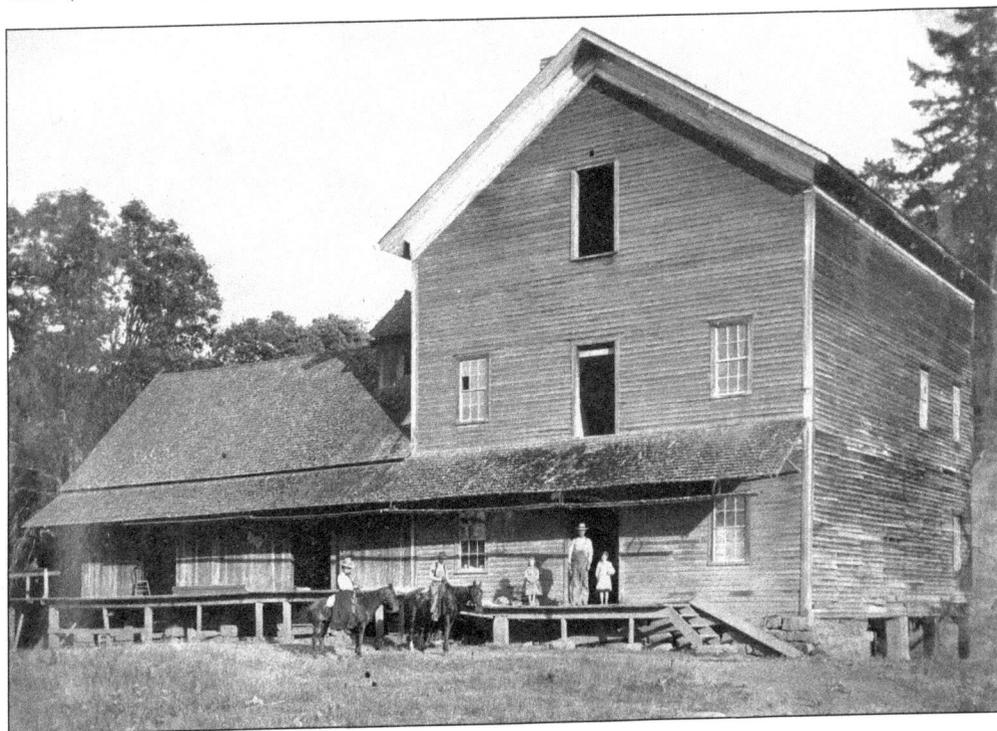

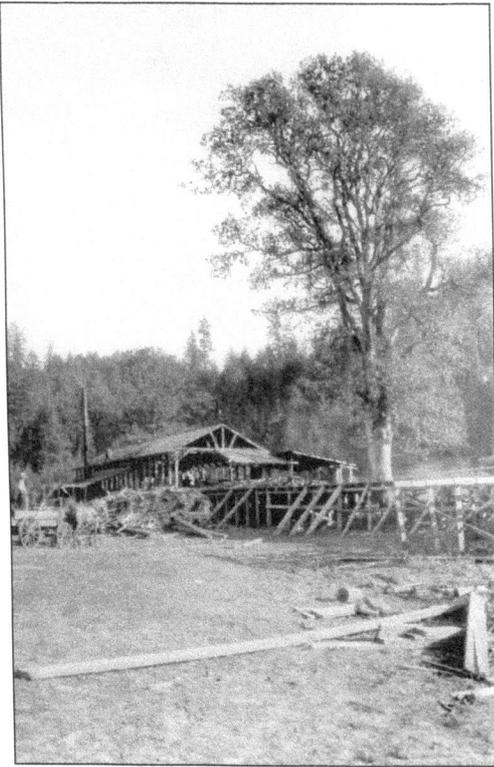

John Franklin Sutherlin was a millwright. He owned and operated lumber and gristmills during his active life in Oregon. His son, Fendel, was equally as industrious. This sawmill was located on the Sutherlin mansion property and was owned and operated by Fendel. (Courtesy of Pauline Wells Holley.)

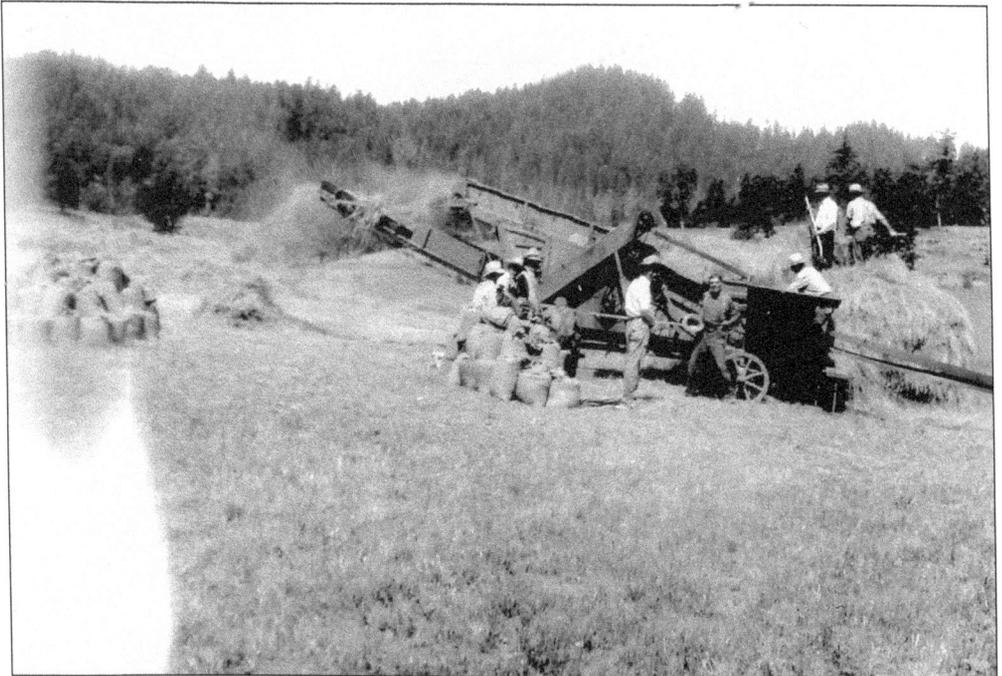

This early combine was used for haying in the late 1930s and early 1940s. It is a far cry from today's automatic combines that require nothing more than fuel, hay, baling wire, and one person to operate the machinery. (Pauline Wells Holley.)

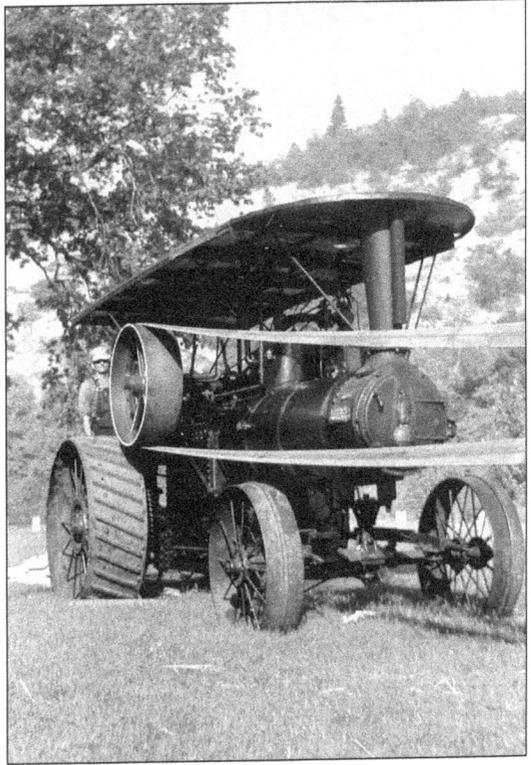

The machine age helped reduce the labor-intensive side of farming. The image to the right is a J. I. Case wood-burning steam thresher built at the start of the 20th century. Pictured below is the first wheeled plow, which was invented by Zara Sweet. (Both DCM.)

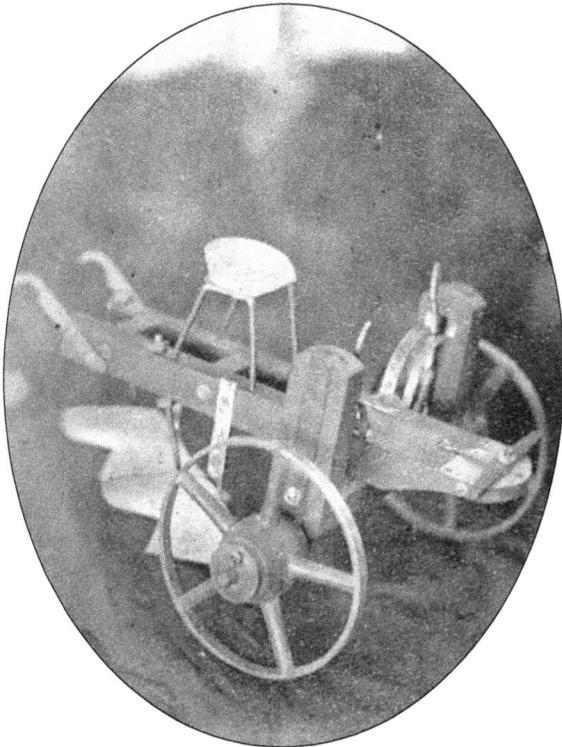

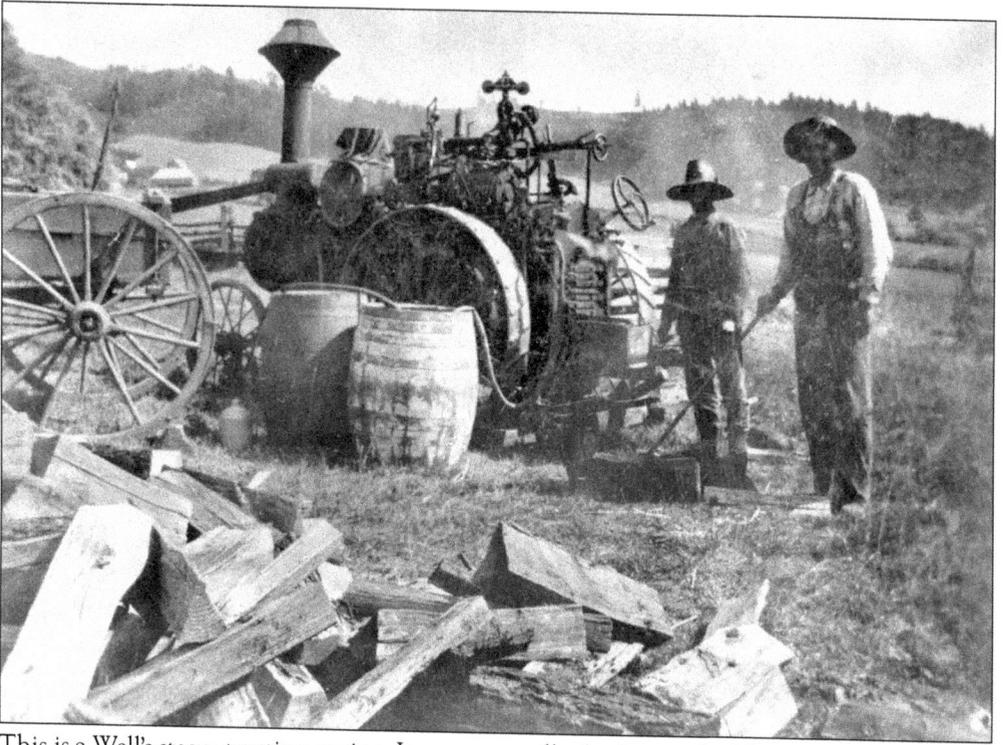

This is a Well's steam traction engine. It was reportedly the first in the Umpqua Valley. Pictured are Frank Walla (left) and Victor Miller. (DCM.)

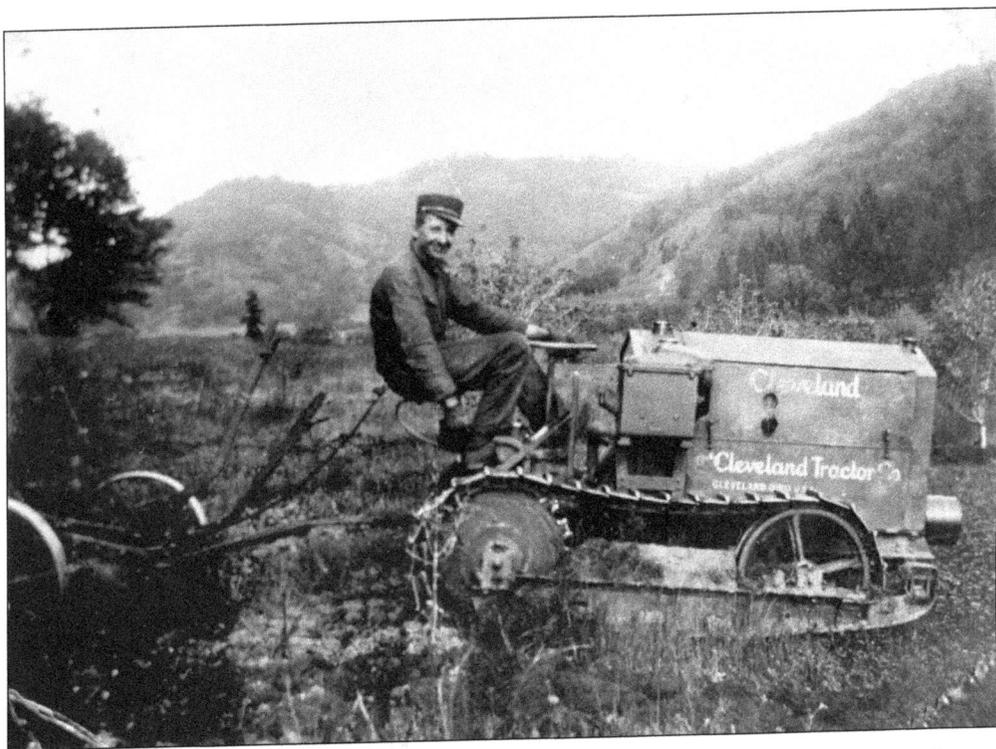

These are early crawler-type tractors. Above is an early Cleveland tractor known as the Cletrac. Below is an early gas model with a single wheel in front and crawler tread drive wheels in the rear. (Both DCM.)

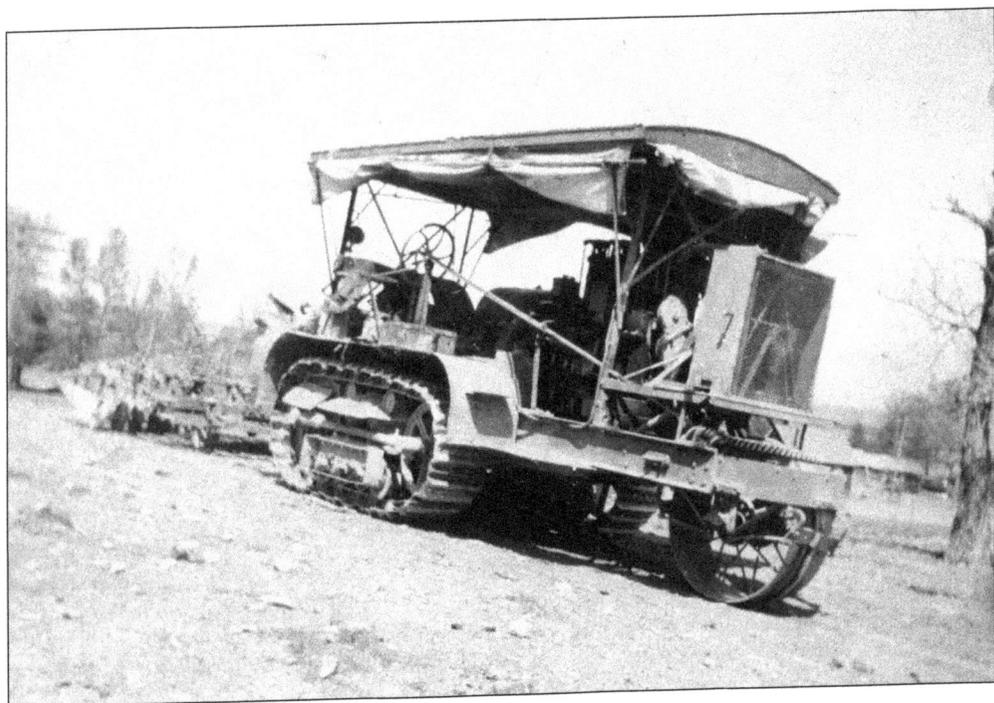

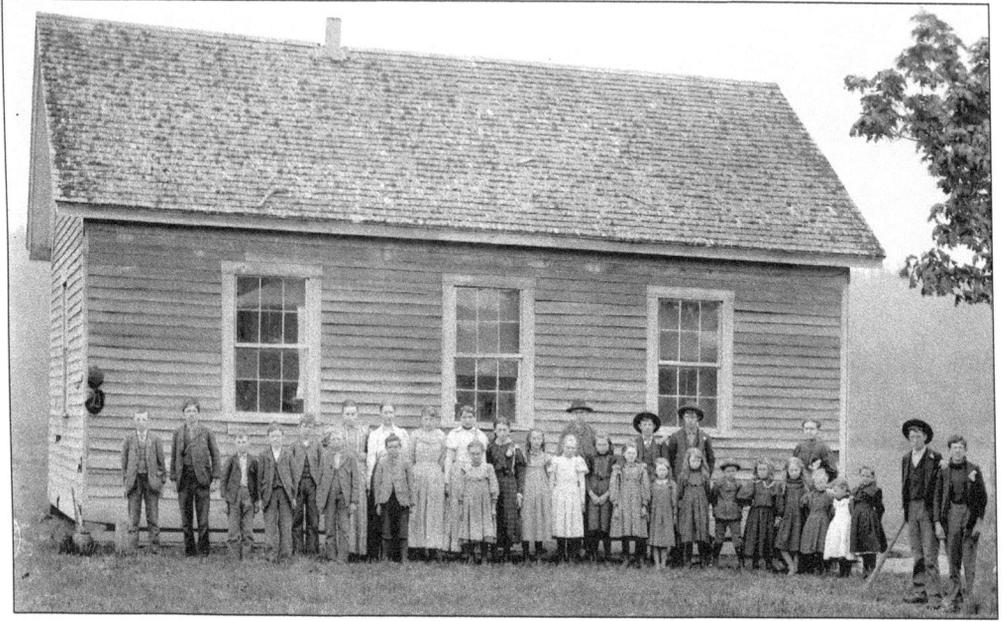

Camas Swale School was built around 1854 and was located near what is now Plat I dam. Pictured on May 14, 1898, from left to right are Giles Hunt, Dora Gammon, Archie Archambeau, Mollie Abeene, Minnie Fraser, Lauretta Archambeau, Essie Hall, Alice Gammon, Lula Wright, Francis Foster, Frankie Anderson, Ruth Keebler, Blanche Bogard, Laura Wright, Ona Webb, Pheabe Abeene, John Abeene, Eddie Keebler, Volney Dixon, and the teacher, Jesse Ohmart. (DCM.)

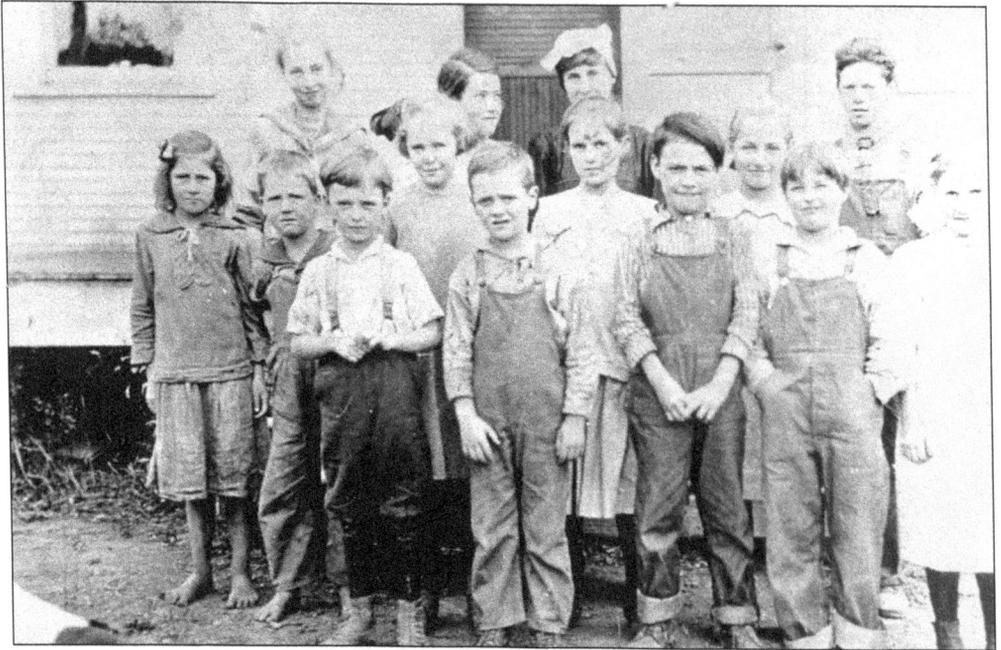

The Nonpariel School group of 1917 included, from left to right: (first row) Alvin Mohr, Ray O'Mara, Dewey Parazoo, Dick Rone, and Grace Filley; (second row) Anita Denley, Joe Denley, Metta Mohr, Ruby Anderson, and Hazel Parazoo; (third row) Helen Galbrith, Leona O'Mara, and unidentified. (DCM.)

22

Three

CAMAS SWALE
BECOMES SUTHERLIN

Anne Sutherlin Waite wanted a town in the area to honor the memory of her father, Fendel. The name Sutherlin was adopted in 1909, and with a population of 455, the town was officially incorporated in 1911.

With the help of her husband, Frank, much of Anne Waite's inherited lands were platted or subdivided in 1901. According to one source, Frank and J. W. Perkins of Roseburg formed the Sutherlin Land and Water Company to encourage the growth of the town and the development of orchards. However, another source says that on September 3, 1904, Frank Waite, Fred J. Blakley, A. E. Caton, and Lynn Caton organized the Calapooia Investment Company for the purpose of bringing electricity and irrigation water to Camas Swale. This company was reorganized and, on November 28, 1904, became the Sutherlin Land and Water Company (which is the current name on county plat maps for the land east of Sutherlin), and Fred Blakley and T. R. Sheridan were named as stockholders. Work to fulfill Fendel's dream began. Irrigation ditches were dug. Flumes were built on the north and south sides of the valley. The next wave of settlers came by train, which took weeks instead of months, across the prairies and mountains. Gone were the days of hunger, illness, attacks by Indians, suffering, and deaths. These new settlers traveled in comparative luxury. Camas Swale began to expand.

Sometime in 1906, the Sutherlin Land and Water Company was sold to J. F. Luse and became the Luse Land and Development Company (LLDC). With the help of his friends in St. Paul, Minnesota, Luse campaigned to sell 10- to 20-acre orchard home sites to Easterners. In many cases, the new settlers bought the land sight unseen from ads and postcards; others came on excursion trains arranged by the LLDC. Several years later, a railroad shipping scandal found the new farmers tearing out the orchards for more profitable crops and/or animals that did not depend on rail transport. This put an end to the land schemes, and Luse went bankrupt.

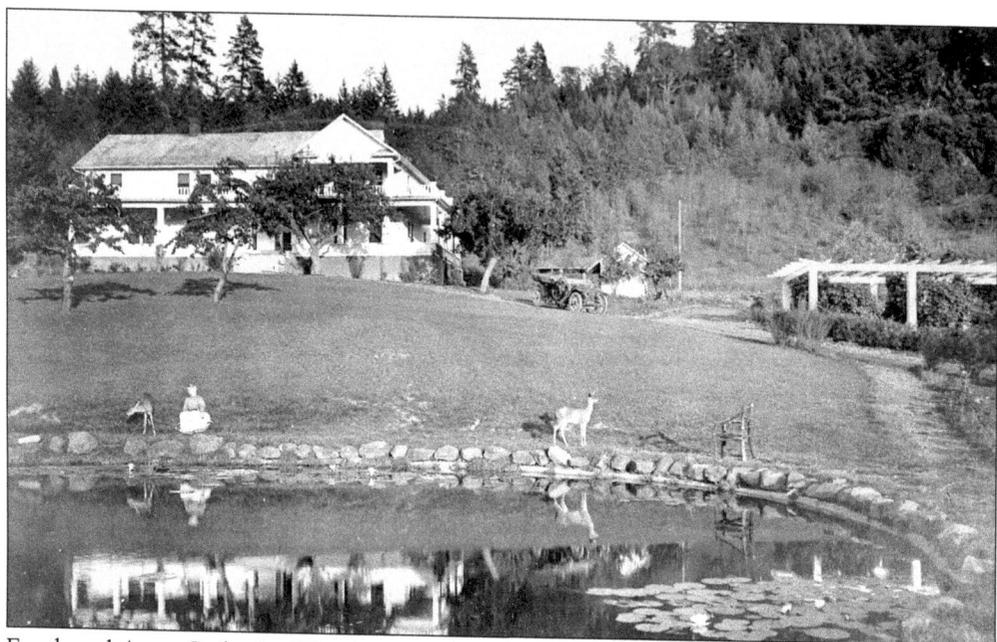

Frank and Anne Sutherlin Waite and her family lived in the Sutherlin mansion (shown above around 1915) after her father died in 1901. Their son, Fendel Waite, is the little boy in the left foreground. The home had 22 rooms and was located in the hills south of where Waite Street curves eastward before becoming Southside Road. After the daughters of Anne and Frank Waite left the area in 1935, the house was occupied by Elton (a local mail carrier) and Bertha Bever, who lived there as caretakers for 10 years. The house had been vacant for more than 15 years (and the target of vandals), when in 1987, the owners, Barbara Catterlin and Walter Bennett, reluctantly set fire to the derelict home. (Above, DCM; below, *The Sun Tribune*, Pauline Wells Holley.)

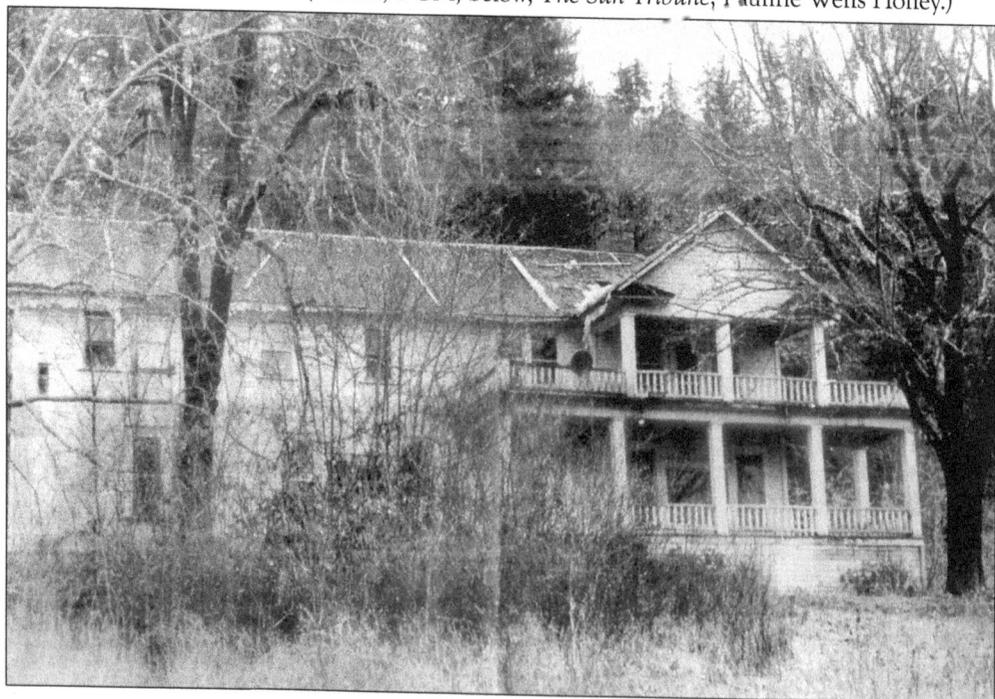

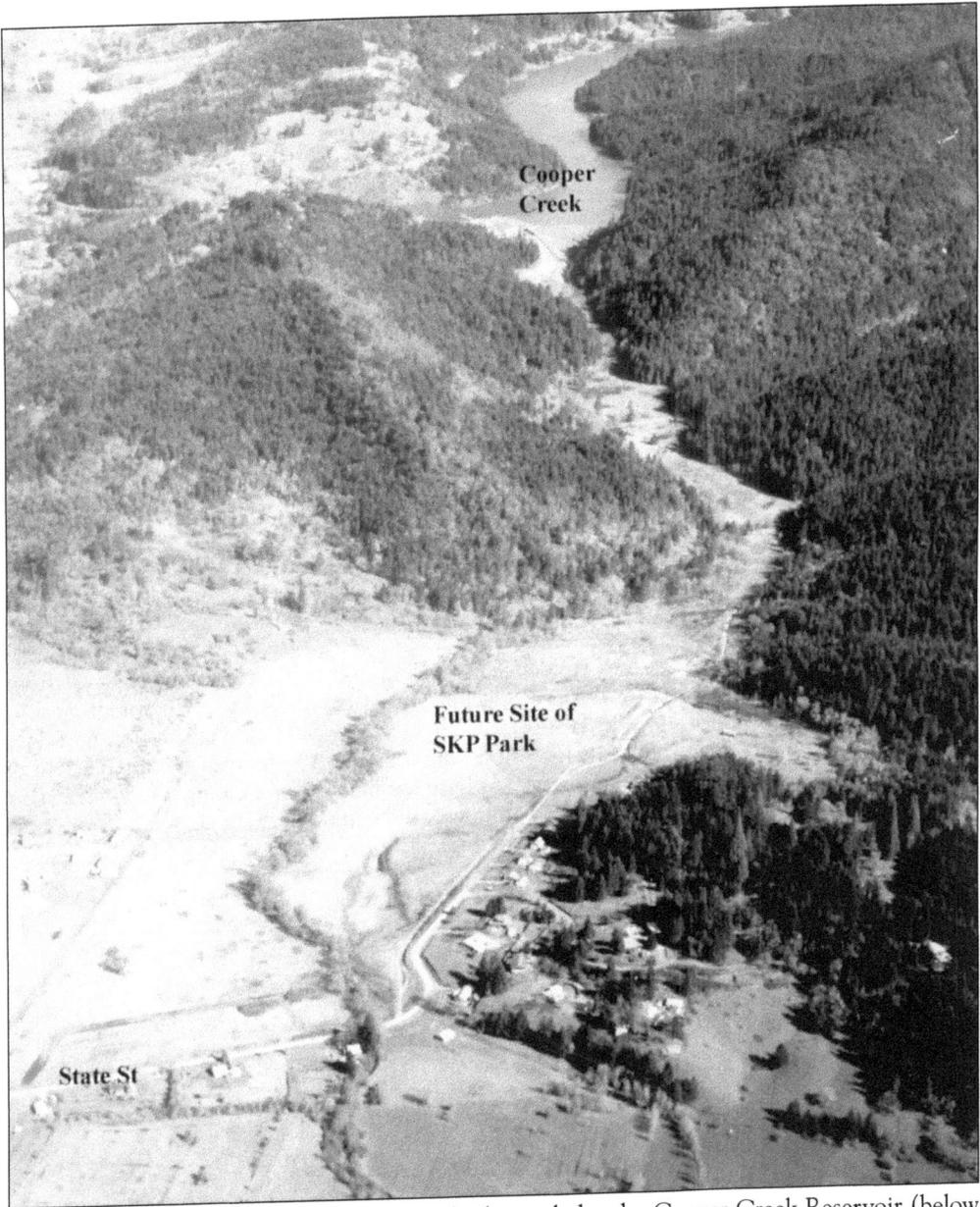

Cooper
Creek

Future Site of
SKP Park

State St

In this *c.* 1960 photograph, Southwest Sutherlin includes the Cooper Creek Reservoir (below the words "Cooper Creek"), the future site of Timber Days Escapee Park (SKP), and the southern terminus of State Street. Notice that if the dam should fail, the SKP would quickly flood. Many early settlers' homes, including J. F. Luse, were located on the elevated ground at the lower right. (Char Hendershott, Sutherlin Visitor's Center.)

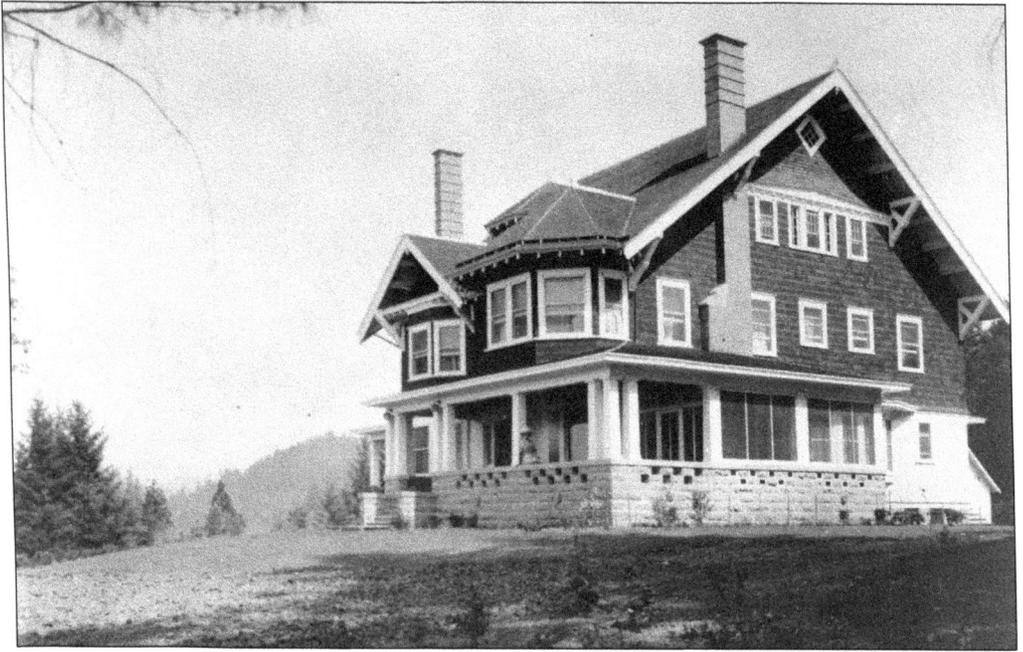

These photographs show the J. F. Luse residence (above) around 1910 or 1911, and the view from his front yard in 1904 (below). Luse's car ("Special Agents Excursion"), in the foreground, is heading to town on State Street, which still leads directly into Oakland via the community of Union Gap. The orchard on the left (which now contains houses) and the area to the right of the curve (now the SKP) were both properties of Luse Land and Water Company. The existing town of Sutherlin can be seen, including a warehouse, the bank, livery stable, school, and such. (Above, DCM; below, Char Hendershott, Sutherlin's Visitor's Center.)

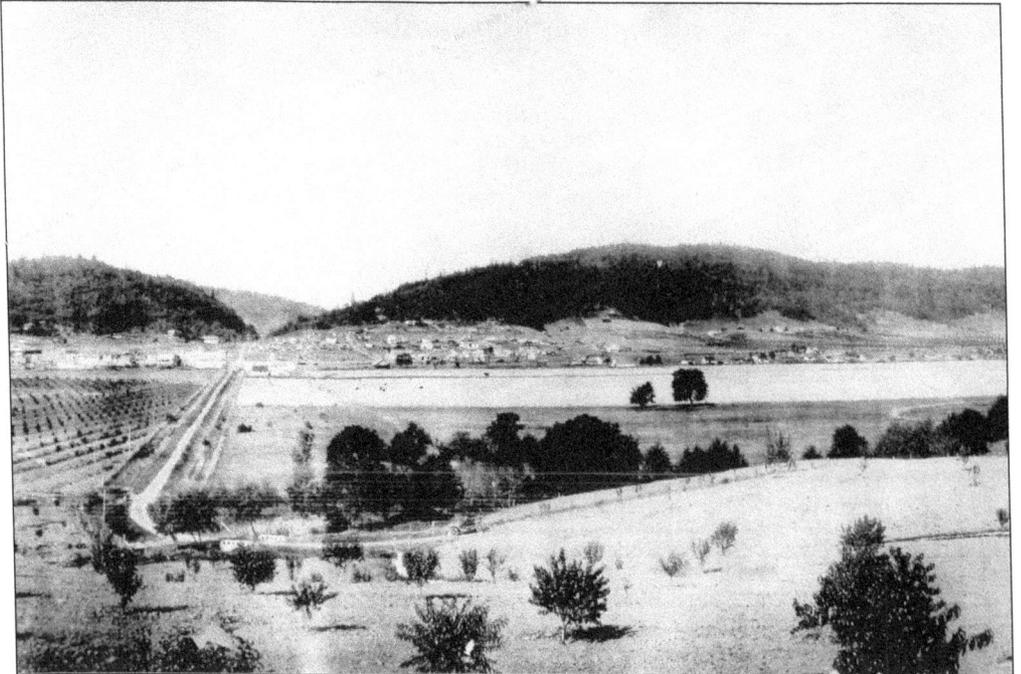

The exterior of the J. F. Luse Land Company Office is shown above. The 1915 photograph below is believed to show the interior of the Luse office. It is uncertain if this building still exists. (Both DCM.)

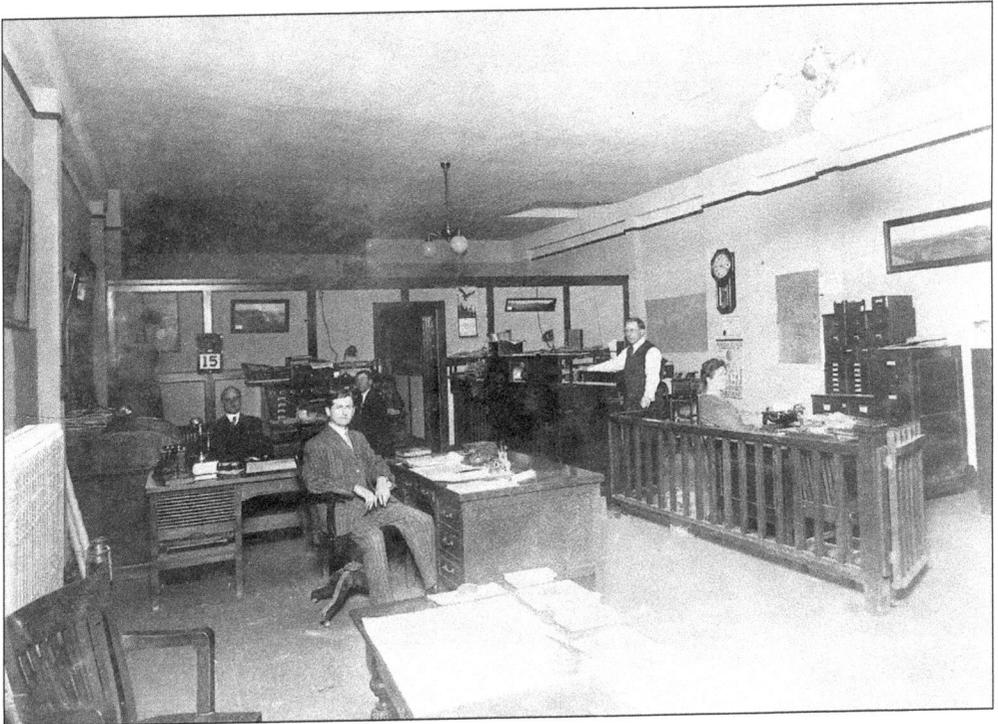

J. F. Luse placed ads, such as the one at left, in Eastern newspapers and used postcards similar to the one below and on the opposite page above to entice investors and potential settlers. Excursion trains were arranged for prospective buyers of the Home in Orchard Tracts (in then Camas Swale). (Left, S100; below, DCM.)

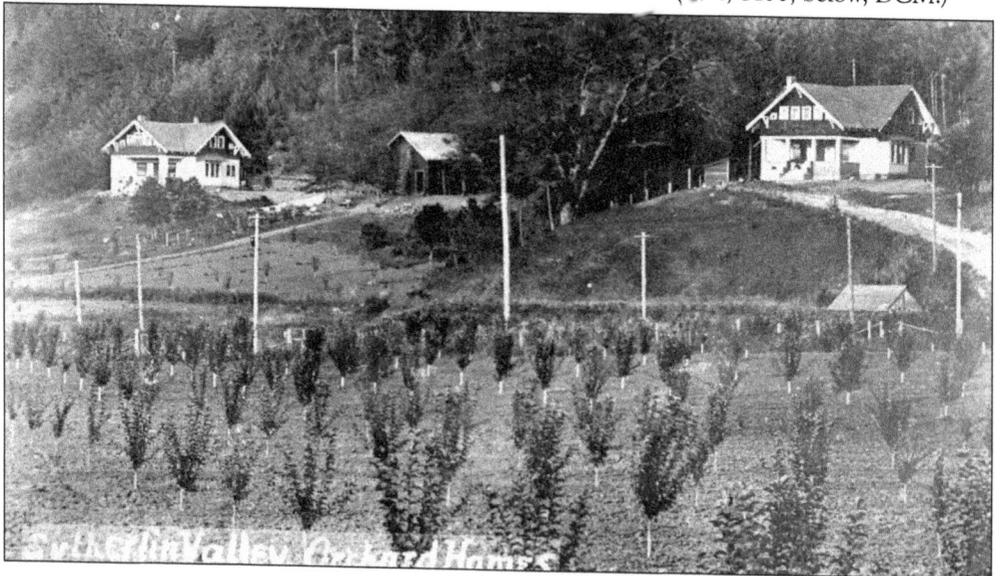

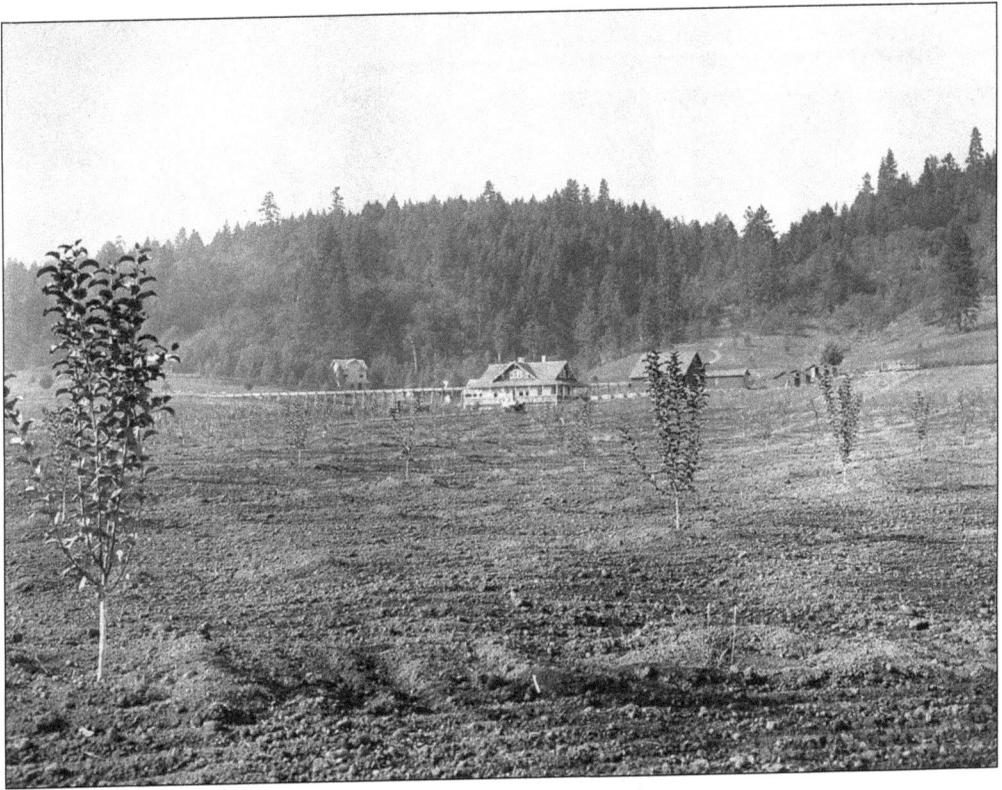

Above, a Luse Land and Water Company flume can be seen in the background. A close-up of a flume can been seen below. It was located along Northside Road, about half a mile east of Sutherlin and the crossroads at the present-day Stop and Shop Market. (Both DCM.)

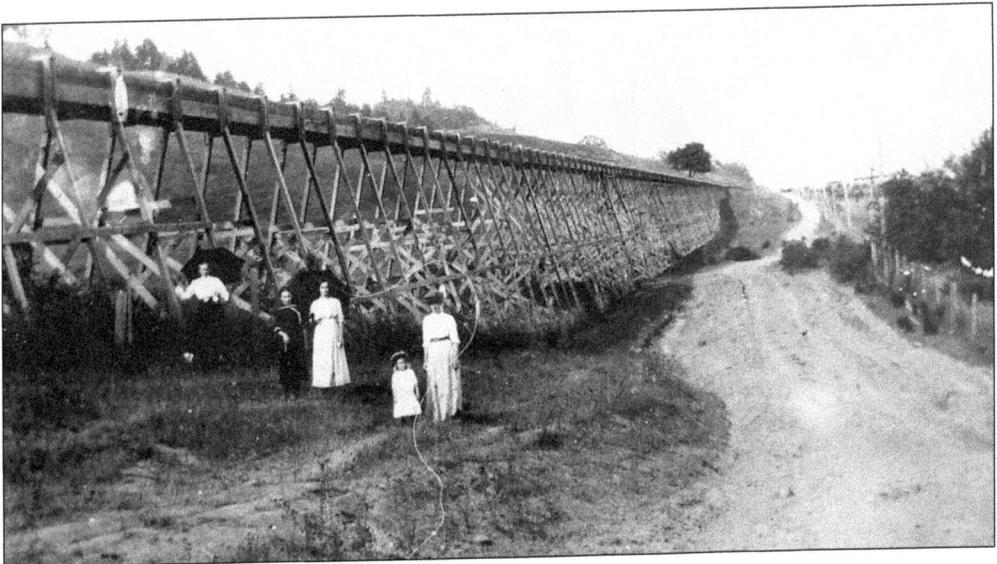

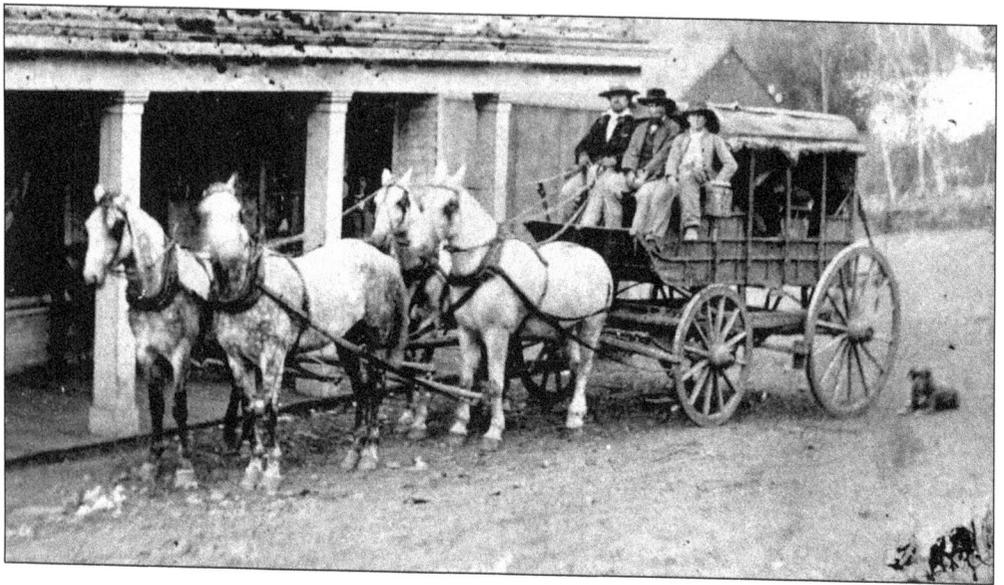

The advance of the railroad marked the end of another part of western history: the stagecoach era. The above photograph was taken around 1869. In the east-facing panoramic view of the main street of town (below), the Bungalow Hotel is on the right. (Both DCM.)

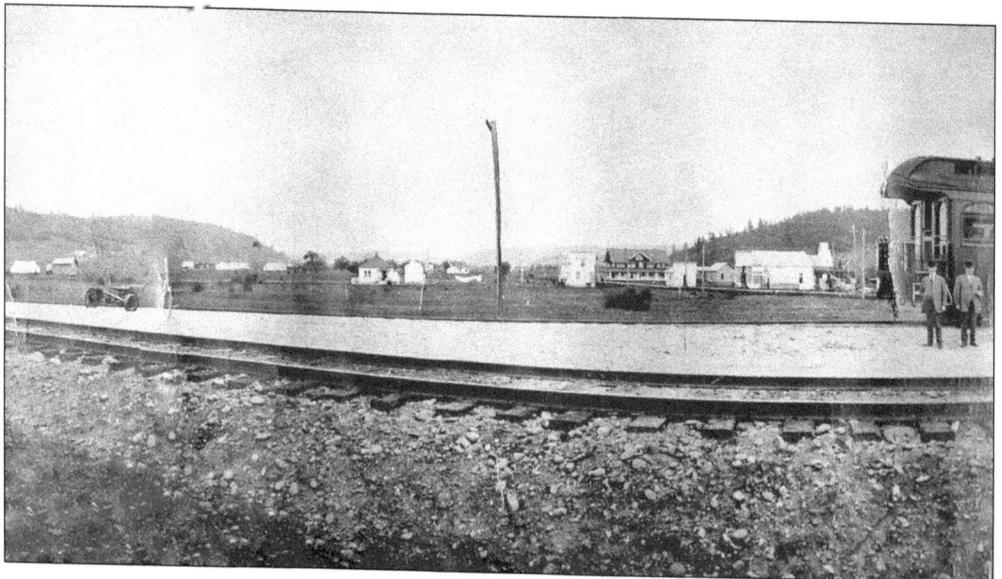

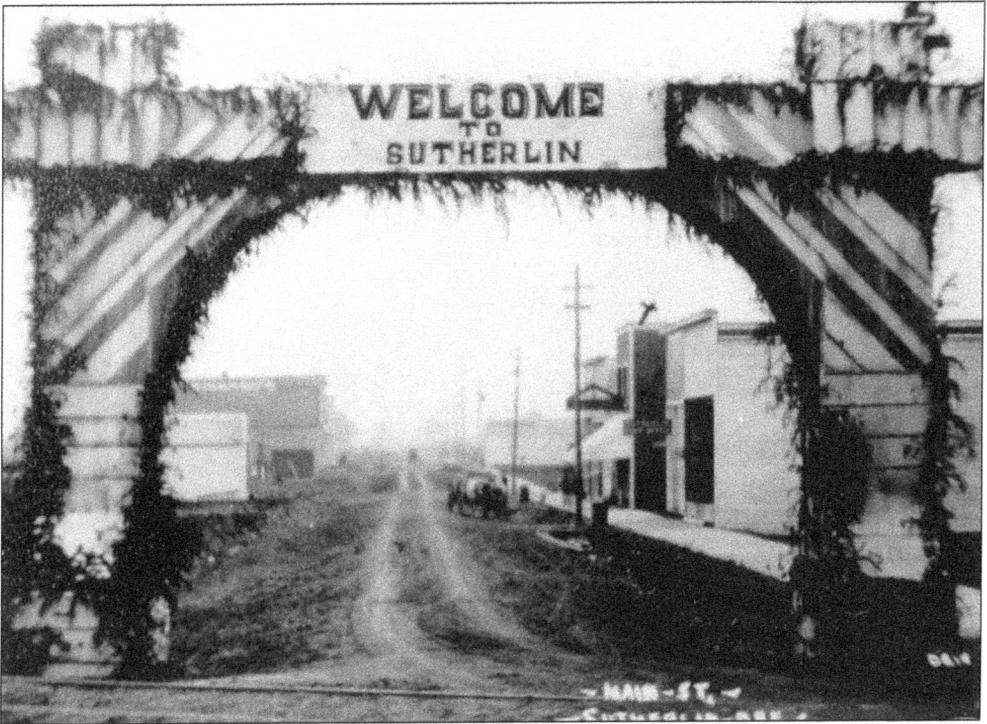

Above, a "Welcome to Sutherlin" arch, decorated for holidays and other events, has been added to the view. Could one of these events be to greet the Excursion Train? The 1912 photograph below may show one such train, or those passengers may simply be returning from a Roseburg shopping trip. Train No. 20 and Engine No. 800 is a 4-4-2 type obtained from Cananea, Rio Yaqui and Pacifico, built by Brook Locomotive Works in 1908, and acquired by Southern Pacific in about 1912. It became the Southern Pacific No. 3066 but was scrapped in 1935. (Both DCM.)

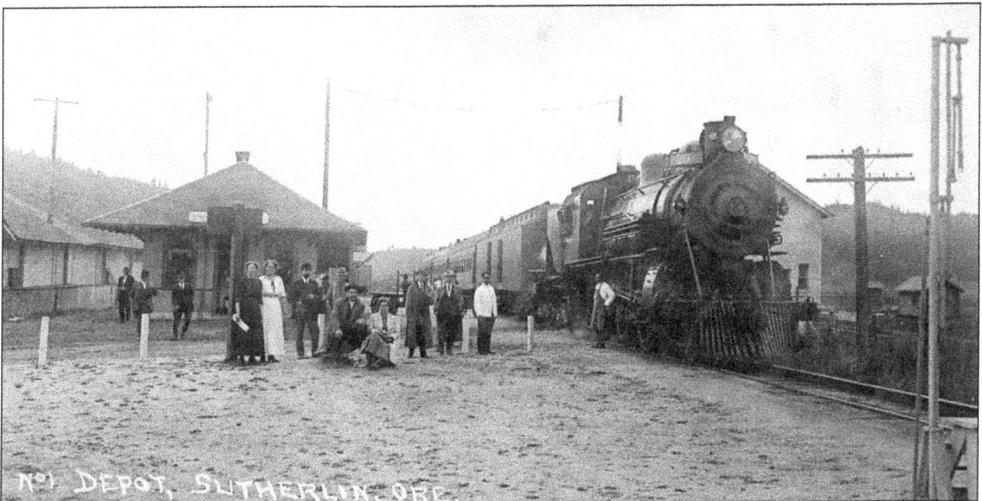

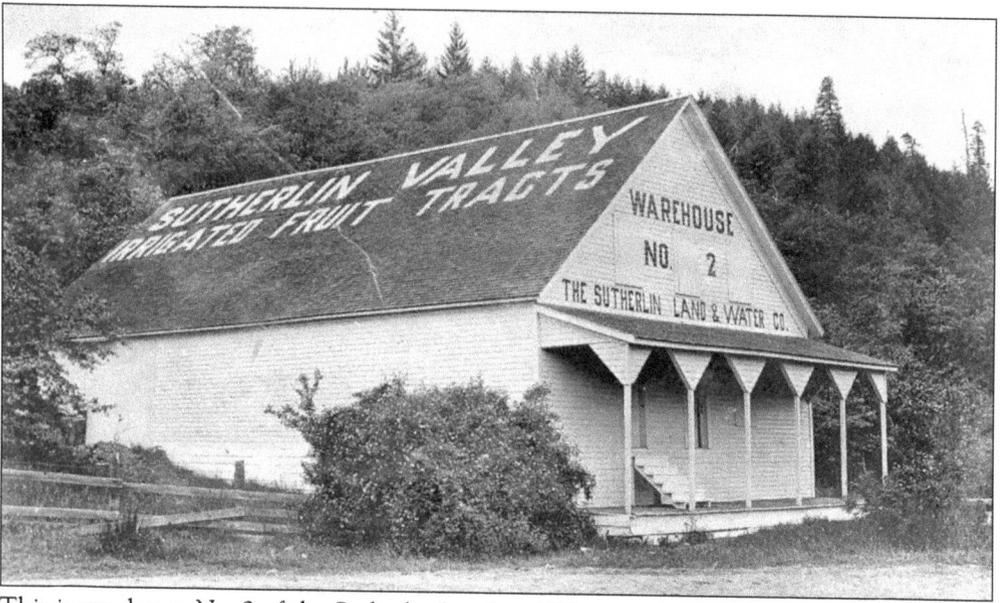

This is warehouse No. 2 of the Sutherlin Land and Water Company. This building burned in January of 1917, along with 80 tons of baled hay. This was just one of several Sutherlin Land and Water Company warehouses located throughout the valley. (DCM.)

Pictured are Ike Dompier (left) and John Smith, who was the blacksmith for Luse Land and Water Development. His shop was in the forks at Fair Oaks. He had a reputation as a rather odd character, and many people were afraid of him. (DCM.)

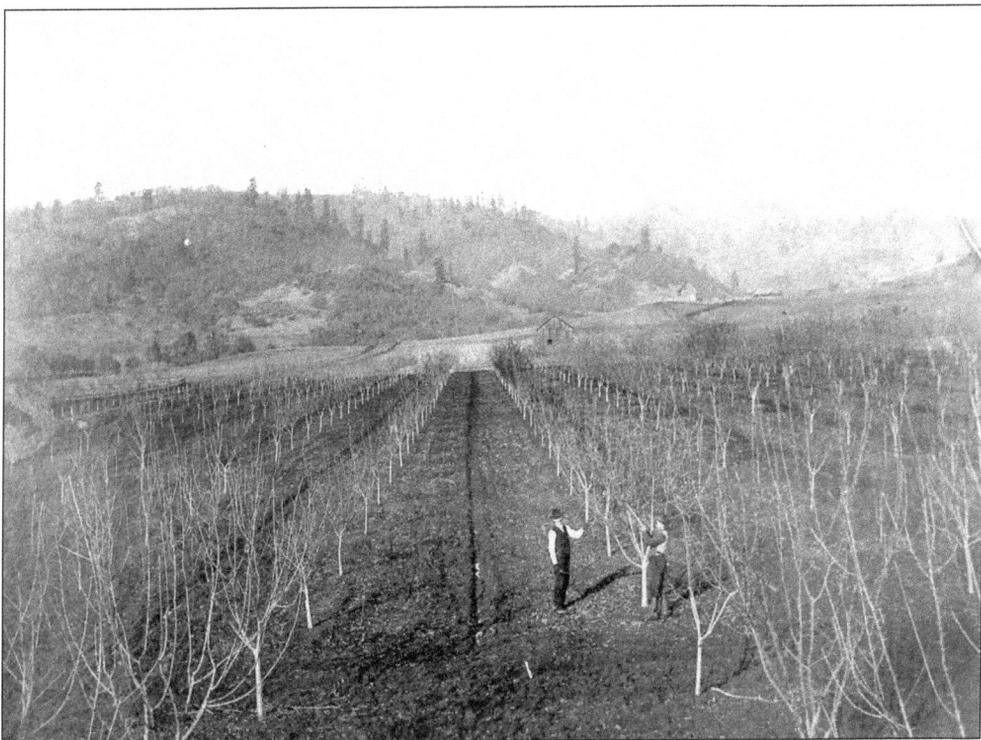

W. L. Cobb Real Estate subdivided the Frank Waite and Fendel Sutherlin ranches where this 10-acre apple orchard was planted. This photograph was taken about 1908. (DCM.)

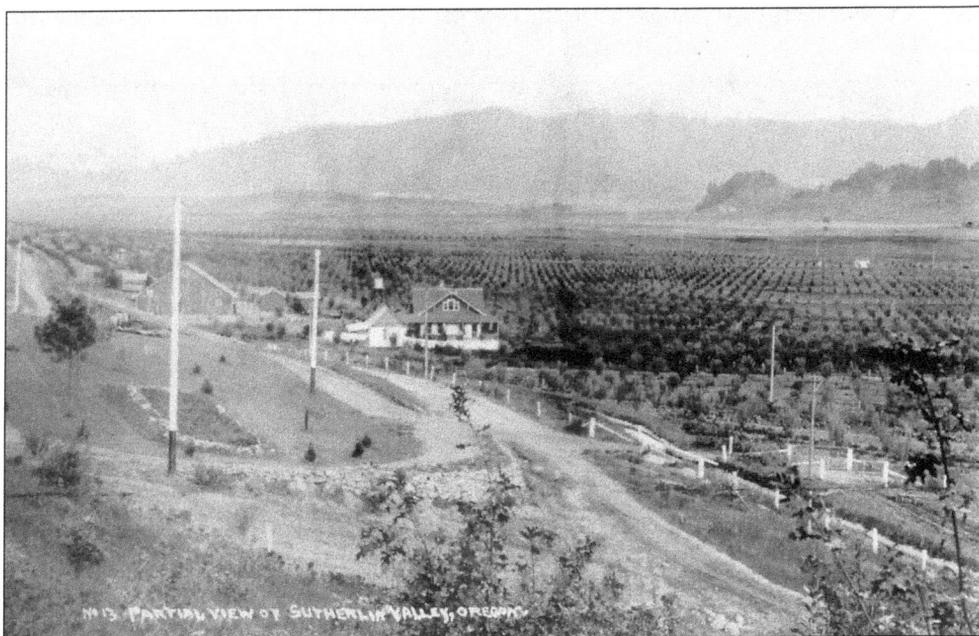

Vintage postcards such as this can be dated by looking at the arrowheads in the four corners of the "Place stamp here" box on the back. All four arrowheads were pointing up, indicating that it was printed between 1908 and 1912. (Oakland Antiques.)

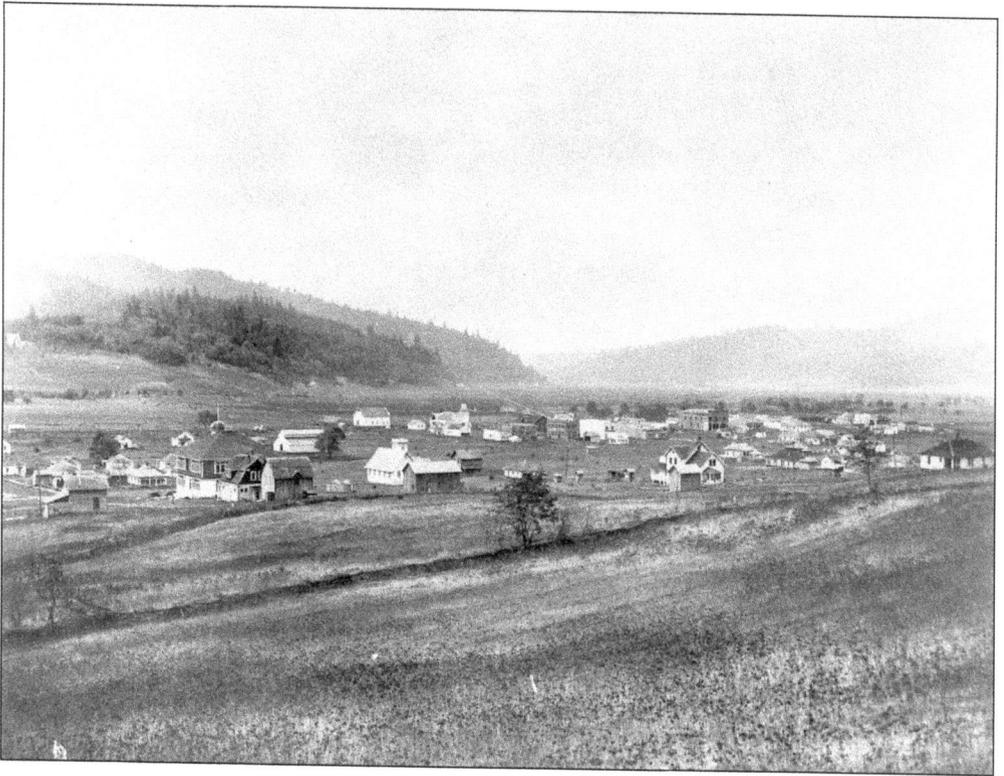

The overview above shows 1911 Sutherlin. Below is an early view of the Sutherlin Hotel and a restaurant. Notice the gas pump outside the Ford car shop and the furniture store on the left. (Both DCM.)

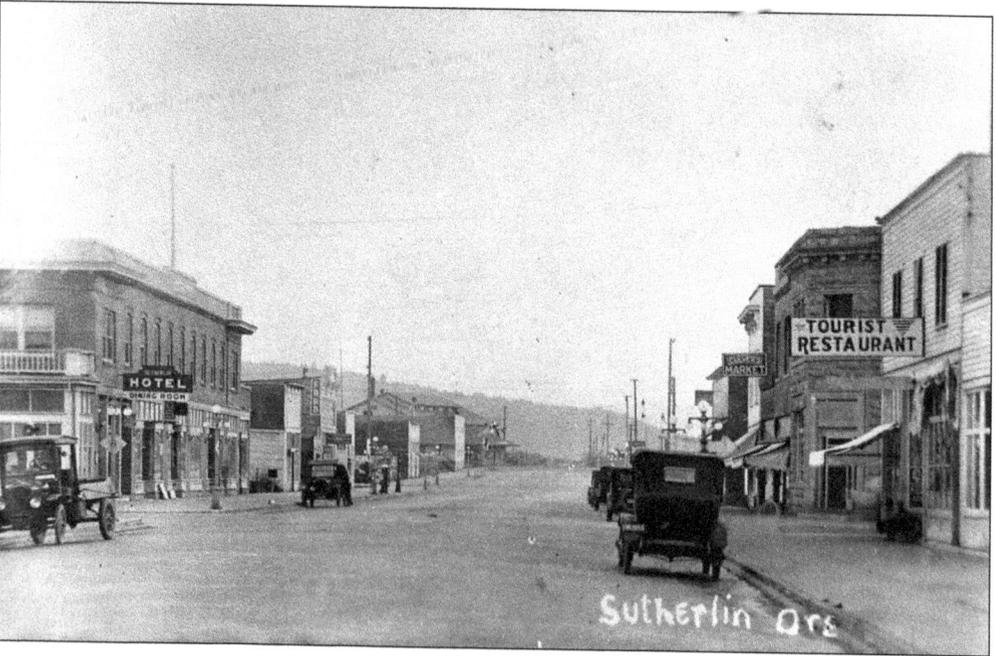

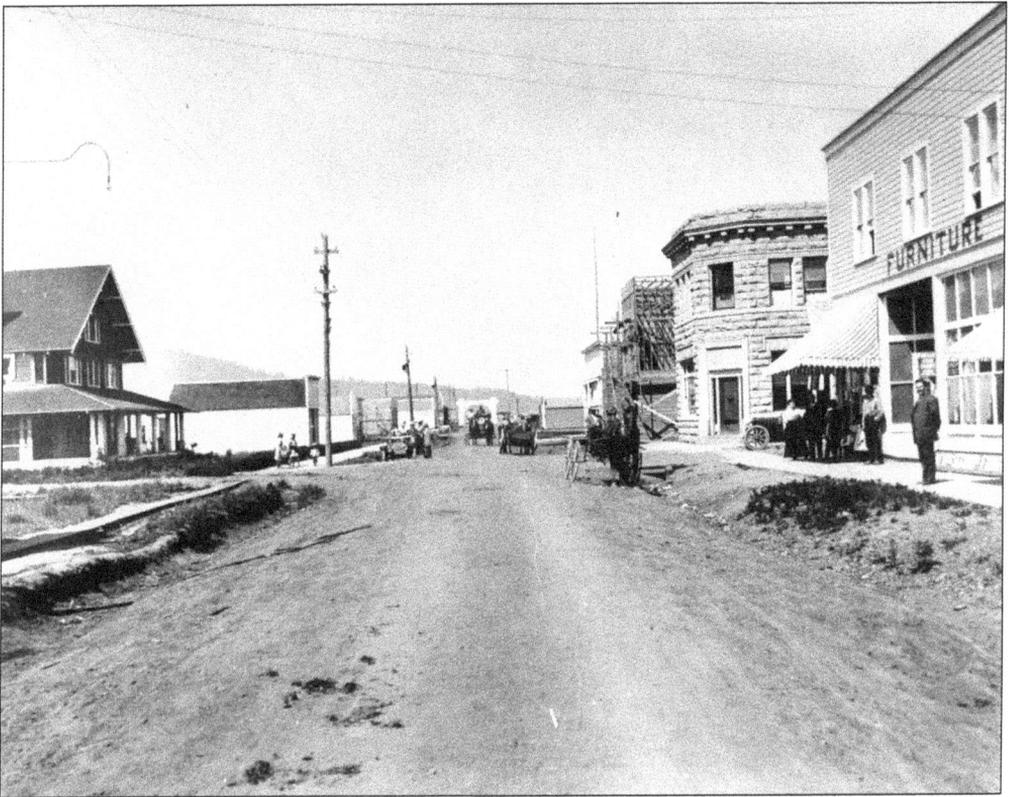

A building is being put up west of the bank. The gap will be filled in by Culver's Meat Market and, later, the D. W. Banker building (immediately next to the bank) in 1916. Below is a close-up of the building and the space between it and the bank. Sadly, the building has been demolished because it was structurally unsound by today's standards. (Both DCM.)

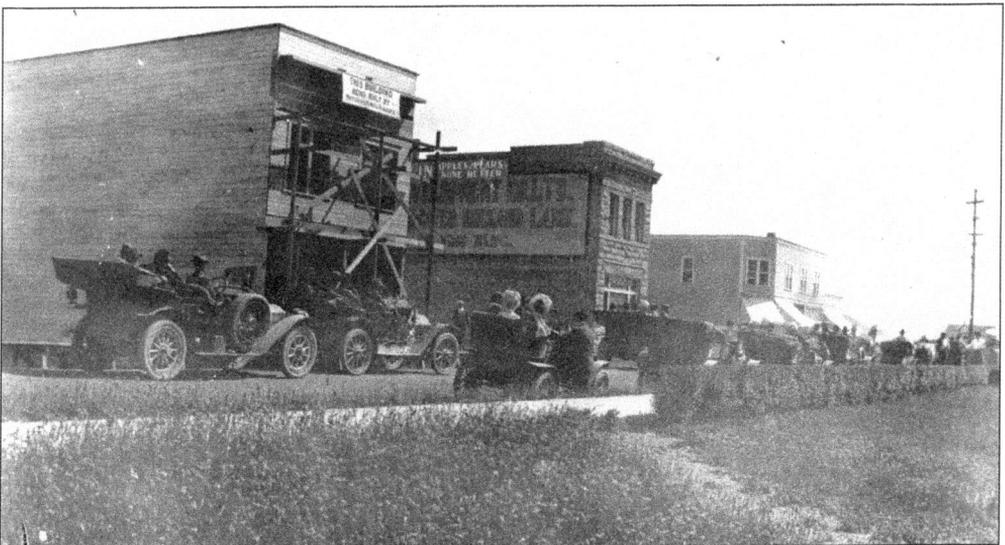

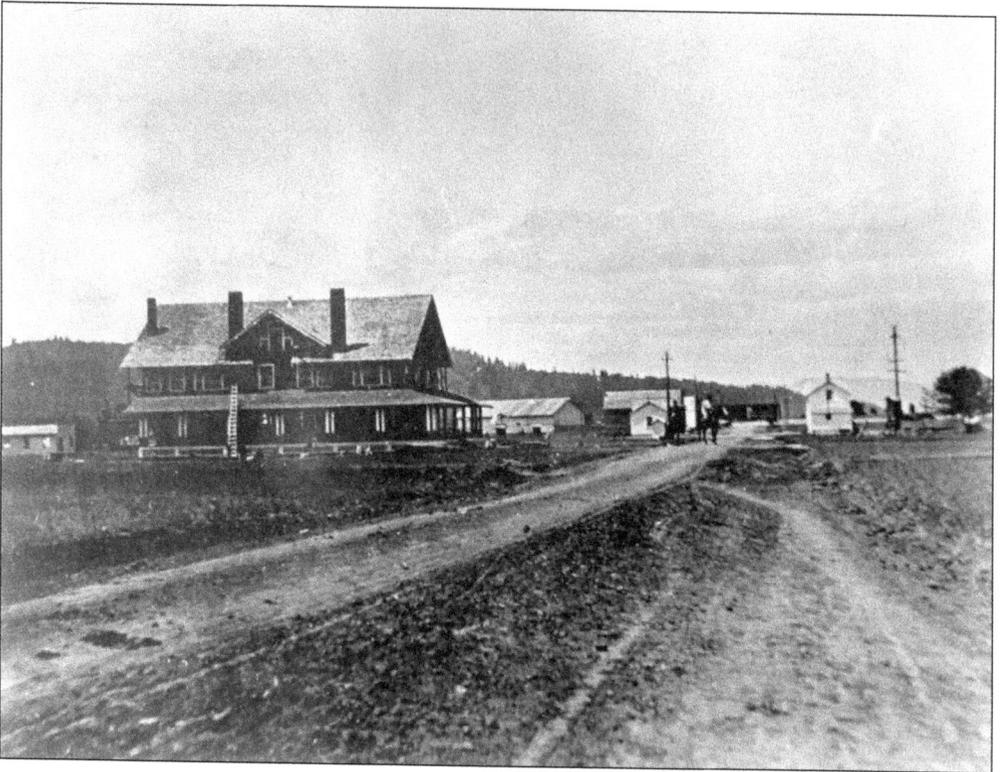

Often mistaken for the Sutherlin Hotel, the Bungalow Hotel was located on the south side of the main street (now Central Avenue), just east of the railroad tracks. It can be identified by the third chimney on the south eave of the roof. The camera is looking east on Central Avenue. (Both DCM.)

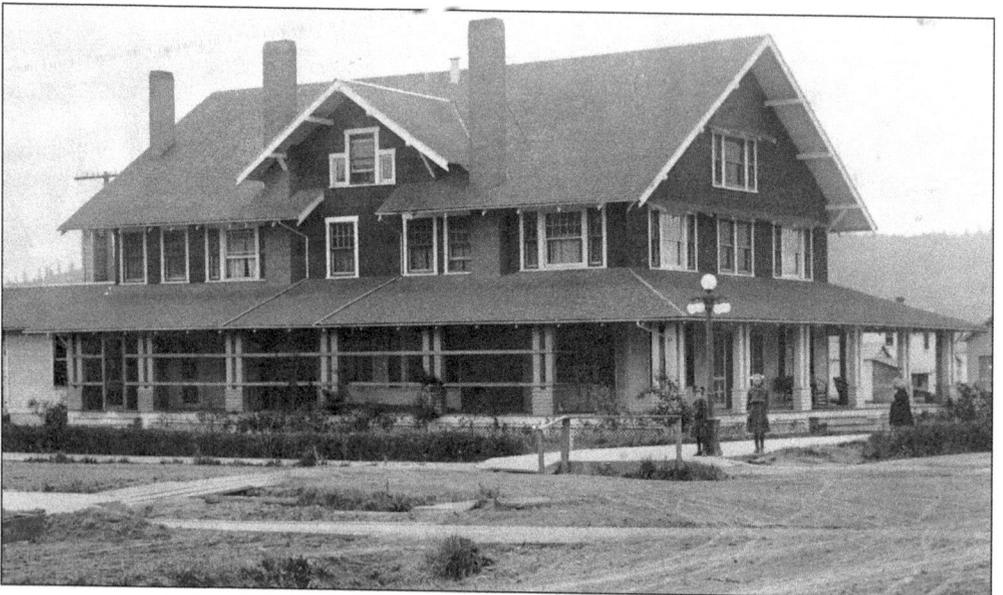

Four

GASLIGHTS AND A GROWING CITY

Dirt streets gave way to gravel and, finally, pavement. Cars and trucks replaced horses and wagons, and gaslights progressed to electricity and eventually to mercury vapor lamps.

The town was growing. In 1908, John Denny moved his family to Sutherlin. Finding no schools, he helped organize the one-room schoolhouse (which he obtained from the Strawberry School District, west of Sutherlin) and moved to a hillside above the town. Denny also spearheaded the fund-raising efforts for the first church in town, which was dedicated on June 9, 1911. It was later destroyed by fire and was not rebuilt.

The first city officials to serve two years each were Mayor W. J. Phillips, Recorder Will J. Hayner, Treasurer W. E. St. John, and Councilmen W. F. Rapelje, A. E. Shiria, F. C. McReynolds, F. W. Franz, T. A. E. Lyman, and A. E. Bamber.

During the 1920s, people began to realize that conditions weren't really good enough for commercial growing, marketing, or transporting of fruits. The irrigation system left much to be desired, the principal markets were too far away, and the railroads charged exorbitant fees that ate up the profits on shipped commodities. As a result, orchards were uprooted. The last fruit cannery closed in 1928, and the local economy suffered.

In the 1940s, although men no longer went openly armed, Sutherlin had earned the reputation of being one of the toughest towns in the state. This may partially have been the result of the November 22, 1912, vote to remain wet, or allow alcohol to be sold, making Sutherlin one of only two towns in Oregon to do so. On Monday mornings, the jails would often be filled with those who had celebrated the weekend in a less than law-abiding manner. One judge owned the liquor store where the miscreants bought their alcohol and then sentenced them on Monday for over-imbibing.

Until 1951 or 1952, Sutherlin had a mayor-council form of government. Later, it reincorporated and adopted the city manager–council format.

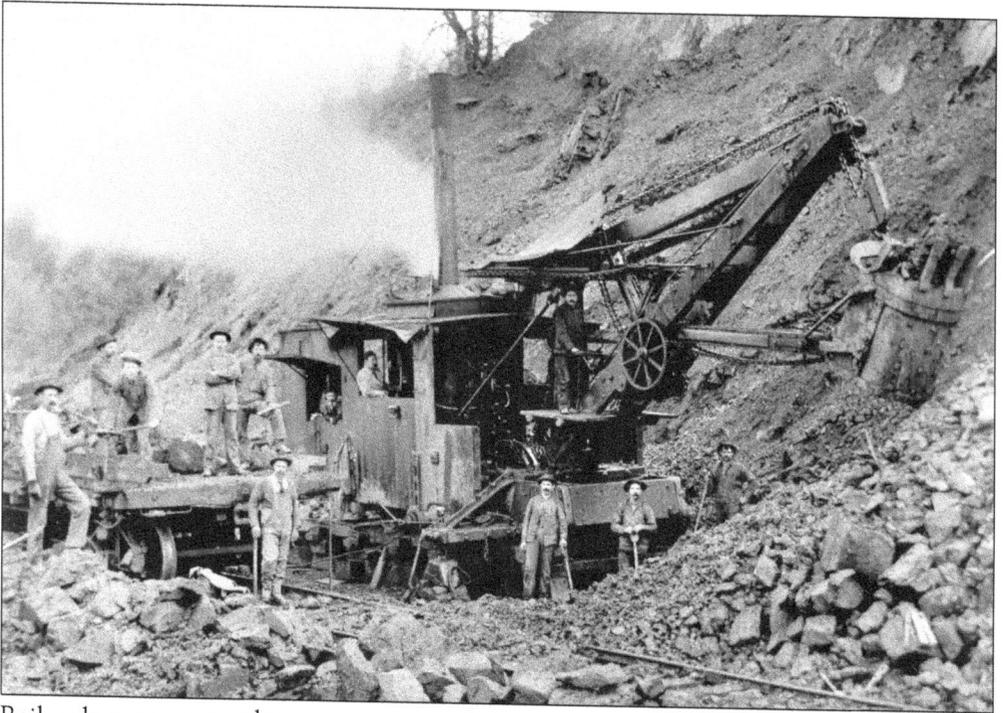

Railroads, necessary to advancement, required a lot of physical labor. The picture above was taken in 1890 and shows an Oregon and California Railroad (O&C) steam shovel with a chain-driven boom and bucket. The crew, link, and pin flatcar are working between Oakland and Whitmore Gap. Below, they are seen widening the railroad cut in the same area. Passenger and freight lines shared common tracks then and now. (Both DCM.)

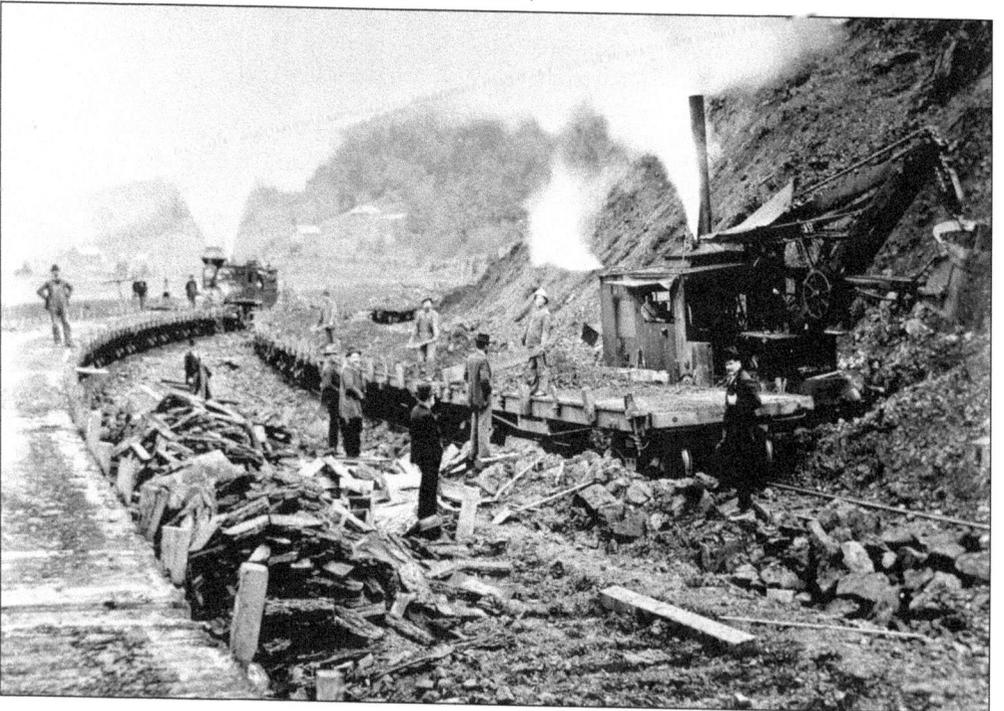

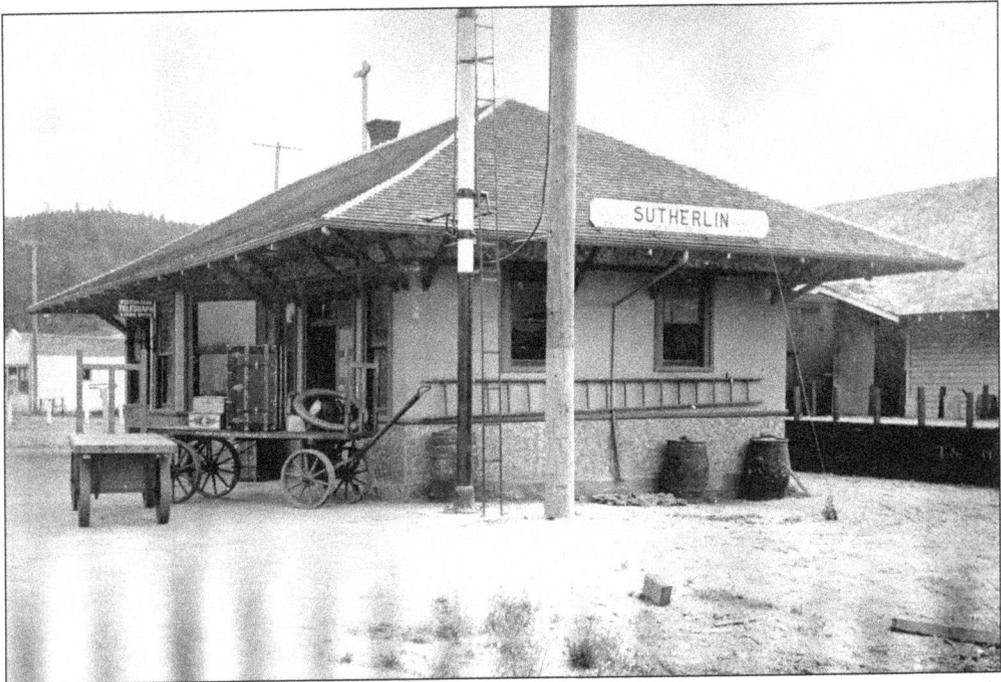

Above is the Sutherlin Southern Pacific railroad station on the O&C line. The 1910 photograph below is of southbound Southern Pacific train No. 13, which features a consolidated-type helper engine on point and road engine Pacific-type No. 2426. (Both DCM.)

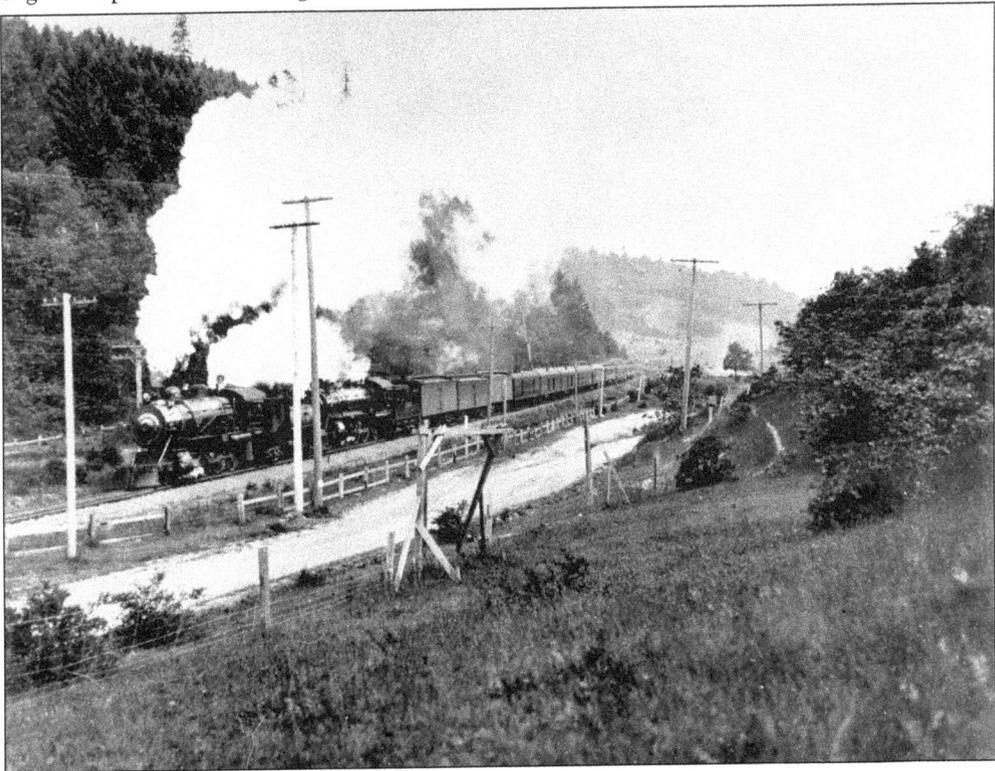

The Brickyard in Whitmore (now Union) Gap provided the bricks for all the buildings in Sutherlin and Oakland. Above is a panoramic view of the brickyard and Whitmore Gap; below is the brick kiln itself. Charles Neal was a railroad section foreman. He is pictured in the white shirt and vest. His grandson is a volunteer at the Douglas County Museum. (Both DCM.)

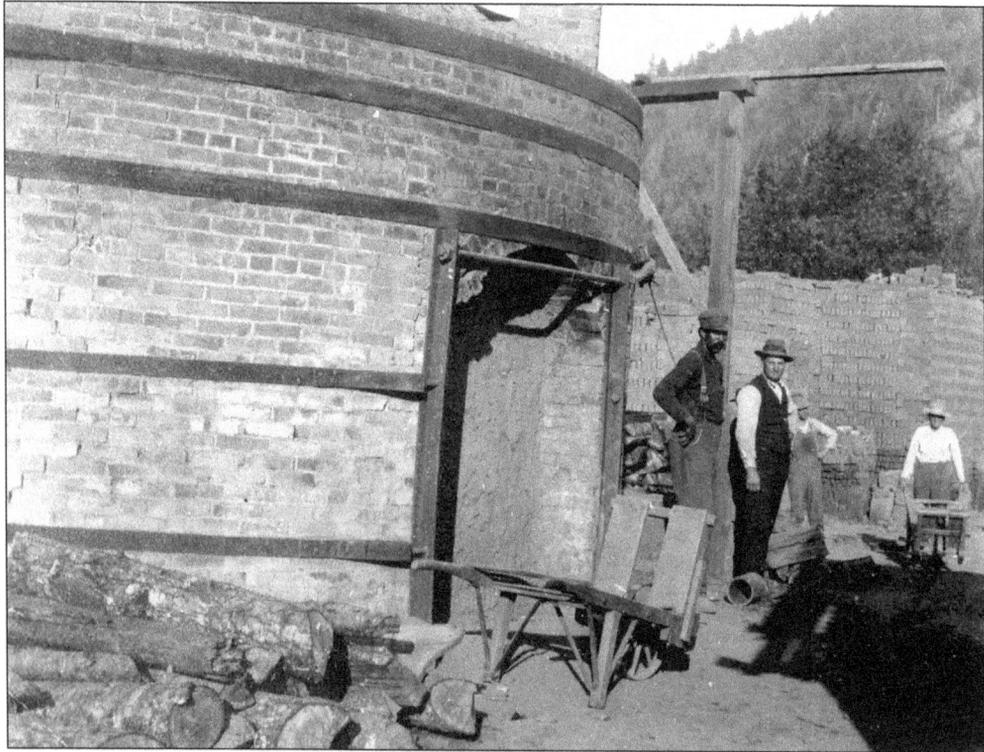

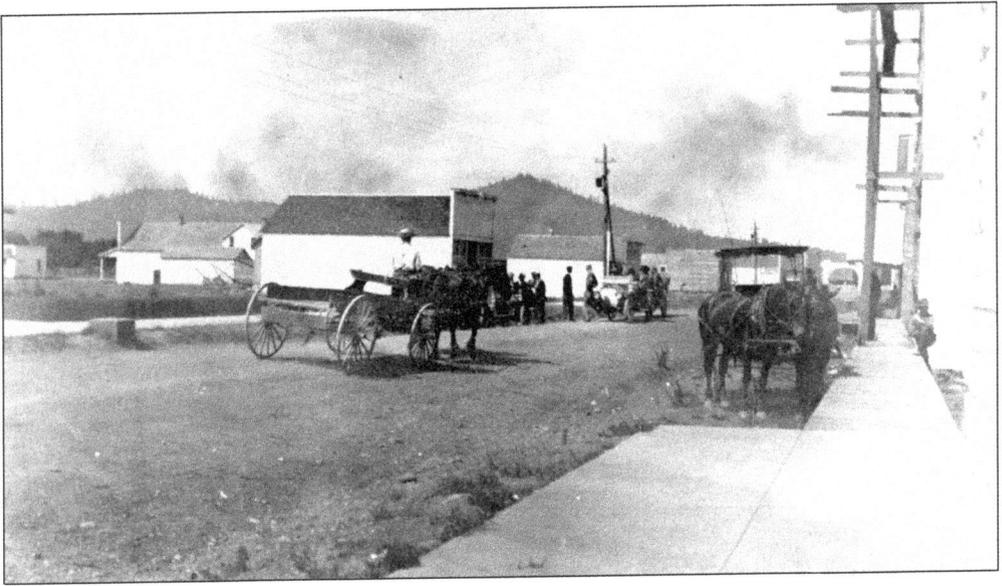

Above, looking west toward the railroad tracks, horses and wagons are still the most reliable forms of transportation, but automobiles are coming on the scene. The "Welcome to Sutherlin" arch can be seen in the far right next to the sidewalk. The photograph below was taken farther down the main street, still looking west. It shows a prosperous business district complete with streetlights. (Both DCM.)

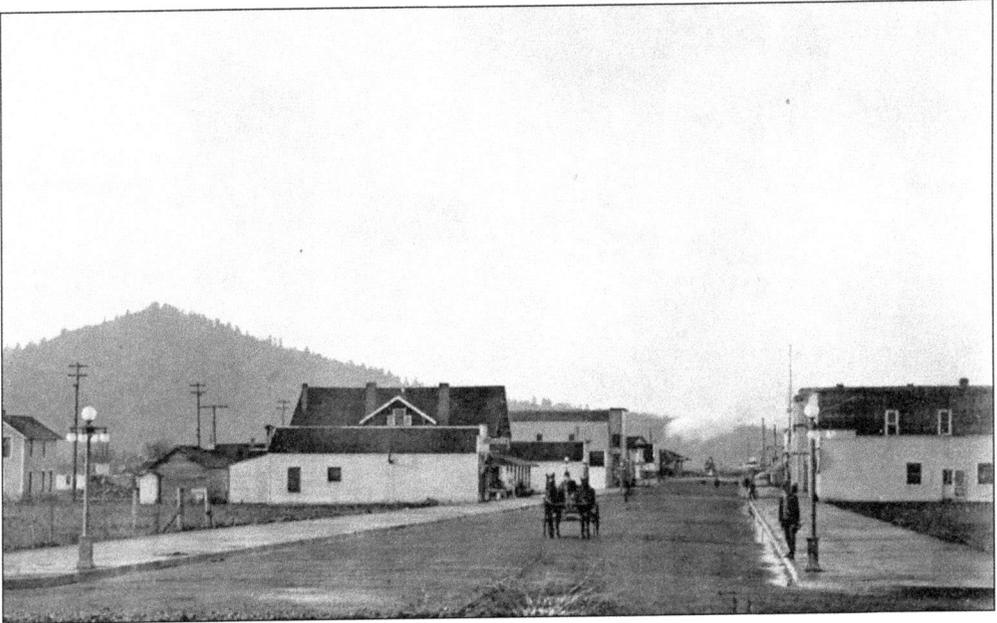

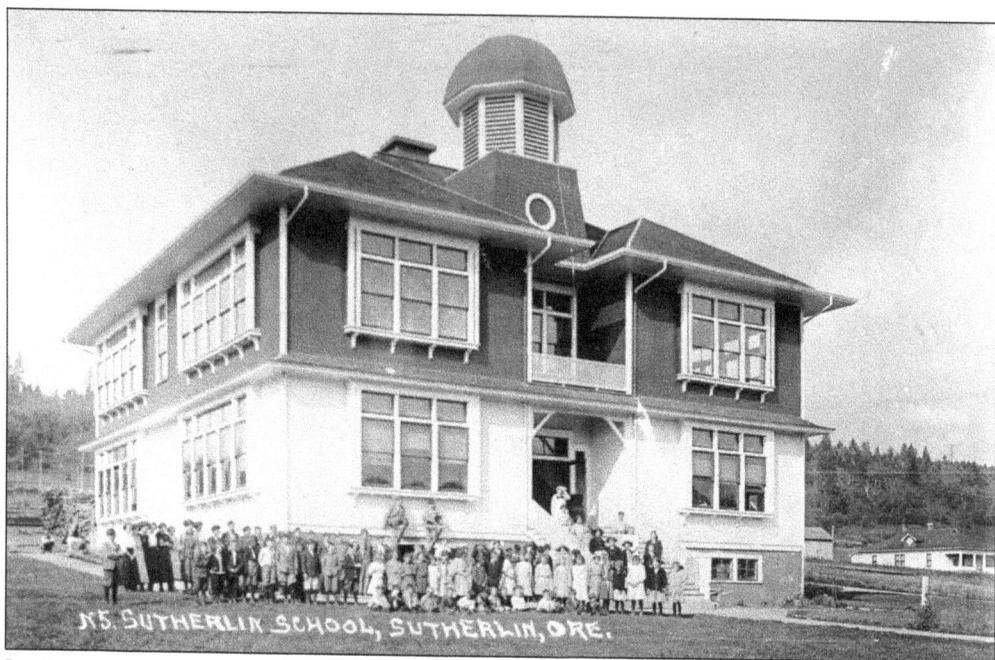

In 1912, Sutherlin built a new school of two stories with a bungalow roof to match the architecture of the Sutherlin Inn. There was a basement, eight classrooms, a principal's office, and a cloakroom. Its first principal, Elmer J. Ortman, organized a proper school for a student body of about 100 children. This building (seen here around 1912 through 1915), Sutherlin Public School, eventually became the high school. (DCM.)

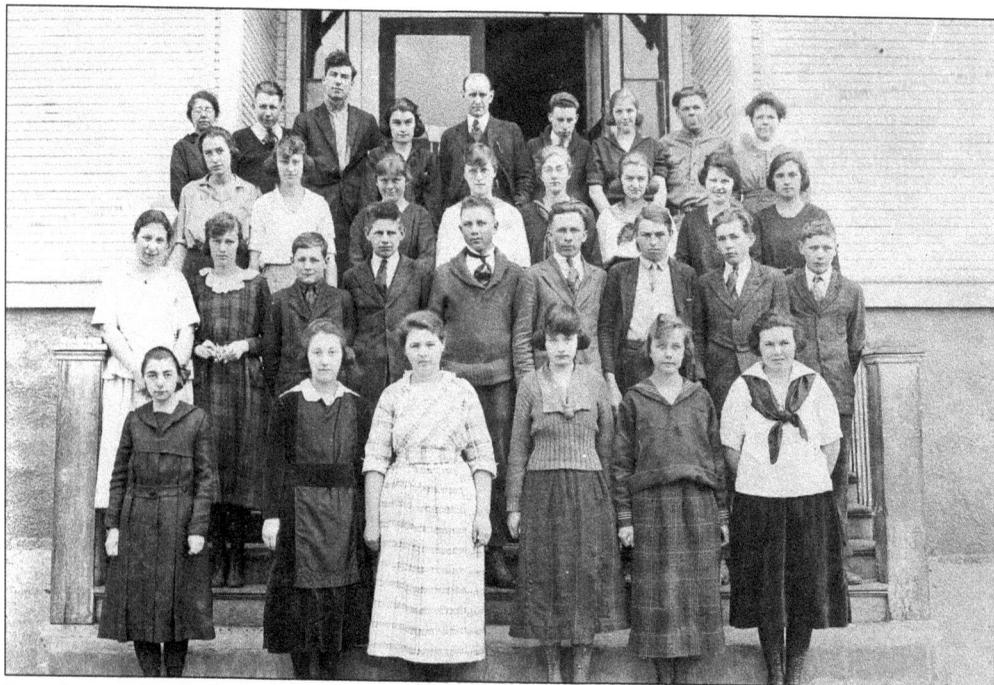

Seen here is the Sutherlin high school class of 1915. James Haines is in the second row, far right. All others are unidentified. (DCM.)

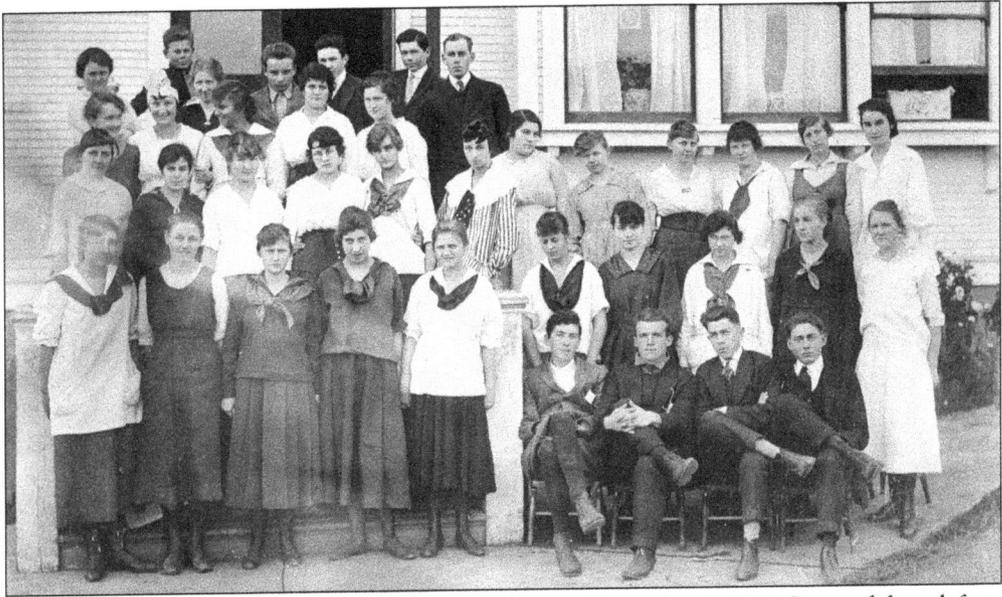

This Sutherlin high school group picture was taken on December 3, 1917. Pictured from left to right are (first row, standing) Elsie Henderson, Dorothy Bruegger, Frances Fredig, Edna Ralston, and Elsie Klawisch; (first row, seated) Earl Smith, Maurice Vogelpohl, William Duke, and Charles Parker; (second row) Nellie Gleason, Blanche Slater, Ruth Roth, Jurie Sellick, Velma Goff, Winifred Culver, Amanda Hinkle, Lucille Rethwell, Margaret Russell, Lillian ?, Vina Fisher, and Iris Goff; (third row) Verna Peterson, Lauise Simpson, Helen McInturff, Minnie Hinkle, Genevieve Shaver (teacher), Allen Tuthill, Ralph Tudor, Russel Kildee, and Professor Shantin. (DCM.)

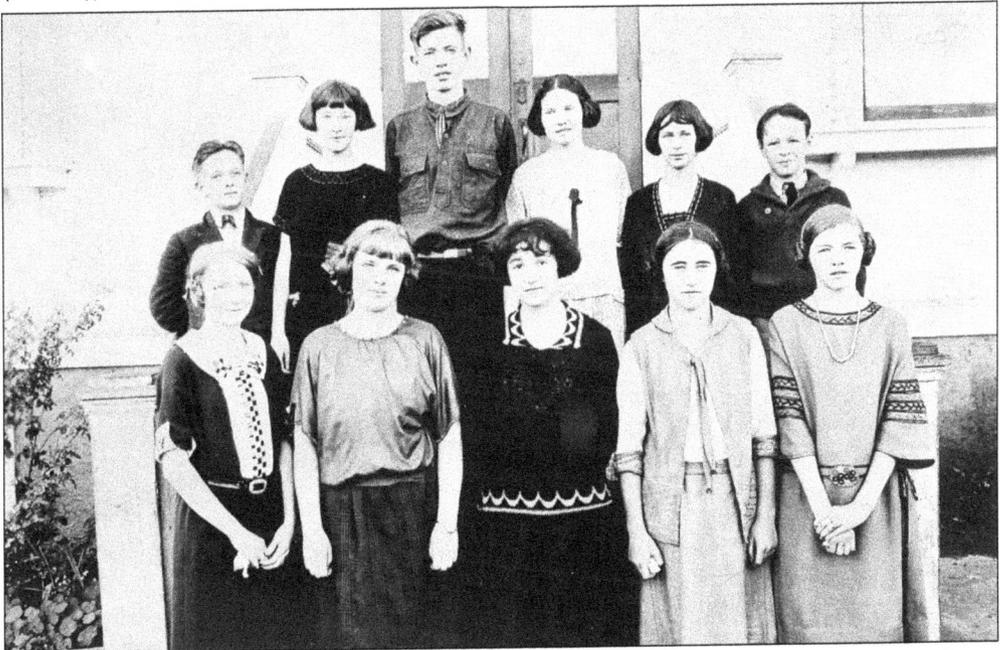

This picture of the freshman class of Sutherlin high school was taken in 1923. Pictured from left to right are (first row) Gertrude Davis, Olive Merritt, Ila Pierce, Mildred Thompson, and Mildred Wilcox; (second row) Sid Wagner, Sybil Avery, George Wilcox, unidentified, Cecil Holgate, and Gilson Marden. (DCM.)

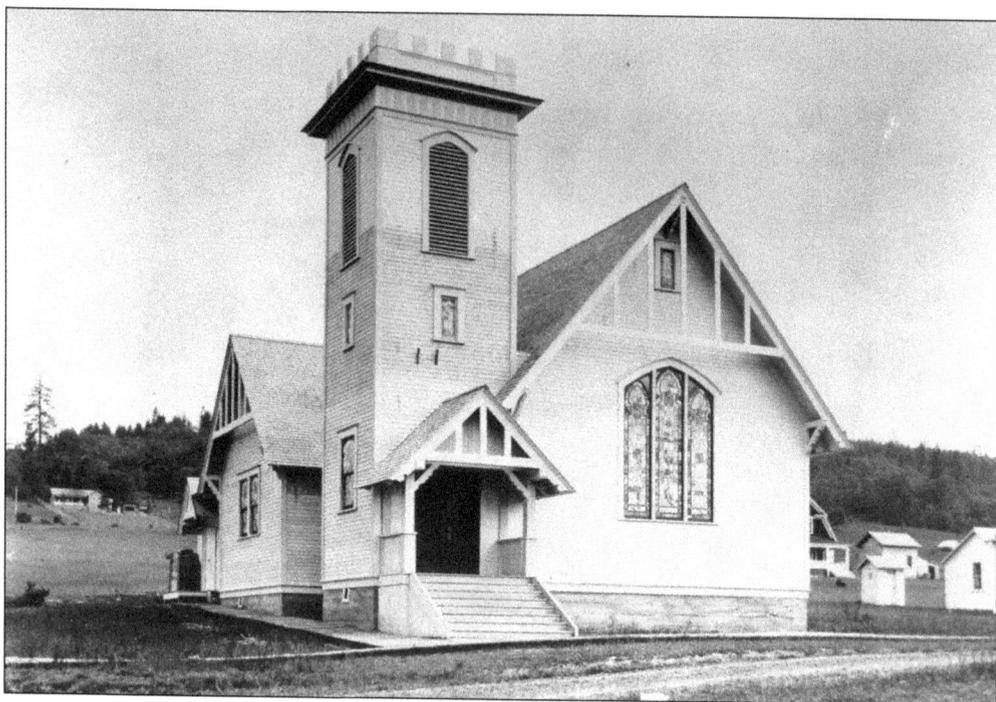

The First Presbyterian Church was built in 1910 or 1911 on Umpqua Street, uphill and on the opposite side of the street from the First Methodist Church (which is still at the corner of Umpqua and Second Streets). The similarities between the two churches seem remarkable in this photograph taken around 1911 or 1912. The First Presbyterian Church burned down in 1937. (DCM.)

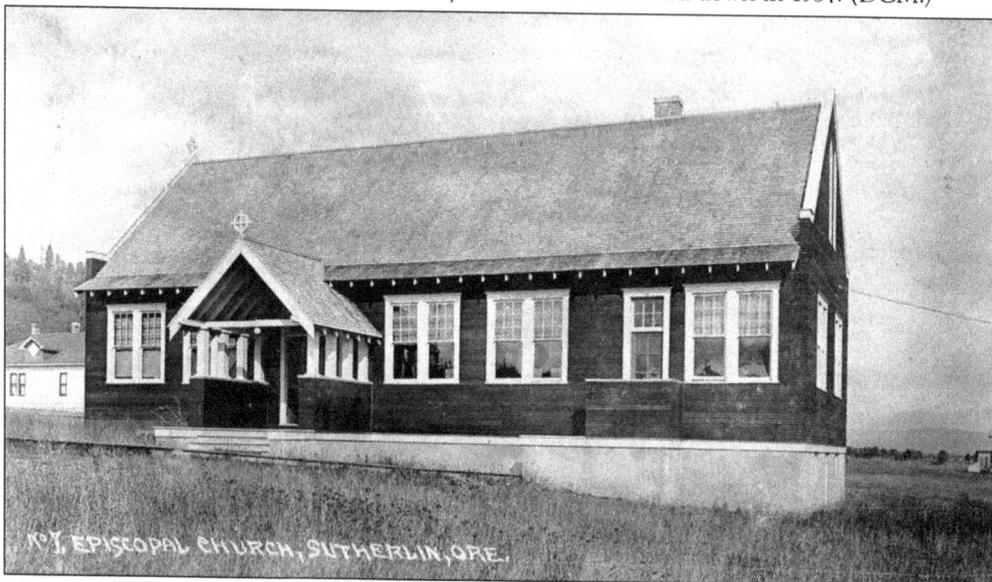

This Episcopal Church (pictured in 1915) was built about 1910. Its mortgage was held by the bank in Sutherlin and was foreclosed when the bank closed in July 1933. The building itself was on the present school grounds just north of the old elementary school. It was used as the art classroom but was eventually torn down. The current Episcopal Church of the Holy Spirit was built in the 1950s on Southeast Umatilla Street. (DCM.)

44

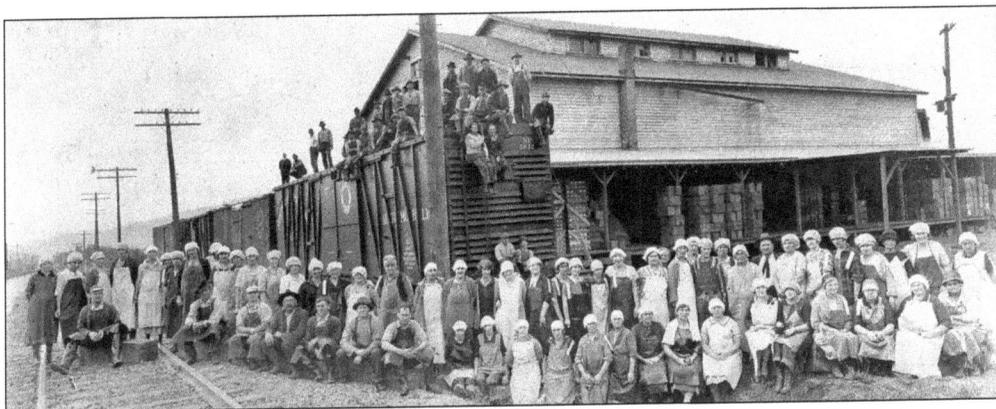

Posed here in November 1926 is the crew of the Frank J. Norton Sr. Cannery on Central Avenue. Frank Norton Sr. is seen in the hat and necktie at the rear of the group. John Cook is sitting on the box between the rails. His family ran Sutherlin's principal restaurant. Eileen Norton is in the back row wearing a dark dress and light hat. (DCM.)

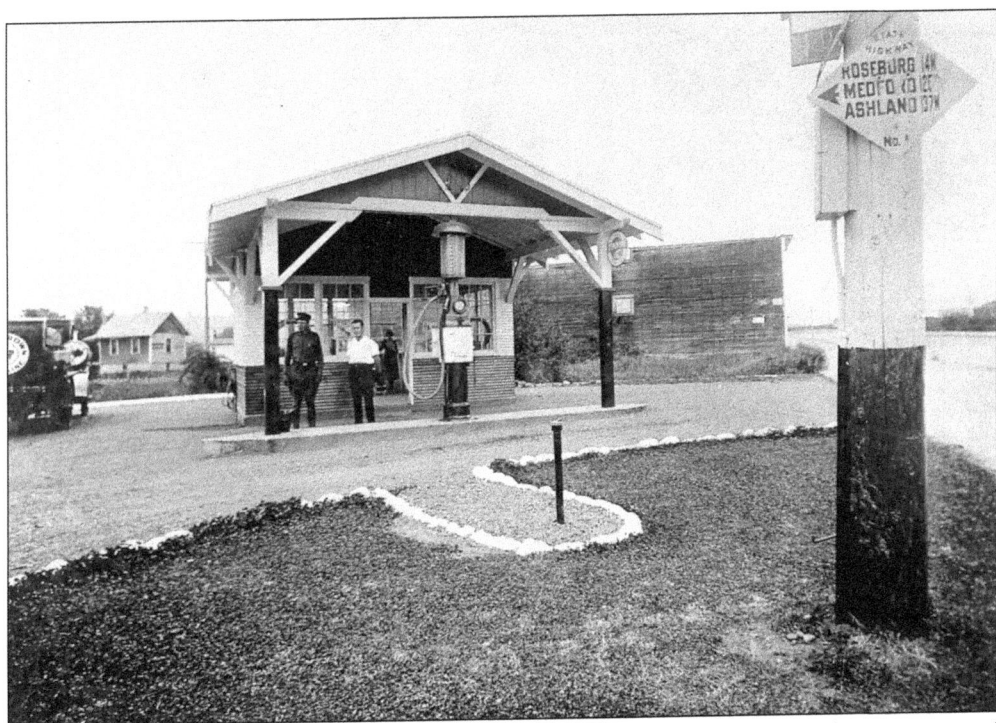

This Standard Oil station (seen here around 1923 or 1924) was on the southwest corner of Calapooia Street and Central Avenue, where JJ's Sports Bar is now (originally the Chevrolet car dealership). The man in the dark uniform on the left is Vanie Walker, Standard Oil Company truck driver from Roseburg. (DCM.)

THE SUTHERLIN SUN

VOLUME I SUTHERLIN, DOUGLAS COUNTY, OREGON, FRIDAY, MAY 19, 1911 NUMBER 43

The first Sutherlin city council meeting was held on May 12, 1911, and this article appeared in the *Sutherlin Sun* on May 19. The entire council was present: Dr. W. J. Phillips (mayor), Will J. Hayner (recorder), T. J. Ardray (marshall), and councilmen W. F. Rapelke (chairman), T. A. E. Lyman, F. C. McReynolds, F. W. Franz, A. E. Shira, and A. E. Bamber. Although the town charter had been granted, it had not yet been received. (S100.)

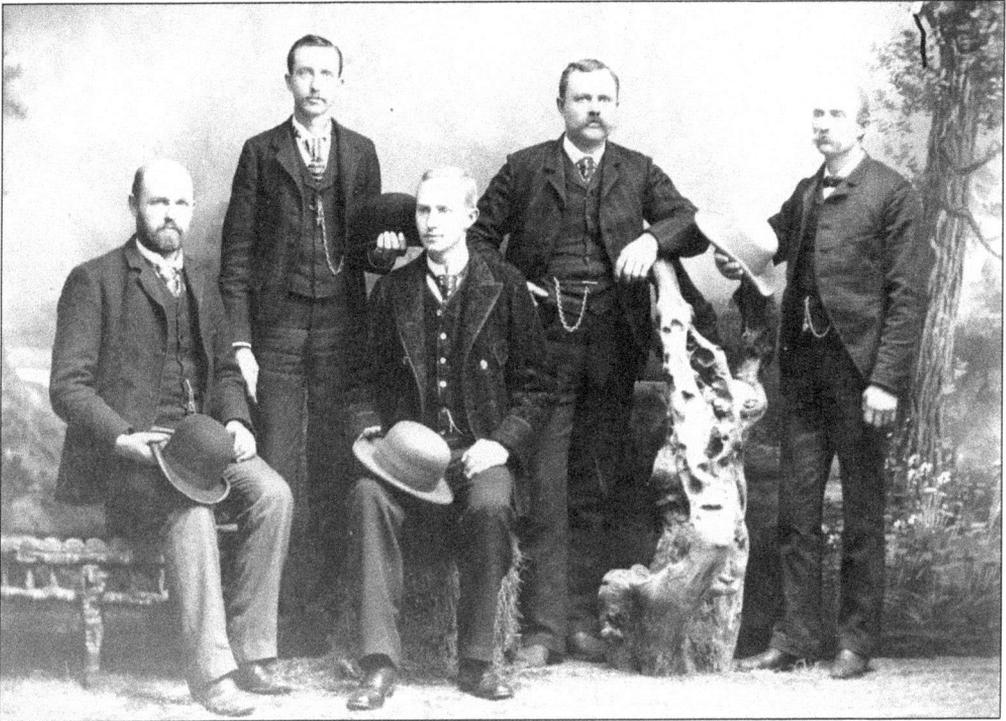

Frank B. Waite married Fendel Sutherlin's daughter Anne. In addition to forming the Sutherlin Land and Water Company and advocating Sutherlin's growth and development, he also built the Sutherlin Hotel. From left to right are the Waite brothers: Jasper, Theron, Douglas, Frank, and Cassius. (DCM.)

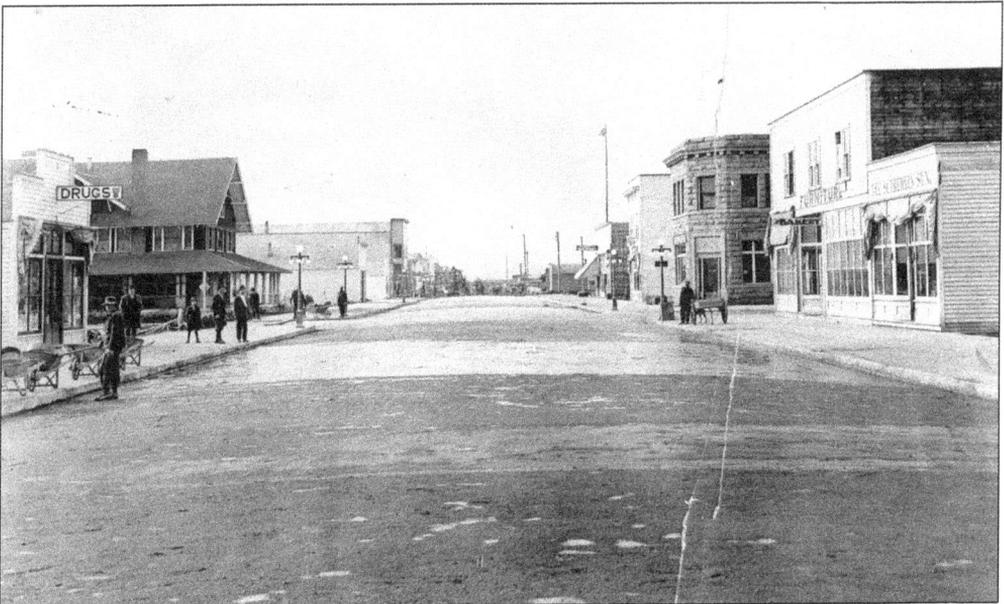

Taken around 1914, this photograph looks west on Central Avenue from around Umpqua Street. The *Sutherlin Sun* office, a furniture store, and a bank can be seen on the right; the drugstore, Sutherlin Inn, and other buildings are on the left. Notice the electric streetlights. (DCM.)

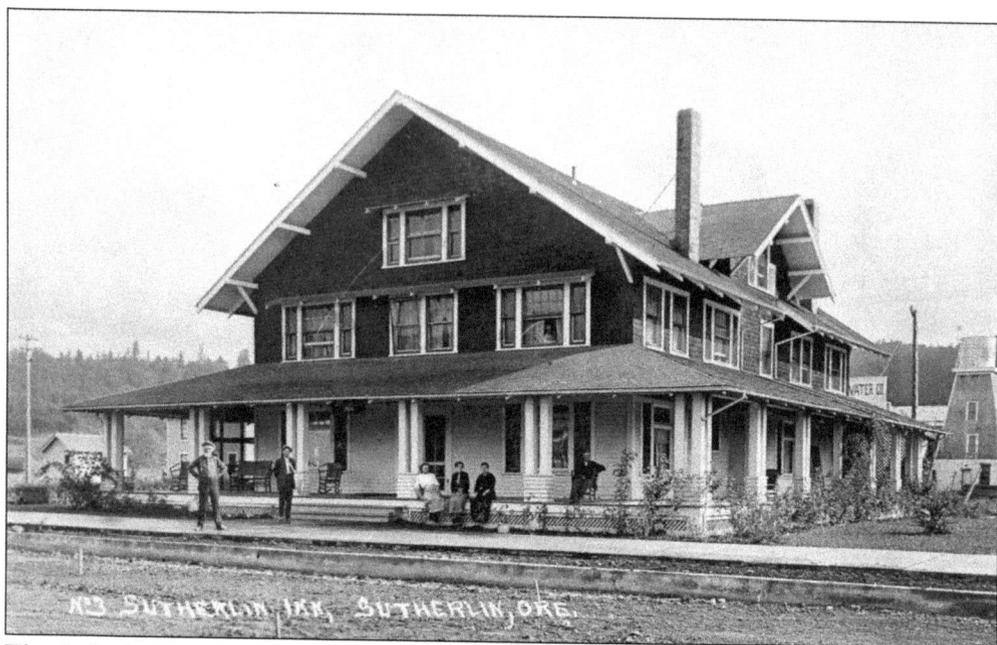

The Sutherlin Inn (above) was one of the first hotels in the valley. Along with the Sutherlin Mansion, it was a frequent gathering place for parties, dinners, and family reunions hosted by Fendel and Lucy Sutherlin. It burned down and was replaced by the brick Sutherlin Hotel (below) in 1914. Built by Frank B. Waite, it served as a community gathering place, Greyhound terminal, and a popular restaurant. It had a beauty shop, barber shop, and coffee shop. Before it was torn down in 1973 to be replaced by the First National Bank, it served for a time as the Seventh Day Adventist Academy. (Both DCM.)

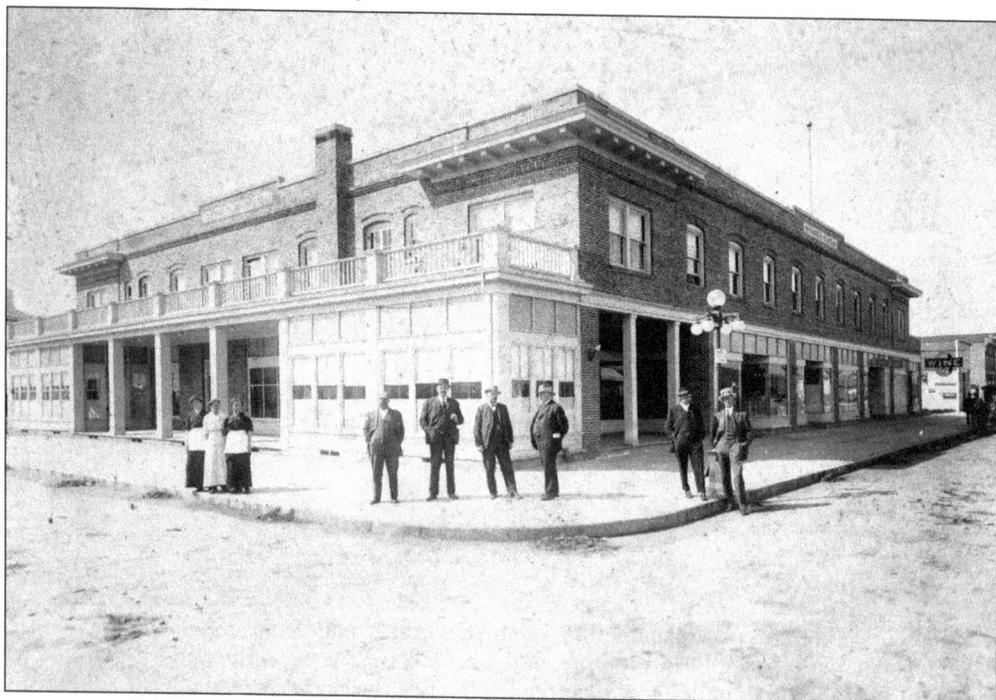

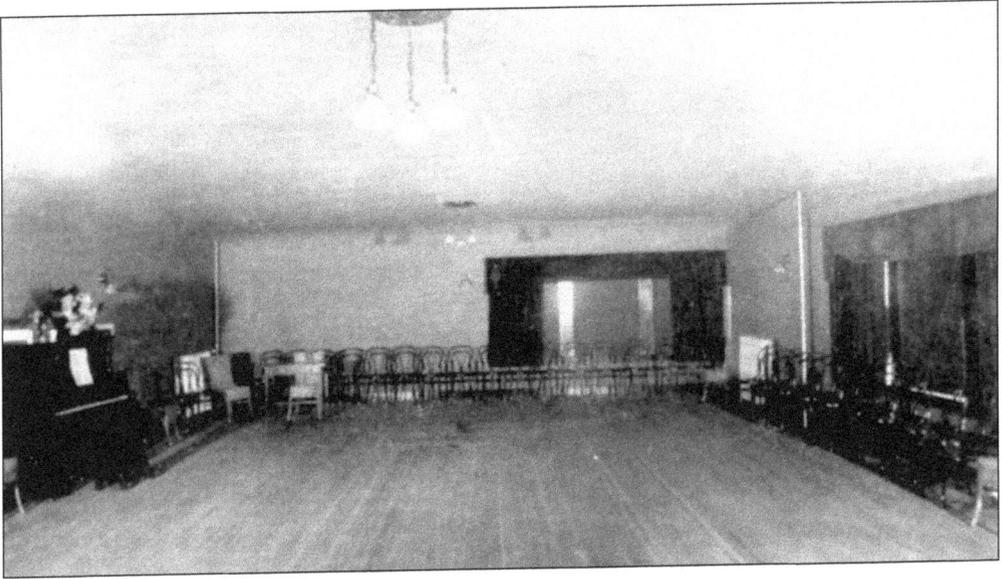

Shown here are the ballroom of the Sutherlin Hotel (above) and the lobby (below). (Both DCM.)

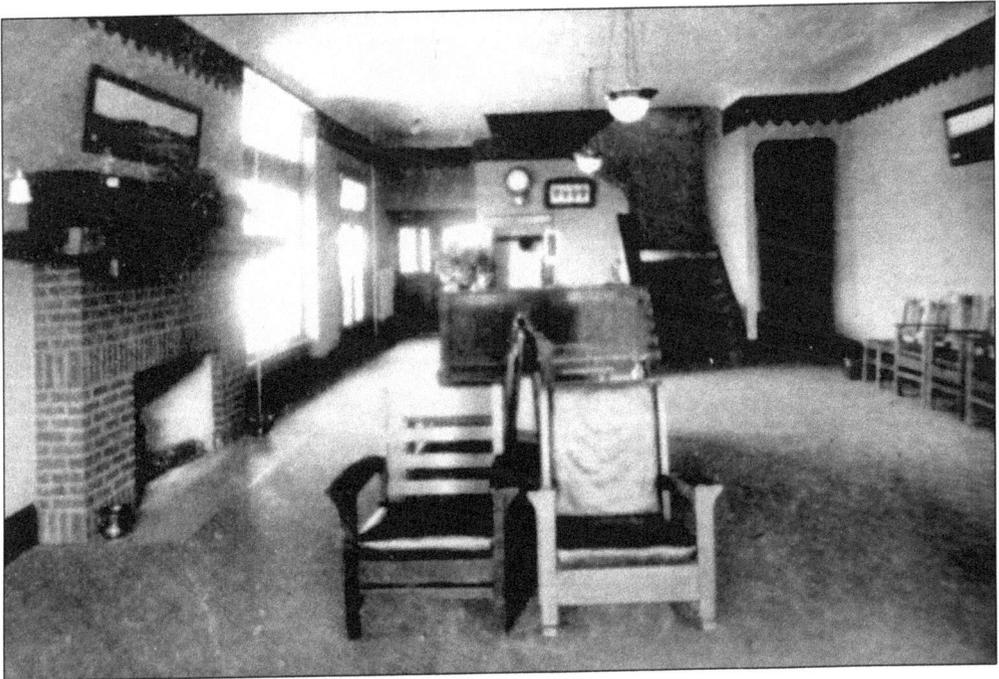

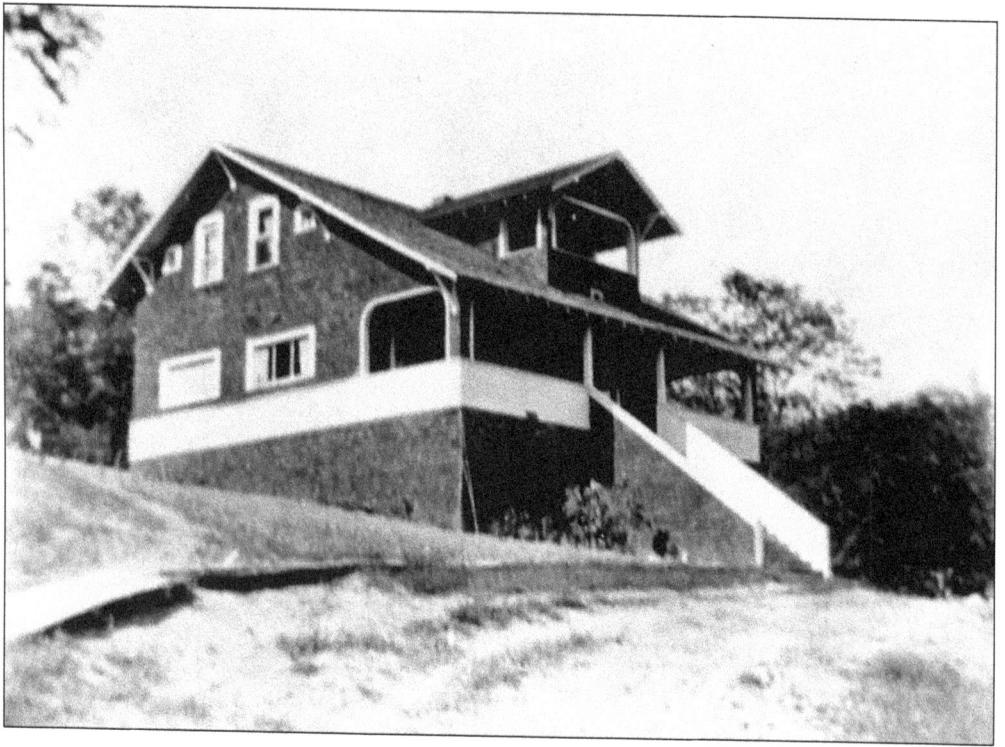

There were a variety of architectural styles for residences. The home of D. W. Banker (above) is a traditional bungalow style. It was known as Chi Lodge. The photograph was taken around 1921. Banker's Central Avenue building housed the infamous Jug's Tavern. The image below (taken around 1915) shows residences on Fourth Street. (Both DCM.)

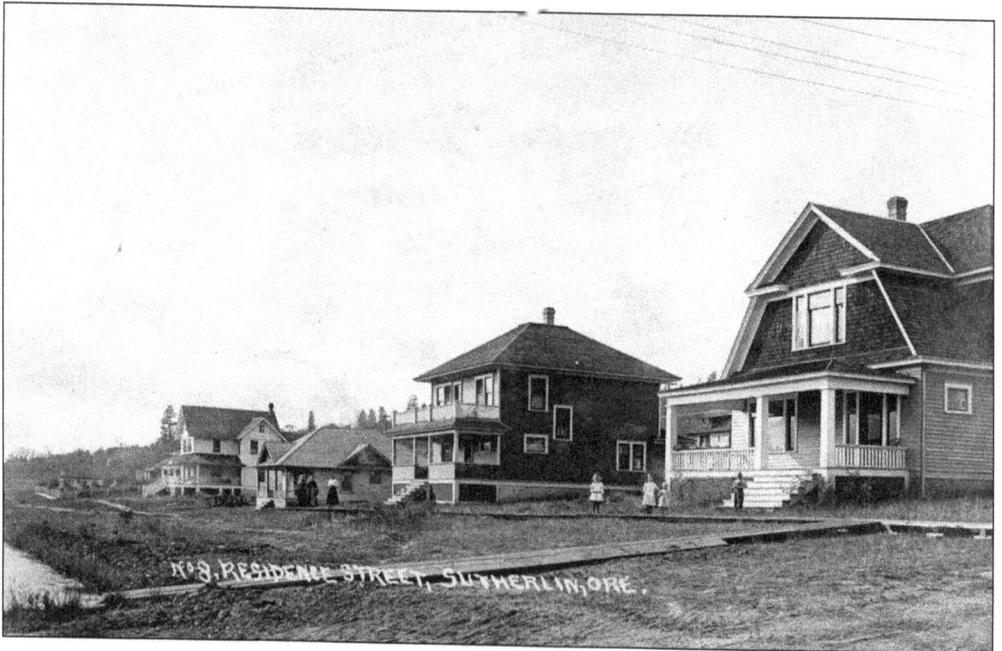

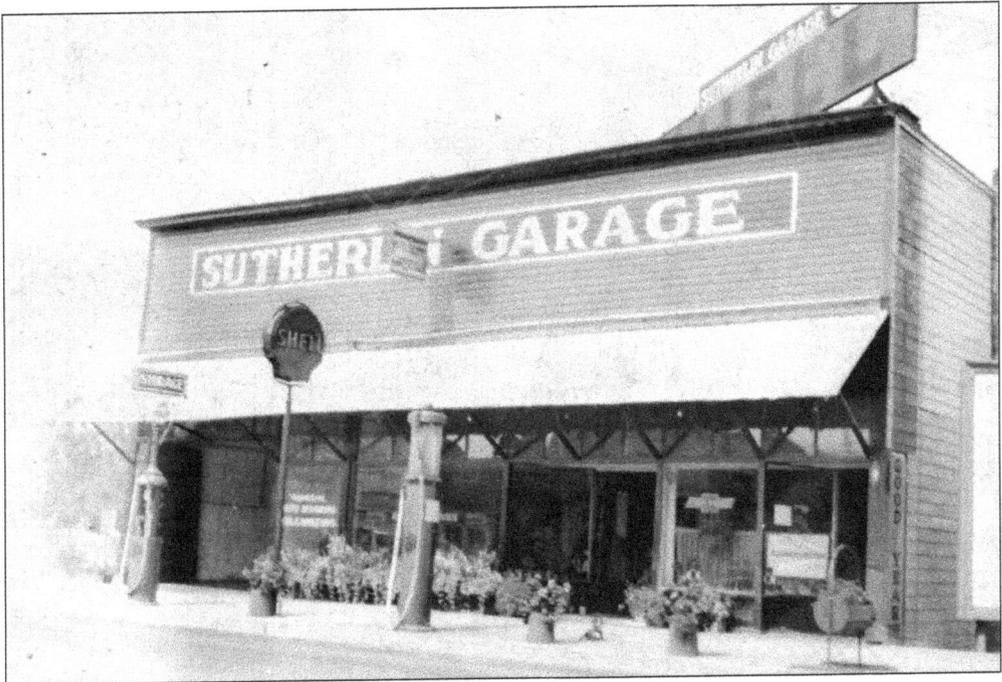

Automobiles were becoming all the rage. Naturally they needed fuel and repair: enter the Sutherlin Garage in the middle to late 1920s and the indispensible garage truck. Notice how close the gas pumps are to the street. Guess that was a No Parking Zone. (Both Gail Hodapp.)

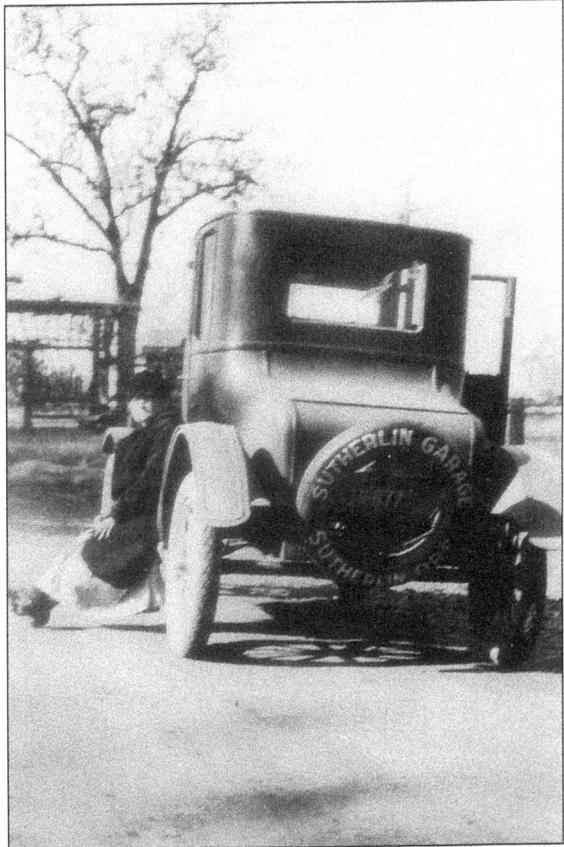

Culver's was a family business from 1913 through the late 1990s. Originally just a meat market in the area occupied by the old Grand Theater (only a bigger building), a deli was added and they moved to the Leenders Insurance building. In 1923, they moved for the last time and added a restaurant. Culver's had a brief revival from 2005 to 2007 but is now the China Station Buffet. (Both Dana Culver.)

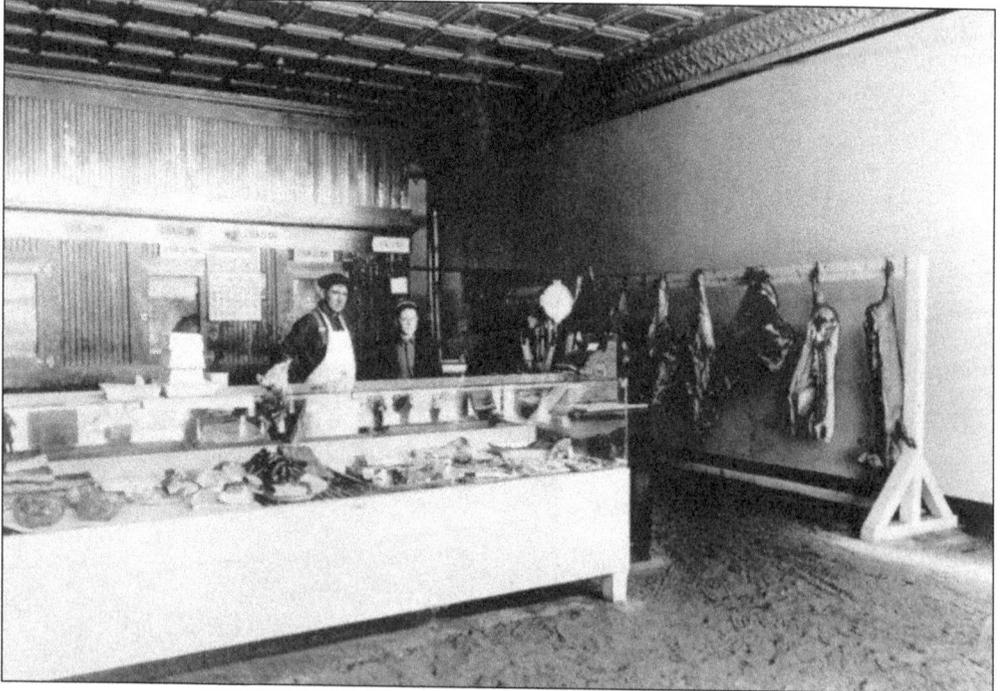

Five

WHEN TIMBER WAS KING

Early in the 1900s, the Roach Timber Company purchased a large tract of timberland from the Umpqua Indians. Logging wasn't a major source of profit until the advent of the steam engine and the mechanization of some of the truly hazardous jobs. In the mid-1930s, Roach derived some income from the property when a logger began to buy and log in the Hinkle Creek area. Then, in 1940, Smith-Wood Products and Rock Island Lumber Company also purchased timber-cutting contracts. In the mid-1940s, Weyerhauser purchased the property from Roach Timber Company and the Smith-Wood Products Company's logging camp and operation.

The third wave of settlers came to Sutherlin during World War II. The country needed timber, and Oregon, especially Sutherlin, was the mecca for professional and amateur timber workers. Sutherlin became the self-styled Timber Town.

In 1948, the centennial of Oregon as a territory, local businessmen decided it was time everyone knew how terrific Sutherlin was. The first annual Timber Days celebration was held as a four-day event over the Fourth of July holiday. Contestants came from all over the state. Championships were won and lost. In the 1950s, the celebration was changed from four days over the Fourth of July to a weekend in August. For 50 years this event was the highlight of the Sutherlin summer calendar.

Weyerhaeuser Engine No. 100 is housed in Central Park, a permanent reminder of the timber industry's contribution to the city's history. After being used in the construction of the Hetch-Hetchy Dam, Weyerhaeuser bought it for its Washington logging operations. Around 1948, it was transferred to the Nonpareil run in Sutherlin, where it remained until 1961 when operations ended.

Transferred to Springfield, No. 100 was rescued from oblivion by Henry "Hank" Halversen. It was moved to Central Park, where it immediately became a children's climbing attraction. In the late 2000s, Richard Jorge spearheaded the drive to preserve and restore the engine. This became a long-term Eagle Scout project, which was hindered by lack of information, the ability to locate materials, volunteer time constraints, and minimal funding. However, the results speak for themselves.

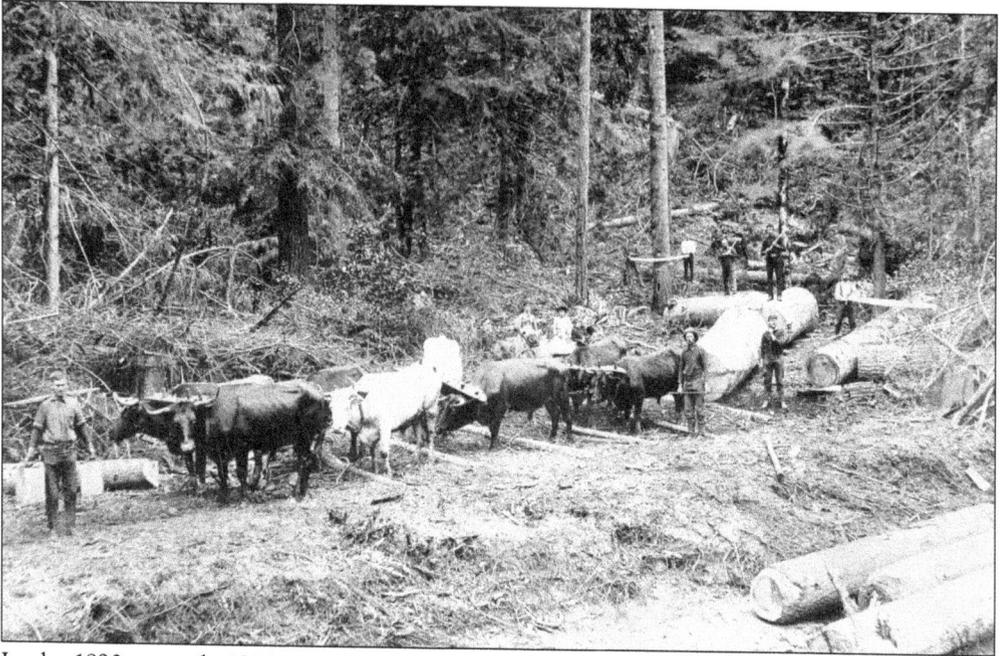

In the 1890s to early 1900s, it was not unusual to see oxen or bull teams (above) employed in hauling logs. Could those be Babe the Blue Ox's relatives below? All too soon, gas and diesel trucks replaced these relatively environmentally friendly teams. (Above DCM; below, Pauline Wells Holley.)

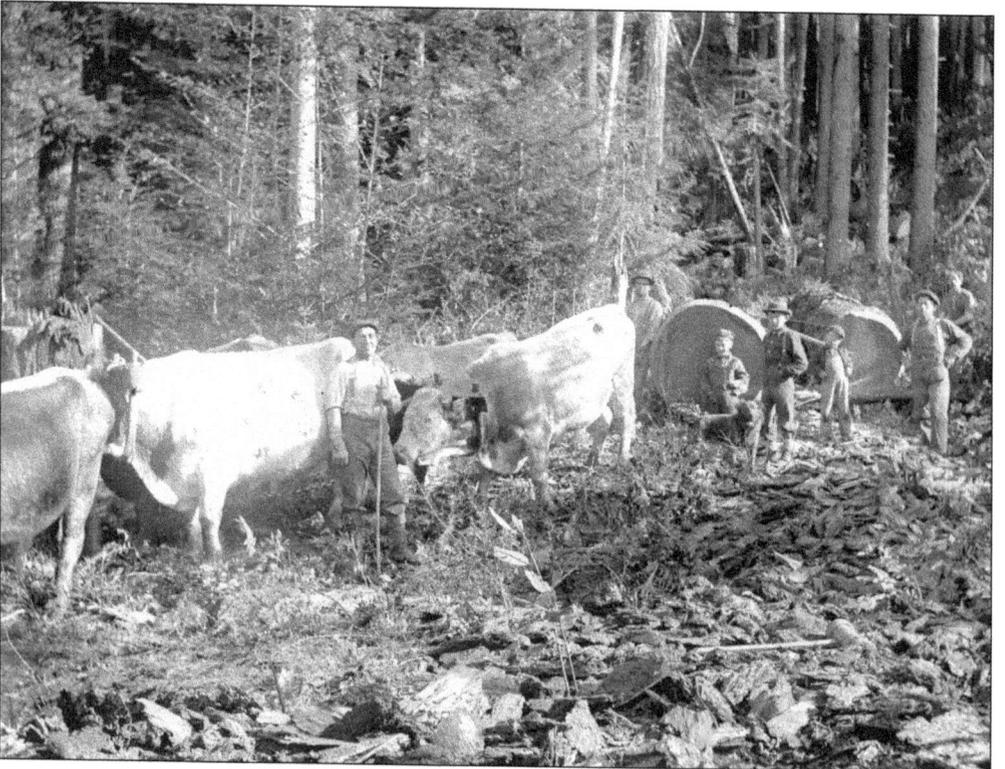

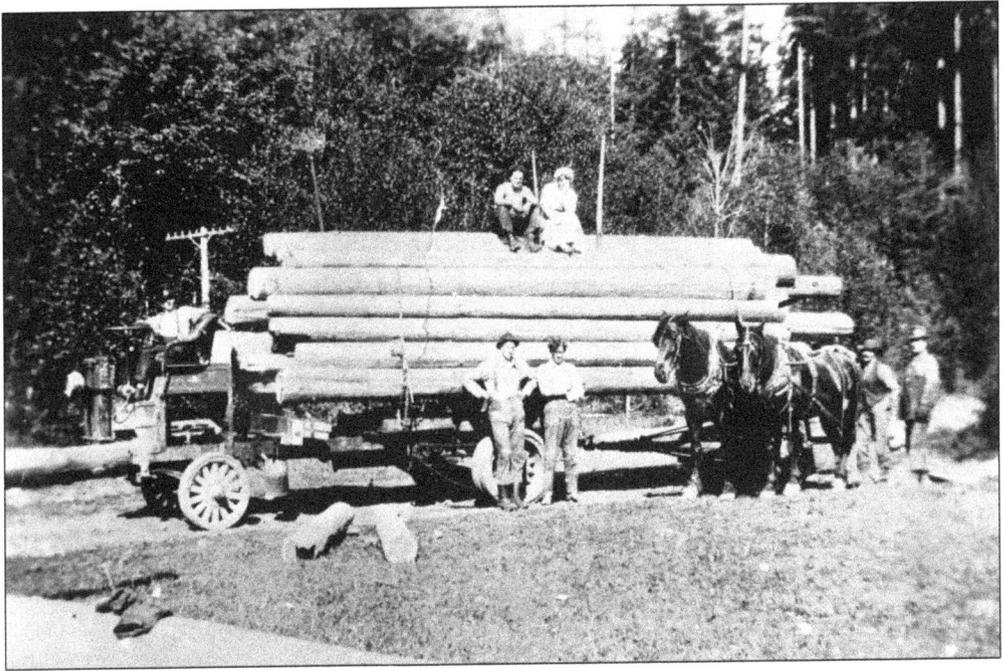

Notice the driver steering the rear half of this early dual-trailer log truck around the corner. Below, a trucker is taking his load of logs from a 1960 job in Fraser Canyon southeast of Sutherlin. Look at the size of the logs in all these images. (Both Pauline Wells Holley.)

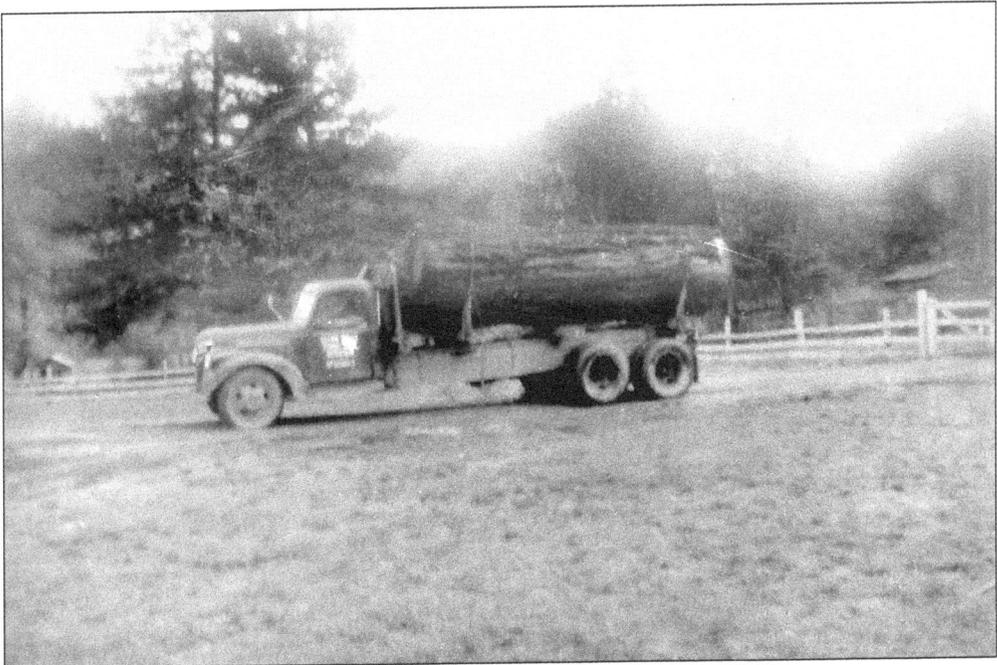

55

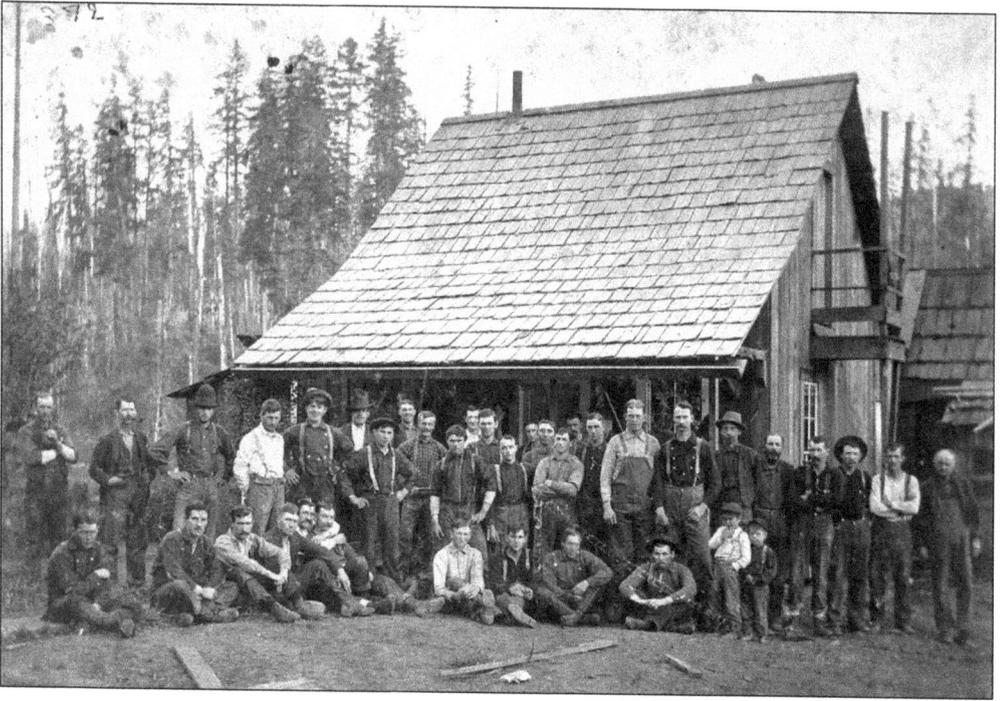

Shown above is the sawmill on the Calapooya east of Sutherlin, which was owned and operated by the McCollums (below). The building in the rear below has a shake roof and board-and-batten construction. It is one and a half stories tall. The timber industry did not really take off until the advent of tractors, trucks, and steam-driven sawmills. (Both DCM.)

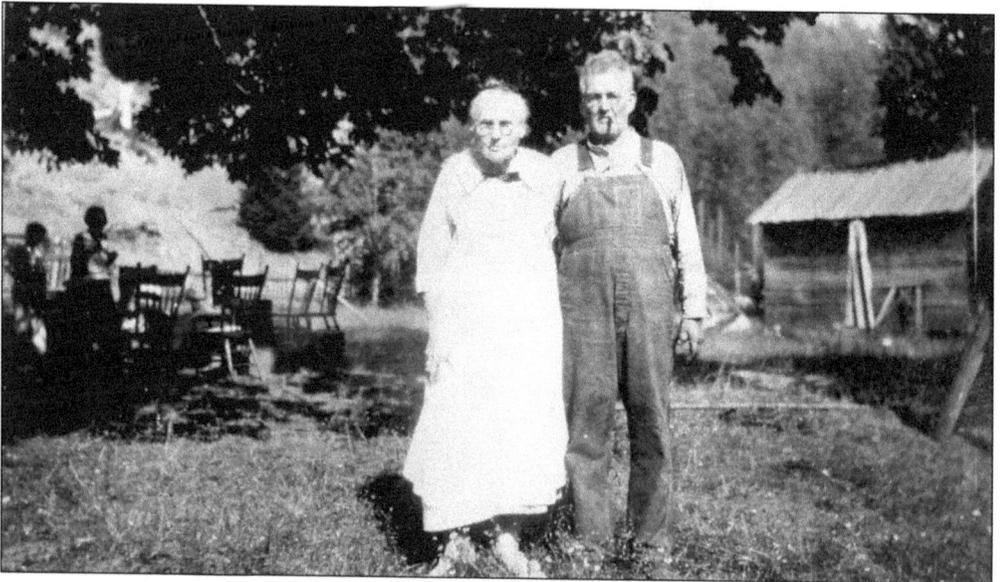

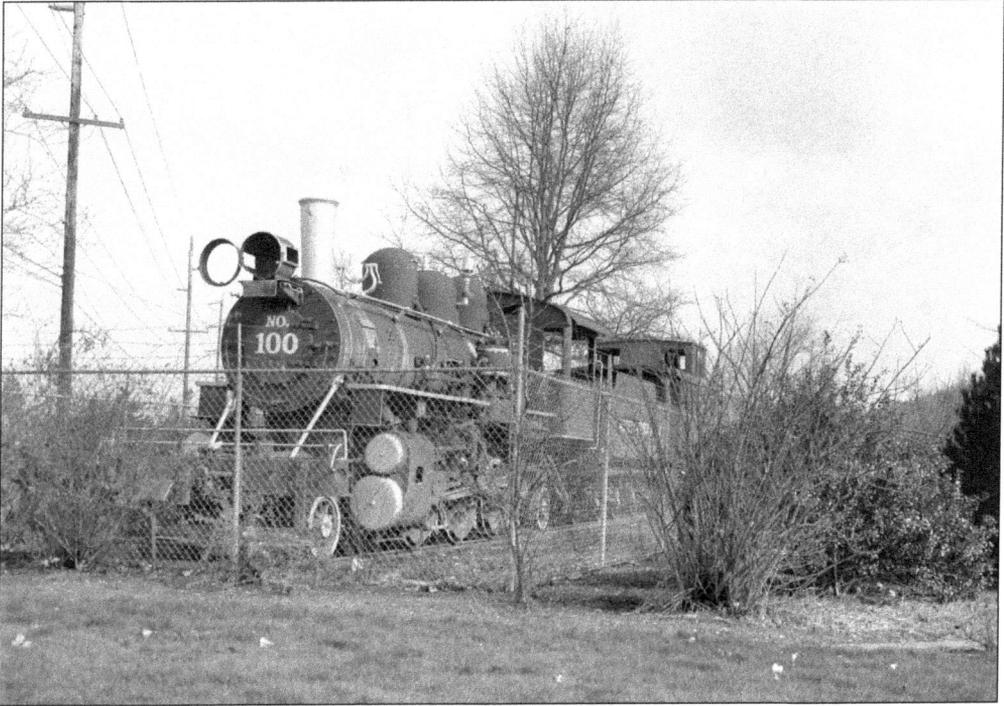

What started as a face-lift project—replacing some lumber, tightening a few bolts, replacing some siding and broken glass, and a nice coat of paint—turned out to be a nightmare. As soon as the siding was removed, reality set in: the studs and main frame were too rotten to hold a nail. The caboose (seen above on February 23, 1988) would have to be rebuilt from the ground up, with no instructions or appropriate material and, worse, no money or labor. In the 1990s, Life Scout Steven Korecki wrote a letter to the editor of the *North County News* asking for help on his Eagle Scout project to restore the train, and everyone responded. When No. 100 was operating, one of its destinations was the Weyerhauser Sutherlin Camp (right). (Above, DCM; right, Pauline Wells Holley.)

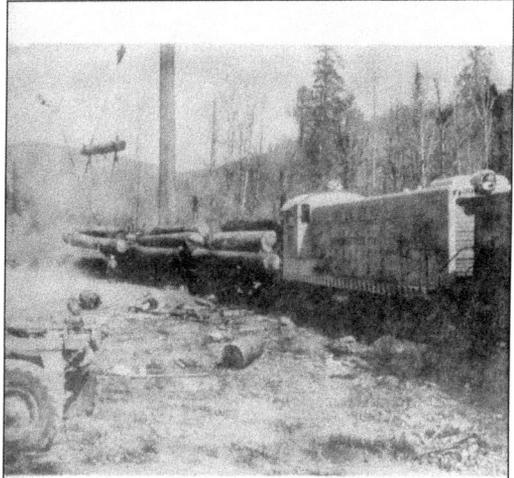

Weyerhaeuser's Camp Sutherlin logging show plays a vital part in the Springfield Branch operation. Over 110 men, earning more than $54,000 per month, work in sending logs to six wood using plants grouped around a sawmill and planing mill.

SPRINGFIELD BRANCH

Weyerhaeuser Timber Co.

57

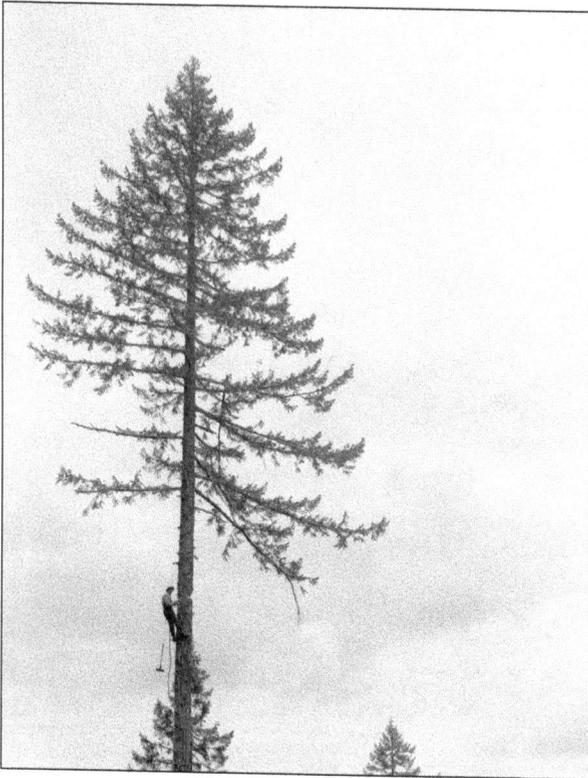

Tree topping is a very hazardous occupation. On June 14, 1955, Leonard "Pete" Bauge (left) shows how it was done. The 1953 image below shows a job well done at Weyerhaeuser's Sutherlin operation. (Left, DCM; below, Pauline Wells Holley.)

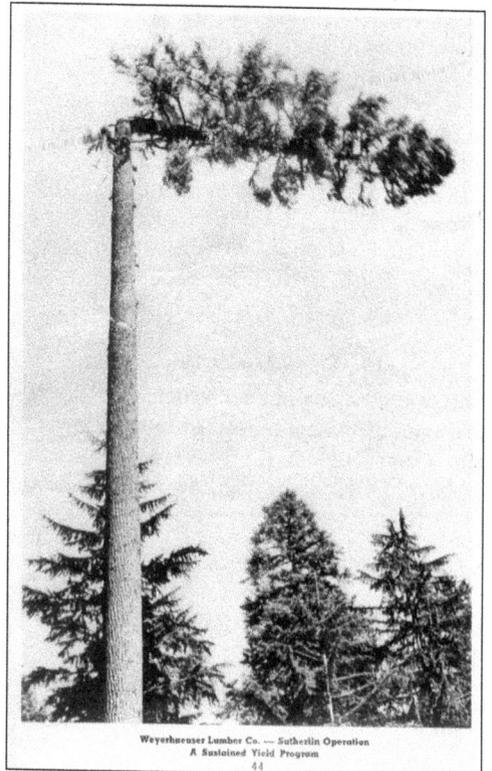

Weyerhaeuser Lumber Co. — Sutherlin Operation
A Sustained Yield Program
44

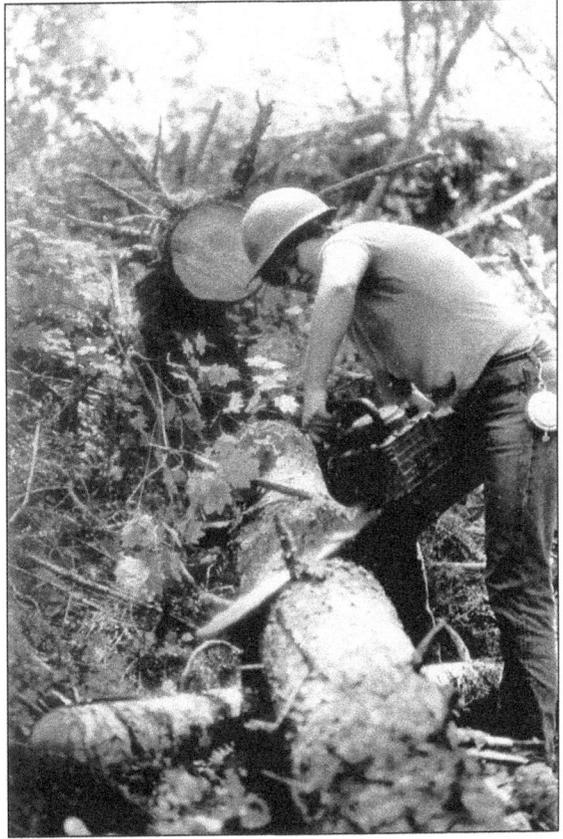

In 1976, Jodi Miller, divorced mother of five, combined her love of Belgian draft horses with her need to make a living and formed the Triple Tree Horse Logging Company. Her for-hire ad tells it all: "Little or no soil compaction, erosion, or damage to residual trees." She consistently placed first or second in Oregon draft horse weight-pulling contests. (Both Jodi Miller Otten Stevenson.)

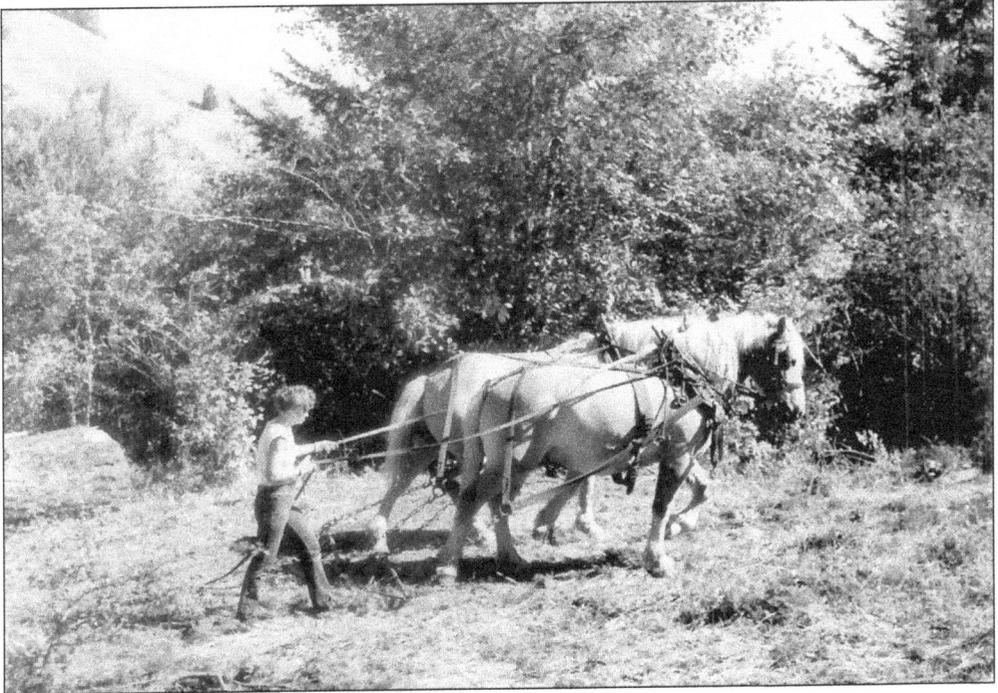

The influx of willing timber industry workers caused a major housing shortage. These enterprising young men (left) chose to set up a tent house. At Interstate 5, exit 136, the horseshoe-shaped buildings (in the foreground below) are the Four Winds Motel, precursor to the Ponderosa Inn, which is no longer standing. Immediately east of the gas station are the original visitors center, gift shop, and a two-story set of additional rooms. The government housing development can be seen east of the inn. The smoke comes from the various sawmills. (Left, DCM; below, Dave Hanson, S100.)

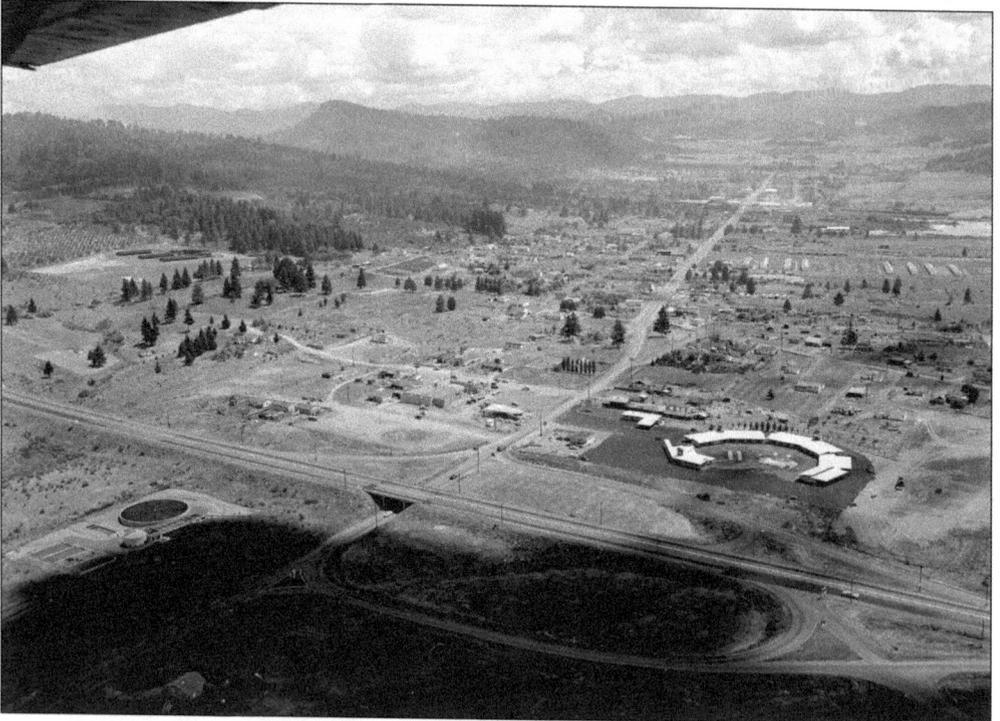

At right, Joyce Botticchio (left) and her friend Betty Pleuara are standing in front of their housing unit, as are Betty's husband, Elmer (below left), and Joyce's husband, Felix. Several of these units were moved to the former Chapel of the Firs on Sixth Street, which is now the annex of the Sutherlin Family Church. (Both Joyce Botticchio.)

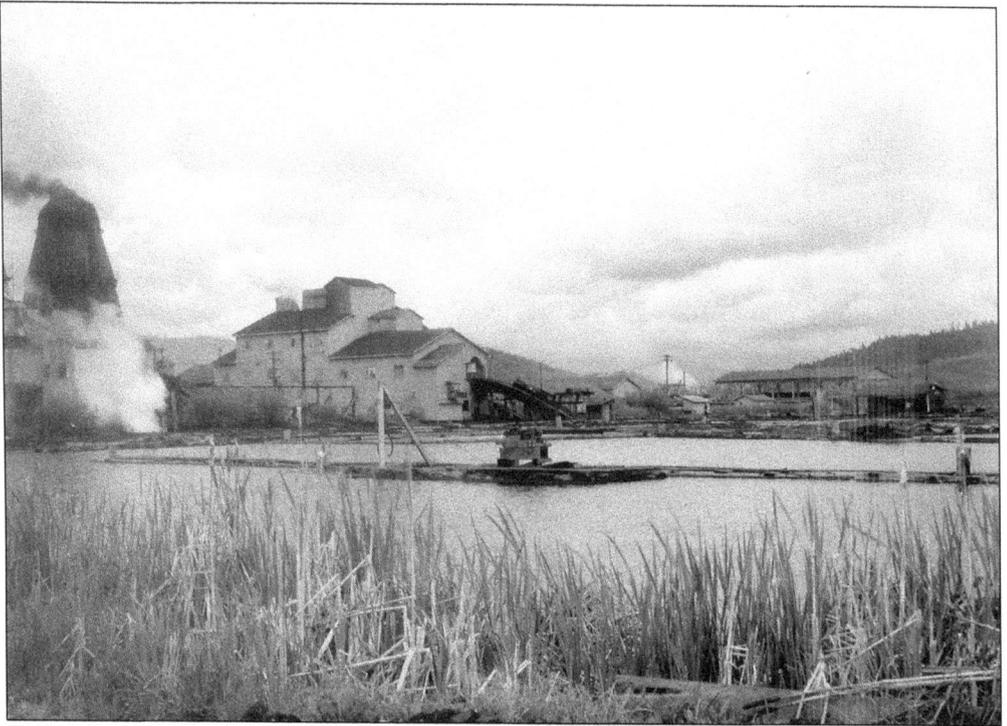

Sutherlin Timber Products (above), owned by Empire Lumber Company, was one of the many mills that operated in Sutherlin. It was located on Hastings Avenue between Calapooia and Taylor Streets. Now only the small office building remains (below). (Both Pauline Wells Holley.)

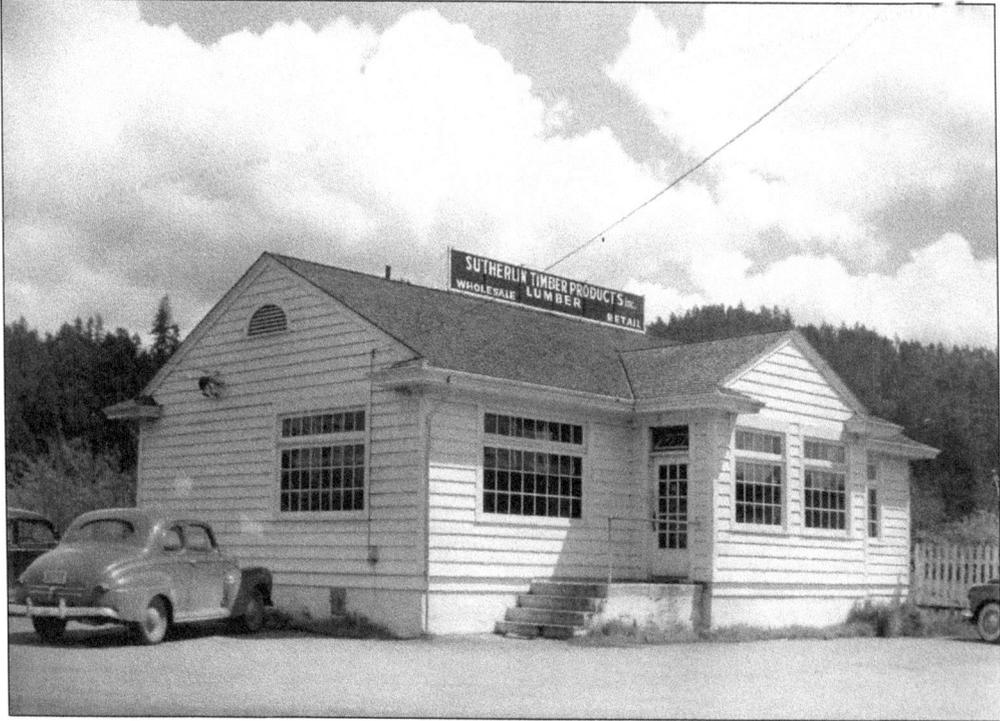

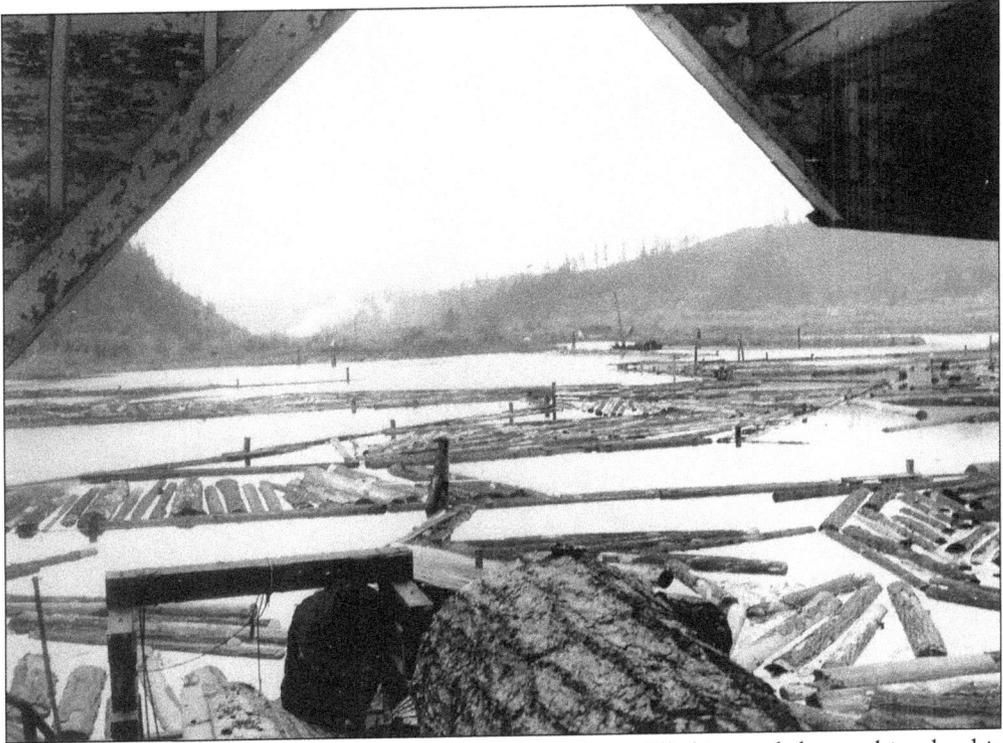

Most of the pond (above) and yard (below) have now been filled in, and the resulting land is covered with houses, apartments, and some light industries. (Pauline Wells Holley.)

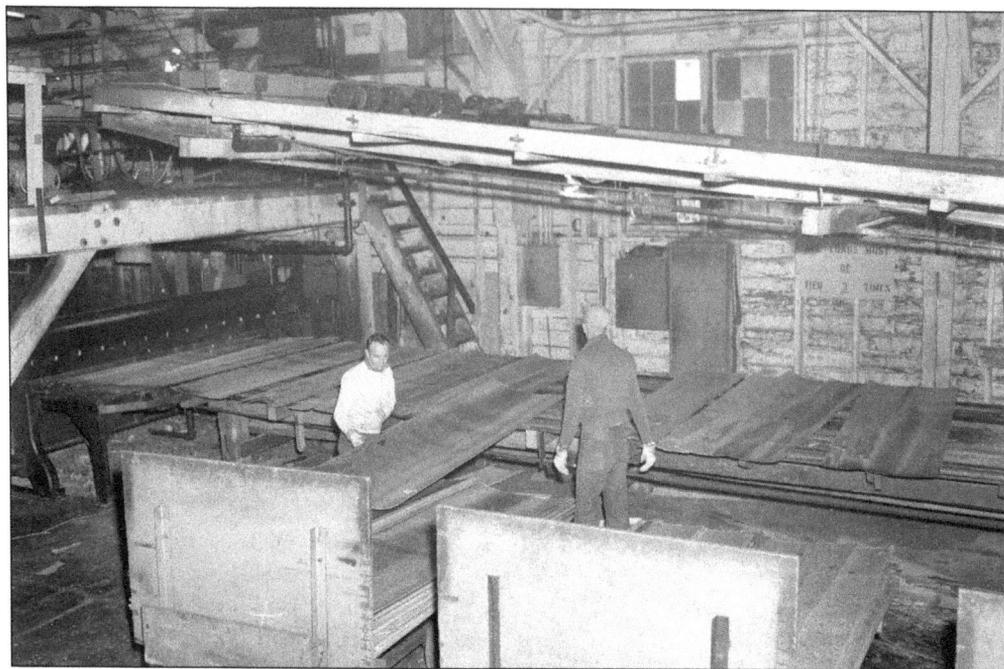

The plywood green chain in the c. 1950 photograph above comes into play after the logs are peeled. The log unrolls like toilet paper onto the chain, where it is chopped into the desired size and then separated by grade. The Sutherlin Products' green chain (below) was probably used for grading raw wood into specified sizes of lumber by the human pullers. (Both Pauline Wells Holley.)

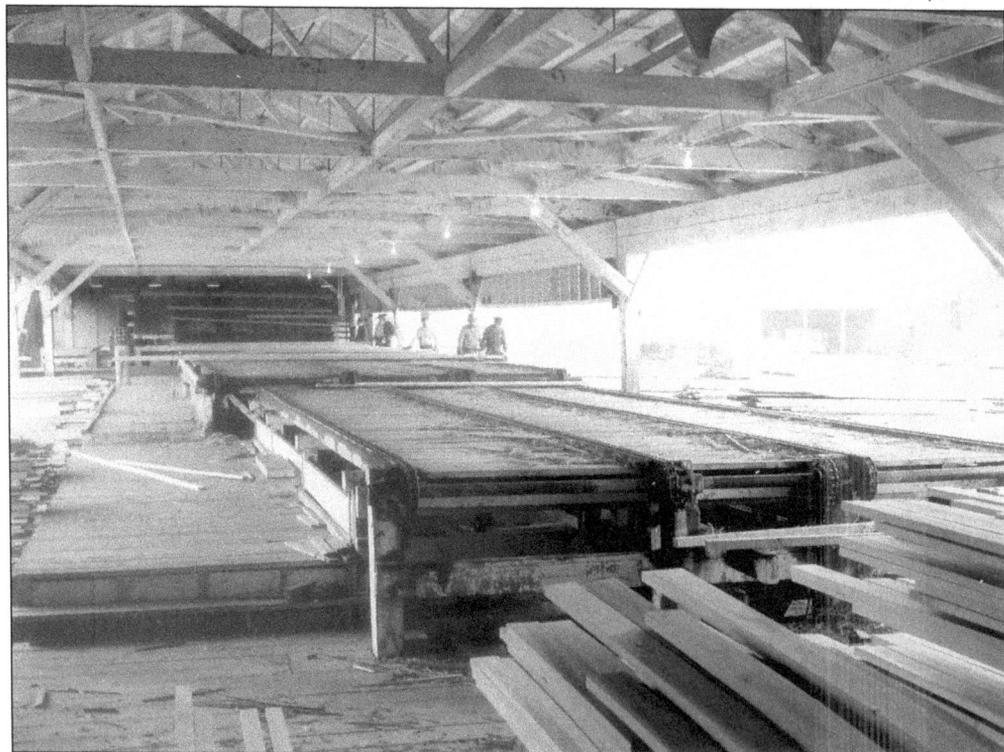

OFFICIAL PROGRAM

----- SUTHERLIN -----

"TIMBER DAYS" CENTENNIAL

JULY 3-4-5, 1948

SUTHERLIN, OREGON

TIMBER CAPITAL OF THE NATION

The centennial of Oregon becoming a U.S. territory was in 1948. Businessmen wanted the world to know how great Sutherlin was, so they held the first Timber Days in conjunction with the Fourth of July holiday. The program cover (right) shows a logging truck and an early view of Central Avenue. It was such a success that they repeated it—bigger and better—the following year (below), and for 48 years after that. (Both Joyce Botticchio.)

DOUGLAS COUNTY TIMBER DAYS

SUTHERLIN, OREGON

JULY 2-3-4 1949

Sponsored by SUTHERLIN POST No. 121 THE AMERICAN LEGION

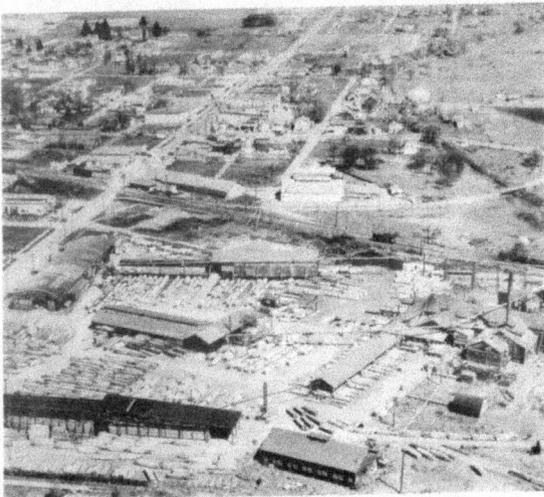

AIR-VIEW PHOTO OF SUTHERLIN

ROCK ISLAND LUMBER CO.

LOGGING AND SAWMILL DIVISION

Manufacturers of QUALITY DOUGLAS FIR, HEMLOCK, and CEDAR LUMBER

"FROM THE TREE TO THE CONSUMER"

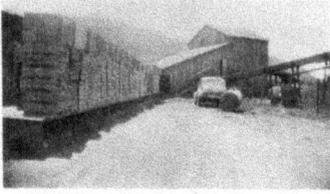

Bielman-Menke Shingle Co.
OREGON CEDAR SHINGLES
Wholesale and Retail
SUTHERLIN OREGON

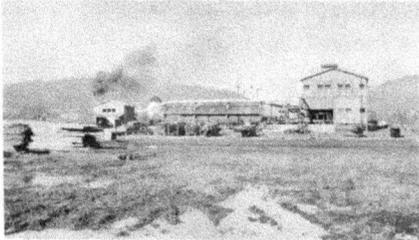

WISHING THE FIRST TIMBER DAYS CELEBRATION A BIG SUCCESS

Western States Lumber Co.
SUTHERLIN OREGON

Approximately every five minutes, loaded logging trucks traveled west from the logging camps along Nonpariel Road (which becomes Central Avenue) to the Sutherlin sawmills and railroads. Pictured in these pages from Timber Days programs are just a few of the mills that earned Sutherlin the title of Timber Capital of the World. Notice the wigwam burners at the Sutherlin Timber and Taylor Brothers Lumber companies. (Both Joyce Botticchio.)

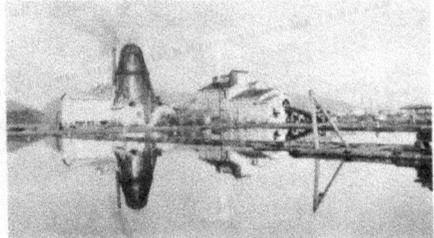

SUTHERLIN TIMBER PRODUCTS, INC.
— 1942 —
Logging and Lumber Manufacturers
WHOLESALE AND RETAIL LUMBER

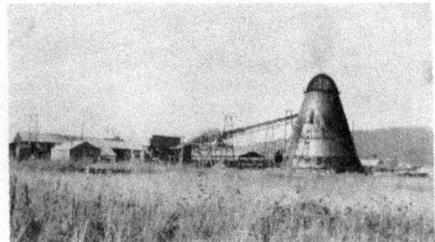

TAYLOR BROS. LUMBER COMPANY
in the Heart of One of the Largest Producing Sections of the Northwest
SUTHERLIN OREGON

Seen here is another of the many mills in Sutherlin in 1948, the Tyee Lumber Company. (Joyce Botticchio.)

This was the Timber Days program of events for Monday, July 5, 1948, including the grand parade, a logging contest, and other events. (Joyce Botticchio.)

SLACK'S
Union Service Station

* * *

Sutherlin, Oregon

L & H Lumber Company
Greetings to Douglas County Timber Days
SUTHERLIN OREGON
L & H Lumber Co started construction April 3, 1946, and began operating September 15, 1946
Their mill specializes in 2 x 4 - 6 s
for the BEST STUDS . . . see US!

SUTHERLIN FRUIT GROWERS

FEATHER FLAKE — NUTRILINE — TRIANGLE
FEEDS, SEEDS, GRASS PLANTS

* * *

SUTHERLIN OREGON

7

The L and H Lumber Company is featured on the cover of this 1949 Timber Days program (left). It ran north along the railroad tracks from Central Avenue towards Oakland. Below is an aerial view of Sutherlin Timber Products Inc. (Both Joyce Botticchio.)

ART AND AL'S

SIGNAL SERVICE STATION

AUTO REPAIR WORK

PHONE 987

Sutherlin Oregon

SUTHERLIN TIMBER PRODUCTS, INC.
— 1942 —
Logging and Lumber Manufacturers
WHOLESALE AND RETAIL LUMBER

X-L COURT
SUTHERLIN, OREGON

* * *

In the Heart of the
"Timber Country"

* * *

PHONE 292

10

These 1949 aerial views of the Weyerhaeuser and North Douglas mills show how extensive both mills were. (Both Joyce Botticchio.)

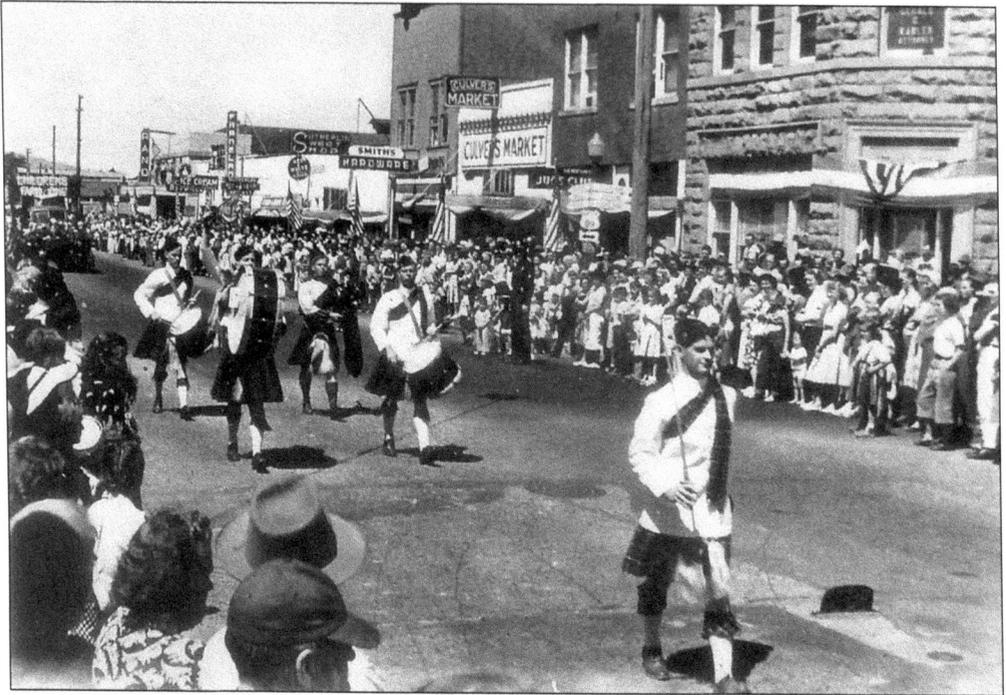

A large crowd of people watched as a Highland marching band strutted its stuff past the State Street bank (above). The clan tartan connects the Sutherlin family with their ancestors in Scotland. In the 1957 parade below, children guide a flower-bedecked chair in front of what was originally the Sutherlin Wine Company building. This building is still standing but has recently lost Vera's Restaurant as a tenant. (Above, DCM; below, Kitty Murphy.)

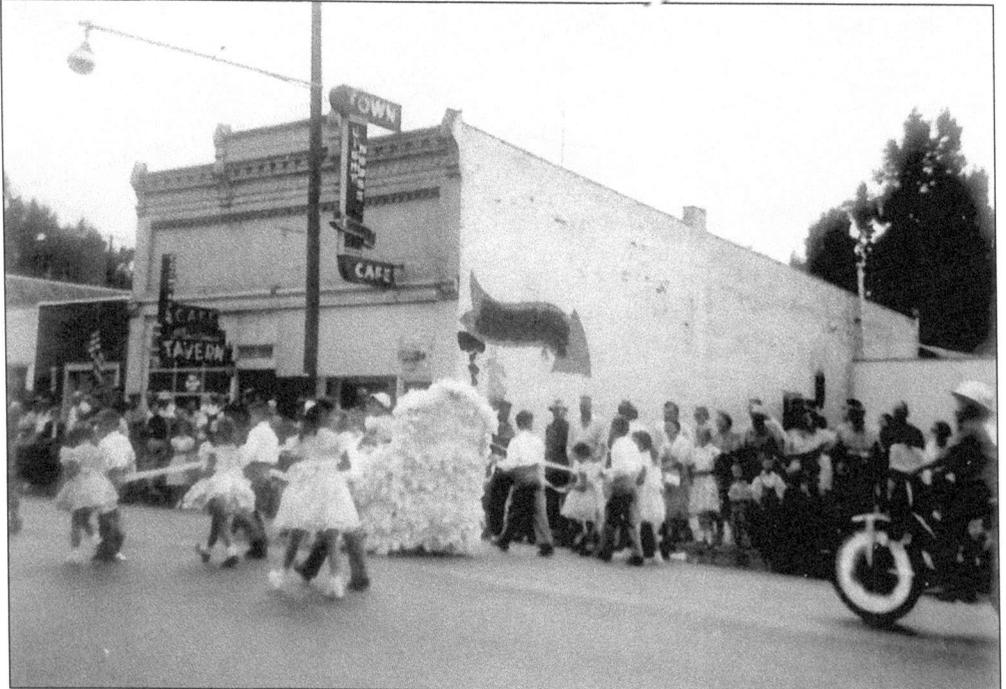

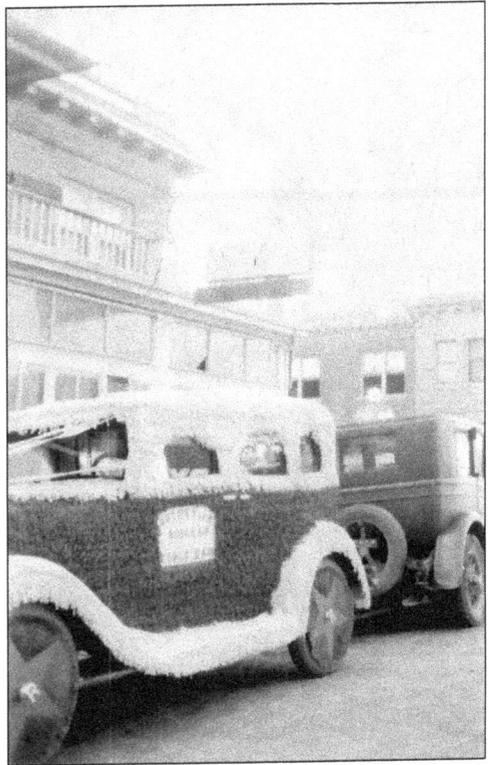

The Sutherlin Rebekah Lodge gaily decorated its car float (right), as did the Lions and Lady Lions (below). (Right, Gail Hodapp; below, Pauline Wells Holley.)

FIRST PRIZE WINNING FLOAT — 1955
Sponsored by LIONS and LADY LIONS

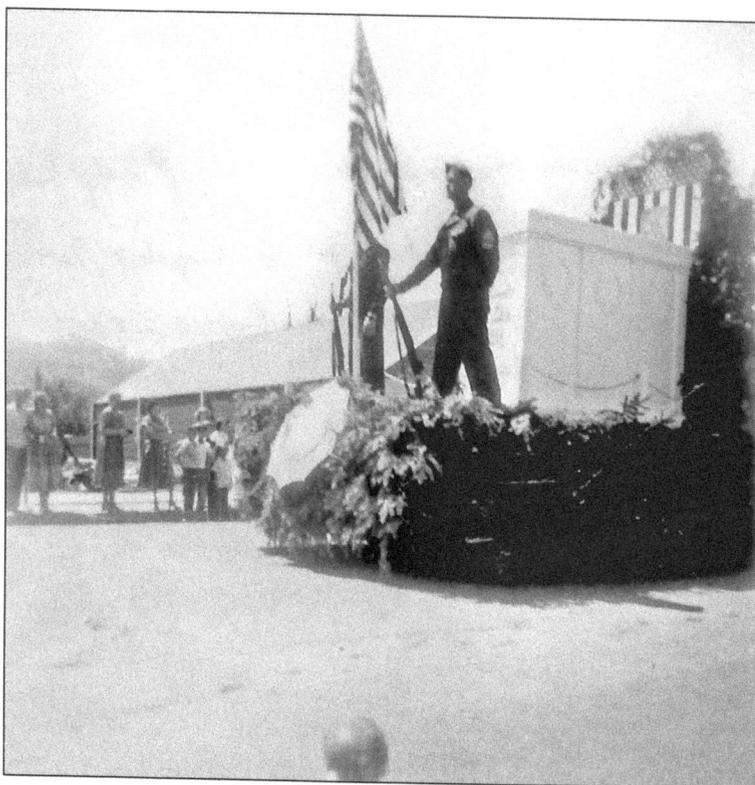

Timber Days parades brought out the pride in people, as seen by the floats that were entered in them. First and foremost, in 1953, a truly patriotic float honored members of the armed services (left). And what's a parade without a marching band? The Sutherlin high school band (below) is preparing to strut its stuff. (Both Kitty Murphy.)

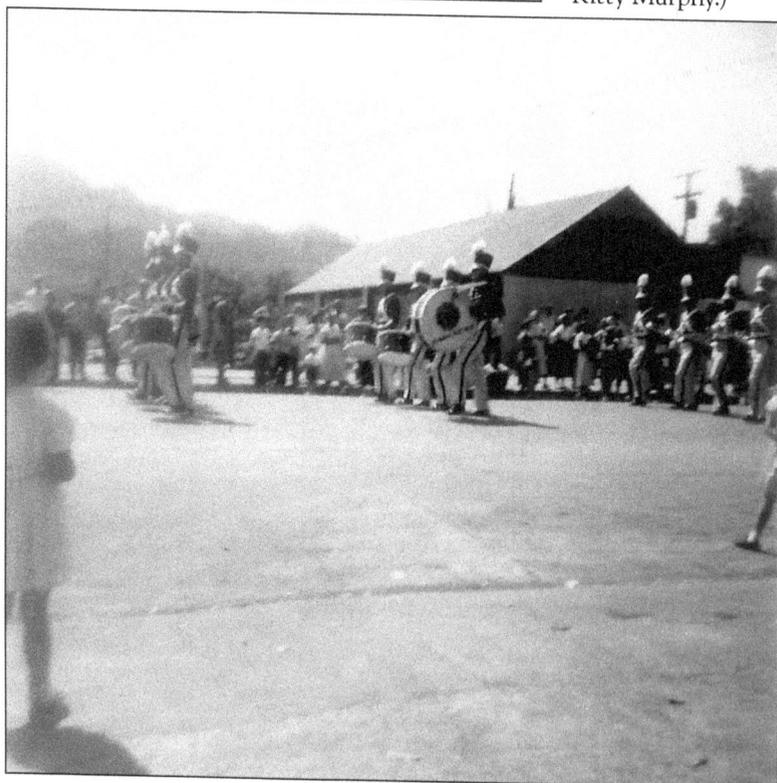

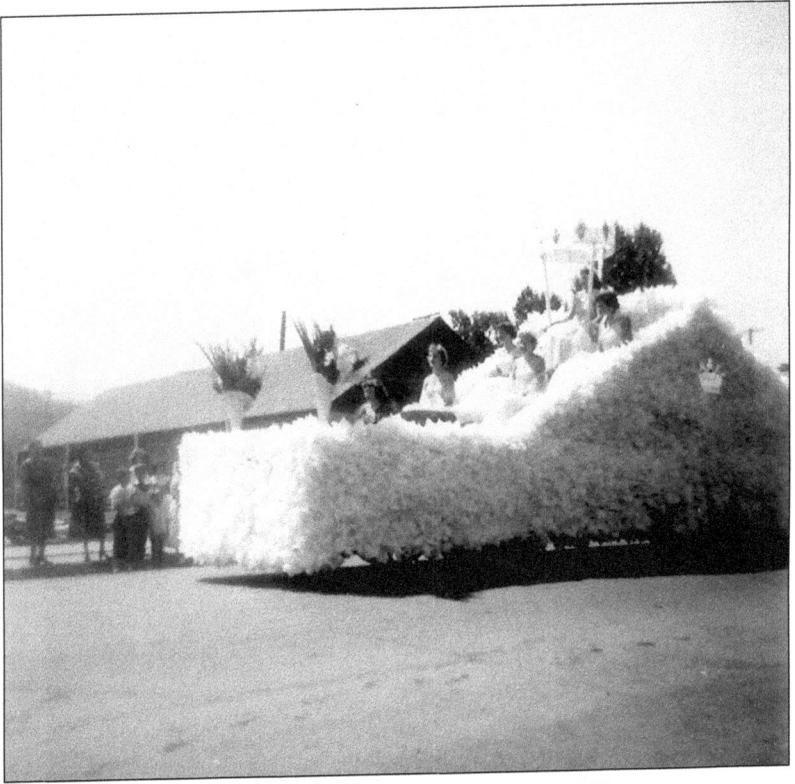

Imagine being part of the decorating crew for the 1953 Queen's Court float (right) or the 1957 Southern Belle float (below). (Both Kitty Murphy.)

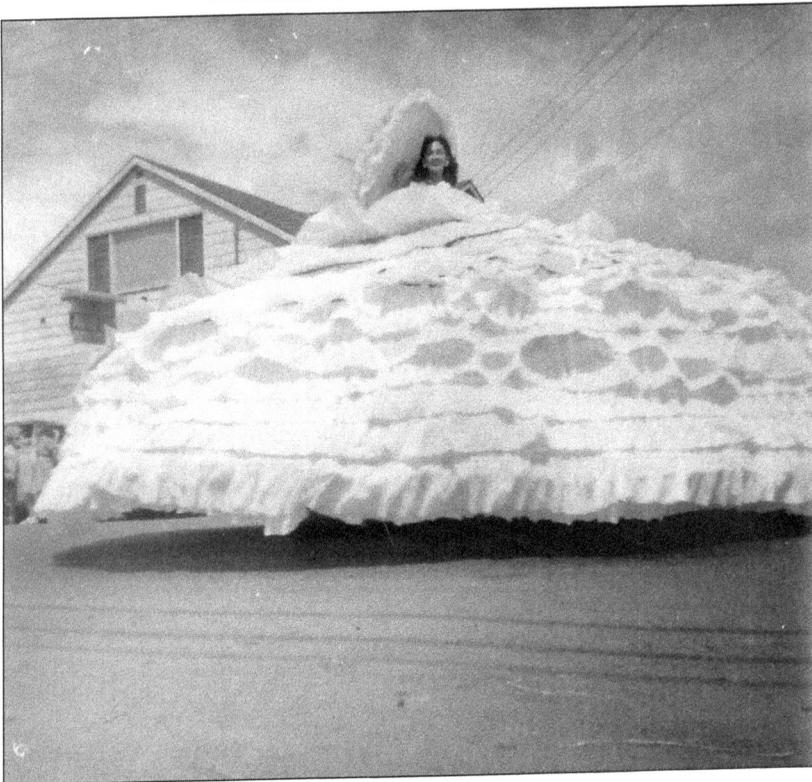

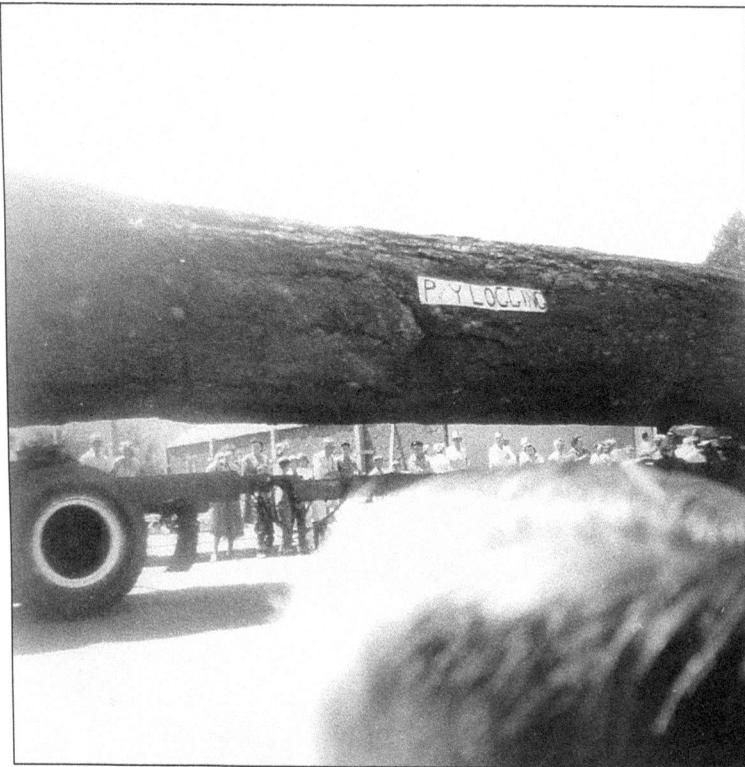

In 1953, a log so big that it couldn't entirely fit in the picture was entered by P/Y Logging (left). The 1959 Timber Days parade entry below is an International Westcoaster log truck owned by R. A. Briggs and Logging. Compare the size of these logs being harvested then with those being harvested these days. (Left, Kitty Murphy; below, Gary Lund.)

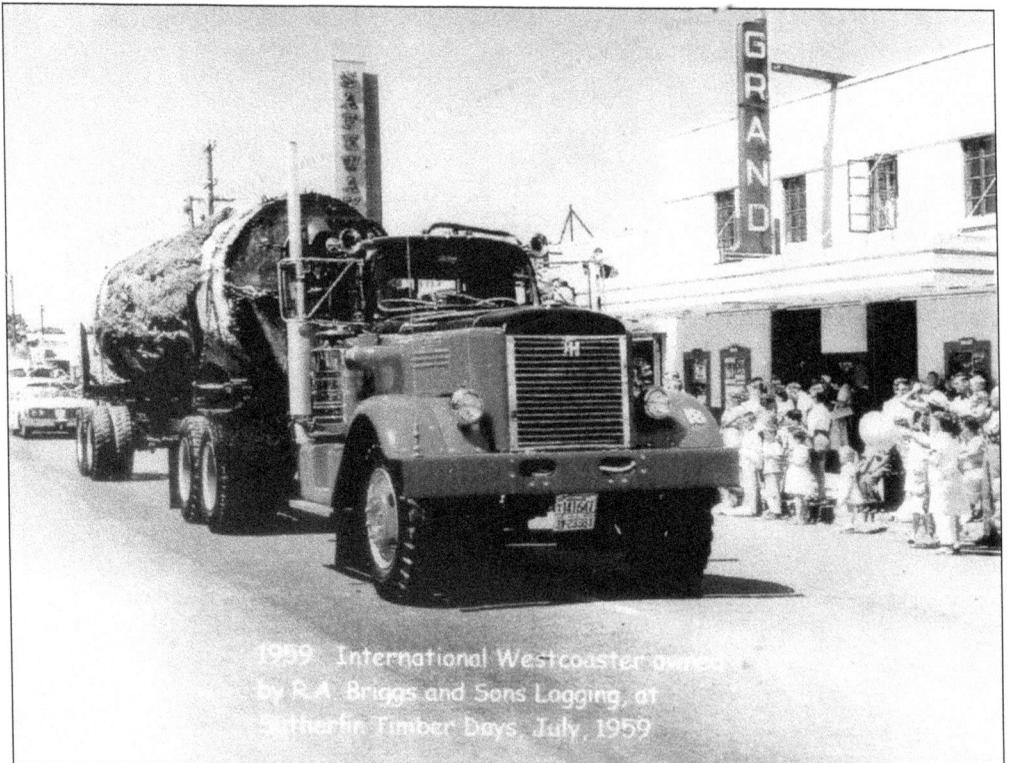

1959 International Westcoaster owned by R.A. Briggs and Sons Logging, at Sutherlin Timber Days, July, 1959

You're never too young to enter a Sutherlin parade. With a little help from mom and dad, this 1959 Timber Days covered wagon entry titled "Oregon or Bust" was made and entered by Kevin Murphy (age three) and his youngest brother, Colin, age one. Logging expertise is not the only Timber Days contest. The winners of the 1958 facial hair contests were, from left to right, unidentified, unidentified, Craig Francis, John Murphy, M. C. Sandy McBride, Harry Bird, Max Post, and unidentified. (Both Kitty Murphy.)

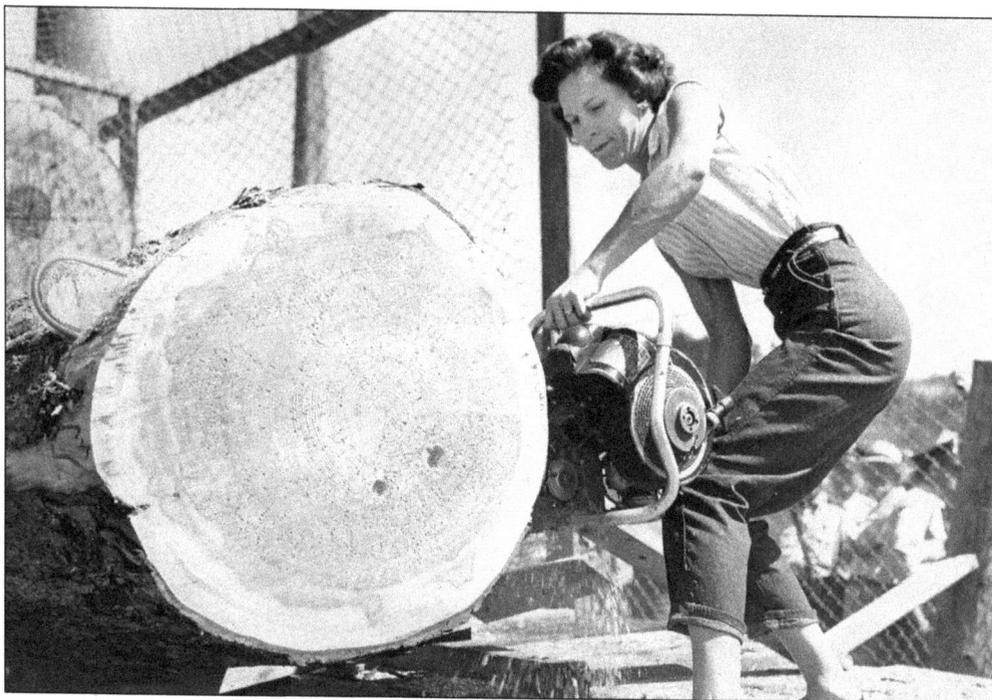

Logging wasn't restricted to the men any longer. Nita Allen (above) performs well at log bucking during a 1950s Timber Days. Jeri Smith (below) won first place in the 1953 lady logger event. (Both DCM.)

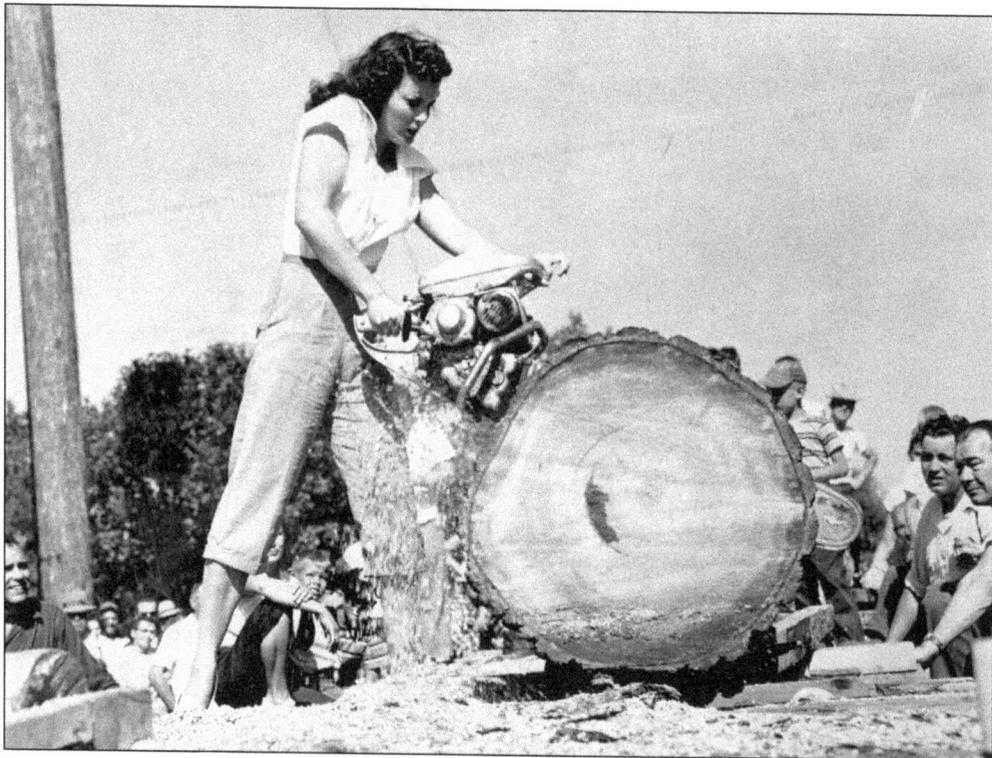

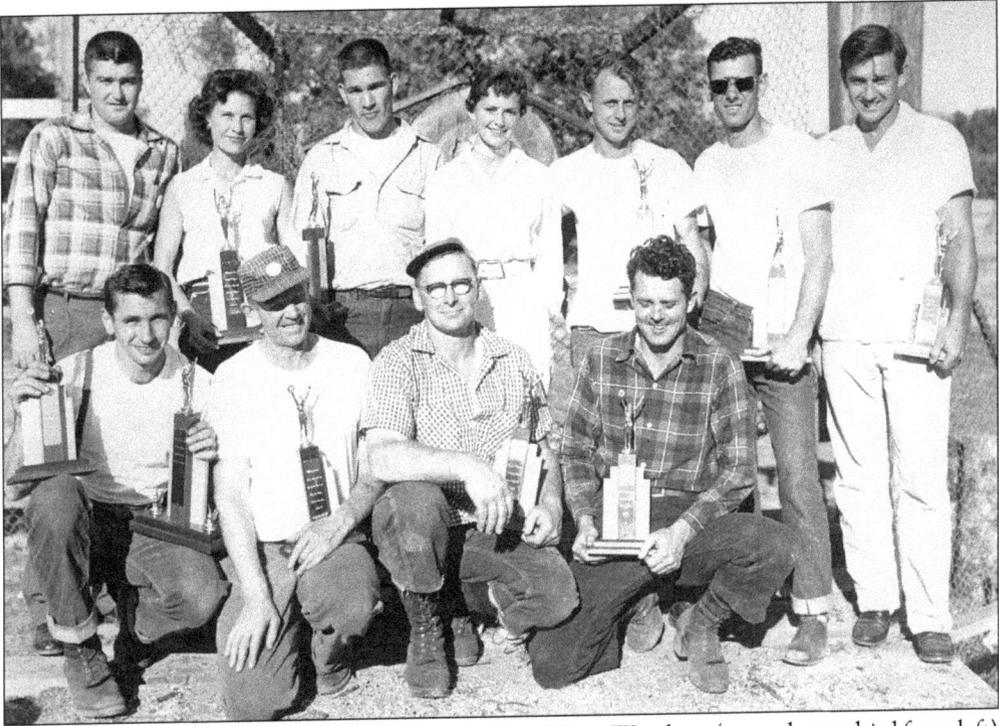

Above, Nita Allen (second row, second from left) and Tom Weathers (second row, third from left) are the local winners at a 1950s Sutherlin Timber Days. In 1953, Sutherlin Timber Days hosted the World Champion Bucking Contest (below). The winners were, from left to right, Pokey Allen, second place; Mr. Firebough from Coos Bay, third place; and A. M. Ison, first place. (Both DCM.)

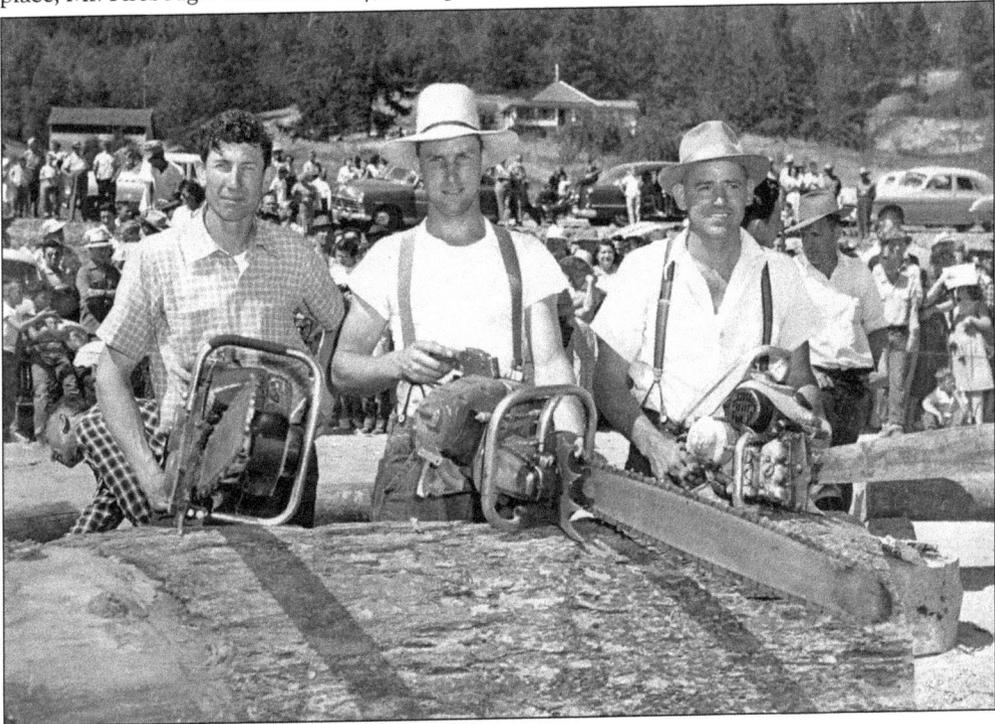

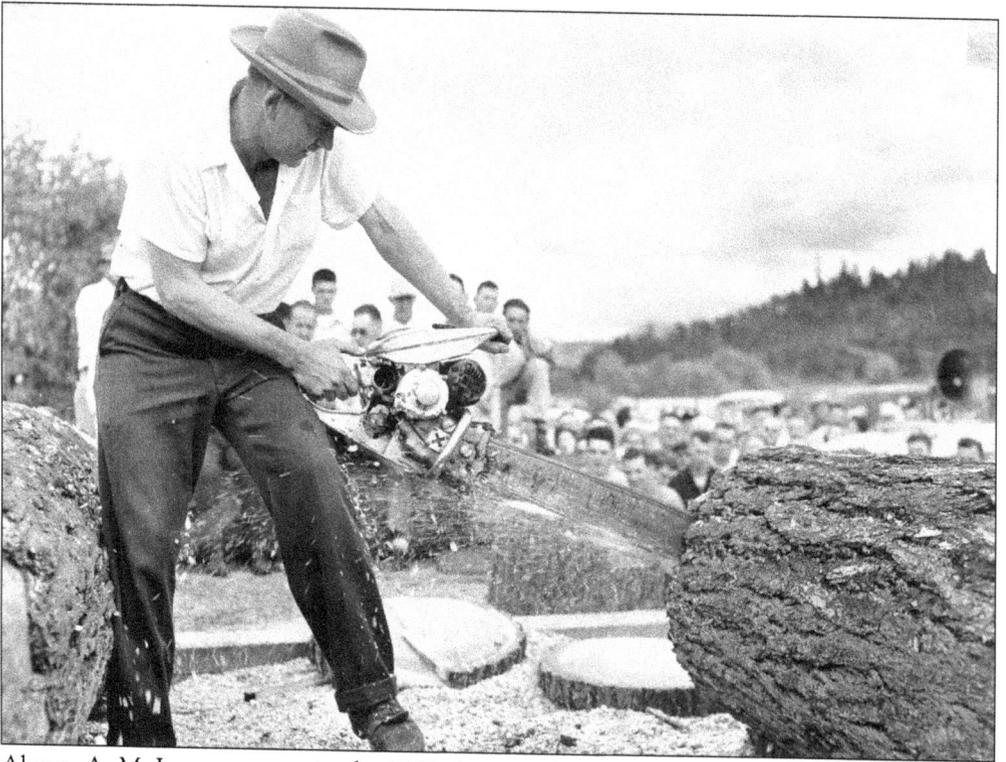

Above, A. M. Ison competes in the 1950 chainsaw bucking contest. Below, Wendell "Pokey" Allen took second place in the hand crosscut saw competition. (Both DCM.)

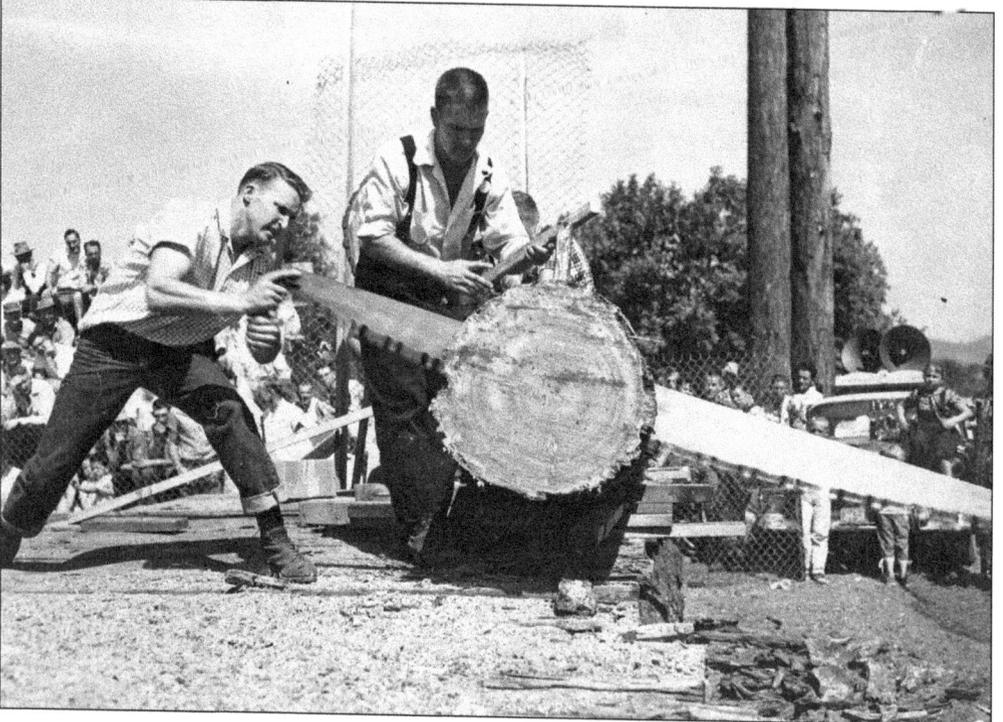

Six

FIRES AND
FLOODS, OH MY!

Disasters come in all sizes, shapes, and venues, but they always come. The combination of wood frame houses and open flames used for cooking, heating, and light was a recipe for fires, leading to complete loss of buildings and, all too often, lives.

The front page of the July 22, 1938, issue of *The Sutherlin Sun* detailed the loss of the Presbyterian church (page 44) and a residence, with damage to several homes, outbuildings, and several acres of second-growth fir and oak timber when fire swept over the north side of town. The fire started in an abandoned chicken house in Whitmore Gap, with the wind carrying embers southwest to town. Both Oakland and Roseburg fire departments responded to the three-alarm fire call. The estimated loss was $15,000, but there was no loss of life.

On May 13, 1974, arson destroyed Sutherlin high school. Early in the morning, a disgruntled student decided to set fire to the school. It was destroyed except for four classrooms on the west end of the building.

On July 5, 2003, Murphy Plywood burned to the ground. The fire started in the rafters and was thought to have been extinguished, but it was not. Several area fire companies joined the control efforts and prevented damage to downtown businesses.

Flooding of the Sutherlin Valley was a perpetual problem, as nature tried to return the valley to its pre-pioneer condition. Frequently, between the months of November and April, the town's streets, homes, and outlying districts were surrounded by or filled with water. Sutherlin Creek was widened. It helped but did not free the town from damaging floods.

In 1960, the Sutherlin Creek Watershed Project was created. Originally the project plans covered 28,960 acres and focused on protecting Sutherlin and the surrounding lands from flooding. As with most bureaucratic projects, this one also grew, until it became Public Law 566 Small Watershed Project. The original purpose was expanded to include a water supply for summer irrigation and for municipal and recreational uses. Plat I and Cooper Creek Reservoirs were created. Again, this helped, but it wasn't until the recent completion of the Central Avenue Sewer Replacement Project that significant progress could be seen.

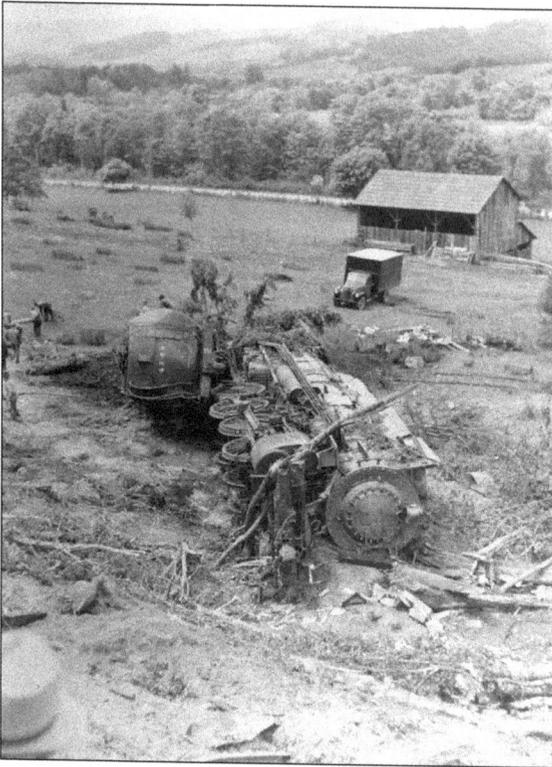

Train wrecks always present hardship, especially if they are passenger trains. Early in railroad history, a train was usually composed of passenger and freight cars. South Pacific train No. 330 and engine No. 4348 wrecked around 1940 between Sutherlin and Oakland. After derailing on the mainline curve, the engine came to rest near Stearns Road. (DCM.)

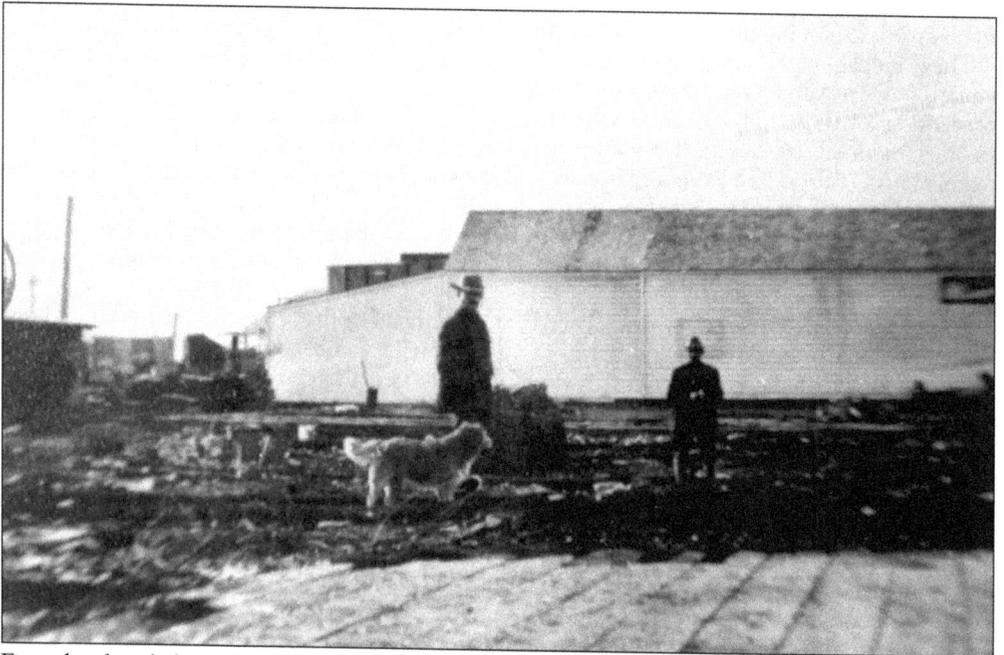

Fire, the dreaded word, was a constant companion of the early settlers. Wood combined with the need to cook, have light, and keep warm were the ingredients for a disaster just waiting to happen. These men and their dog are thought to be walking on the remains of the Bungalow Hotel. (DCM.)

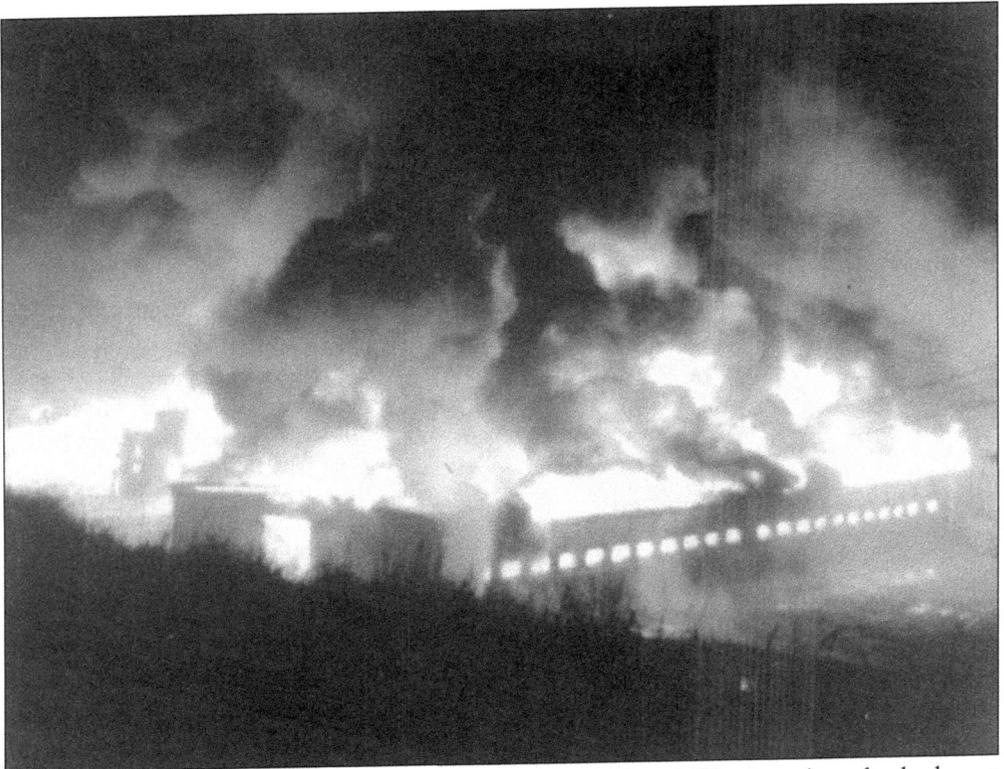

Arson lit up the sky and destroyed Sutherlin high school (above). The four-alarm fire broke out at 3:00 a.m., was contained by 6:00 a.m., but was still smoldering most of the day (below). The only portion of the 27-year-old structure left standing was part of the library and two or three classrooms. (Both Pauline Wells Holley.)

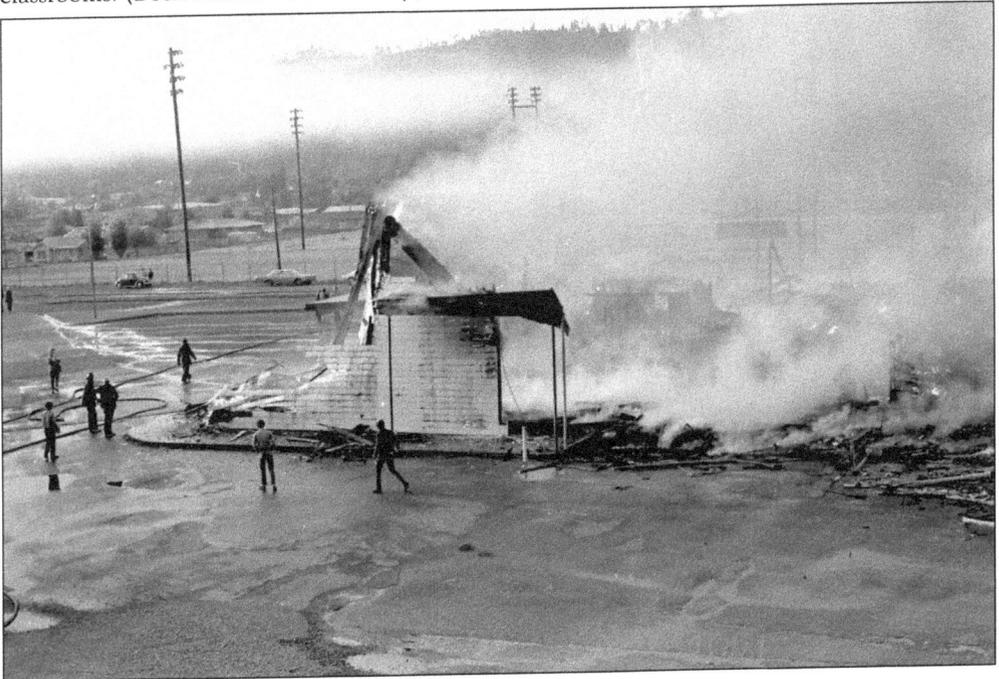

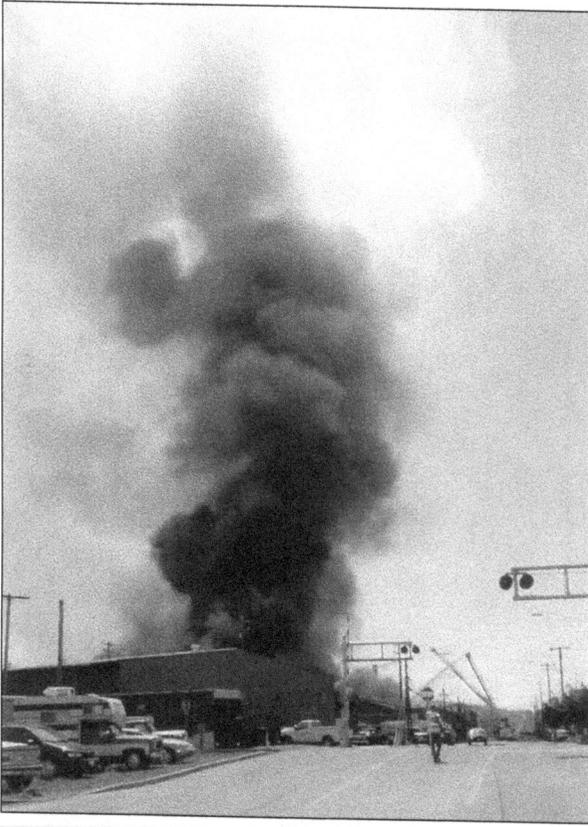

The motor on top of a veneer dryer at the Murphy Plywood plant started a fire that mill workers tried to contain. From all reports, they almost succeeded. The fire call went out at approximately 12:45 p.m. Employees were evacuated. Traffic was diverted. By 3:00 p.m., there were 110 firefighters at the scene. Before nightfall, 3 million gallons of water had been used, leaving only 8 feet left in the reservoirs. The call went out to residents to conserve water, and they instantly responded. All day and night, area fire companies fought to bring the blaze under control. (Both *North County News*.)

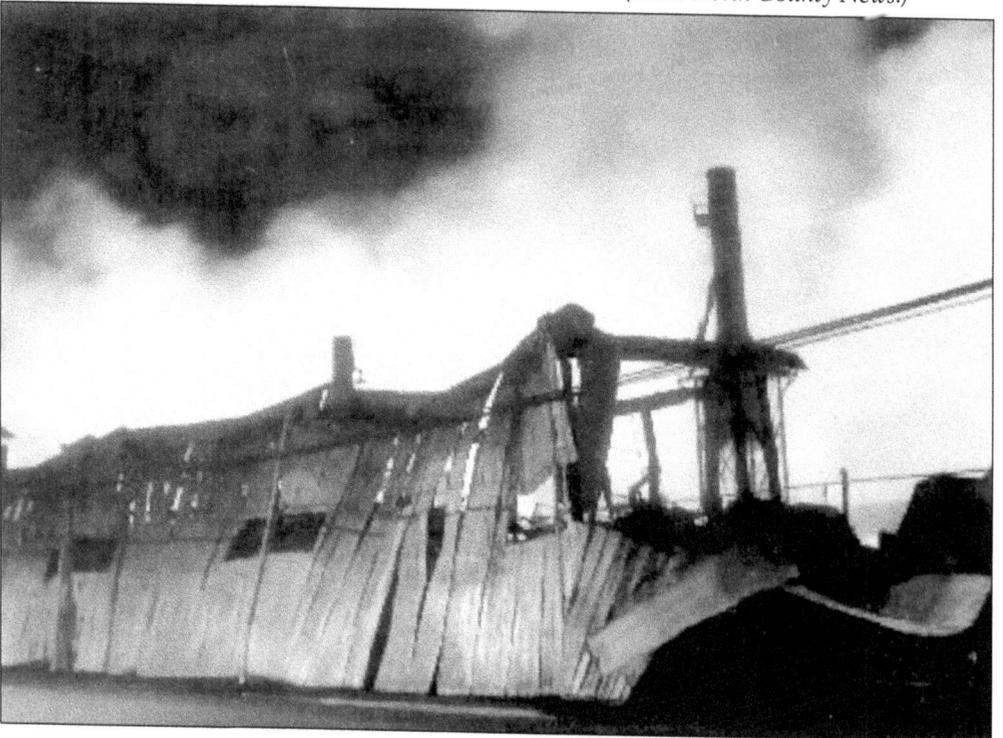

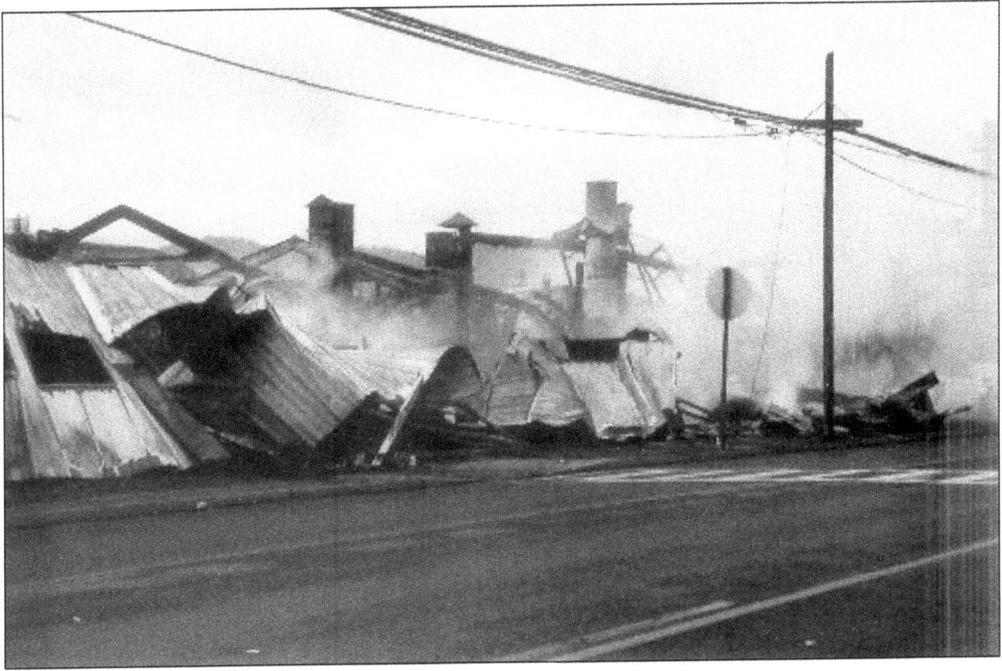

By 10:00 p.m. on day four, the fire at Murphy Plywood had been contained (above), Central Avenue was partially opened to traffic, and phone service had been restored to the west part of town. It says a lot about the Sutherlin Fire Department's plan of attack that there were no serious injuries, no lives lost, and the fire did not spread to any of the nearby businesses. Fourteen months later, ground was broken for Murphy Engineered Wood Products (below). (Above, *North County News*; below, Tricia Dias.)

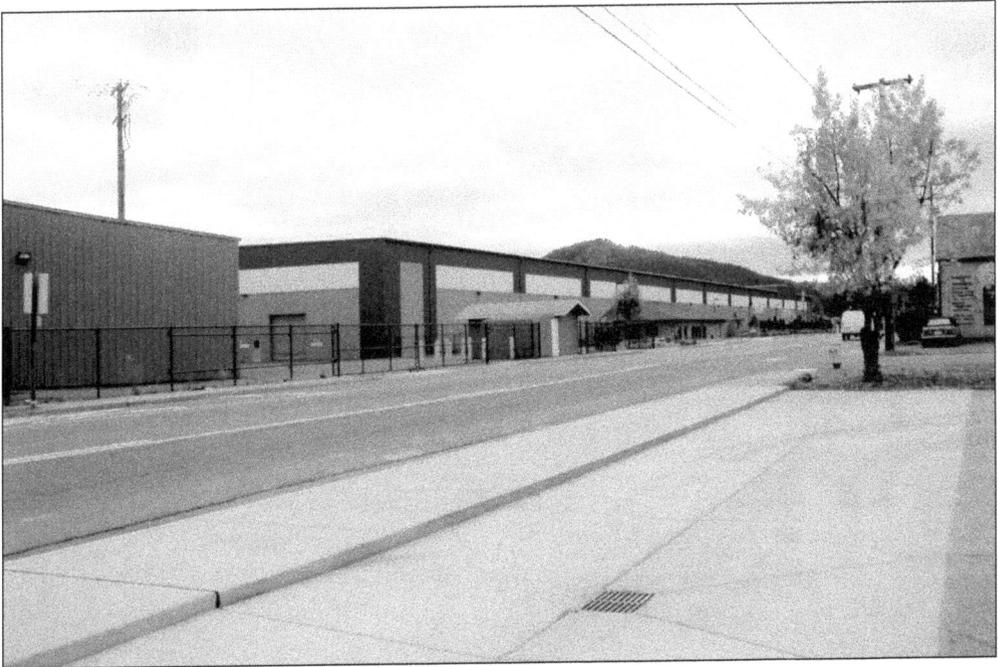

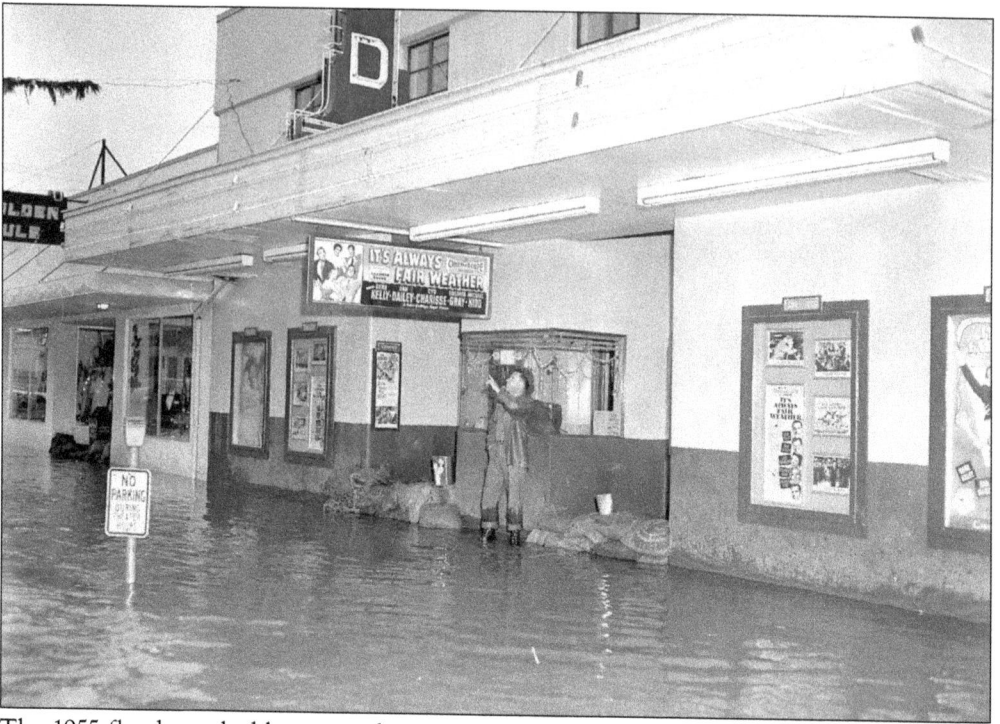

The 1955 flood wreaked havoc in the town. Rowboats were the only form of transportation. Above, water is lapping at the exterior of the Grand Theater as the owner vainly tries to stave it off with sandbags. The title of the film showing is the grossest of irony. Below, a man futilely shovels water out of the door of the Pastime Tavern. (Both DCM.)

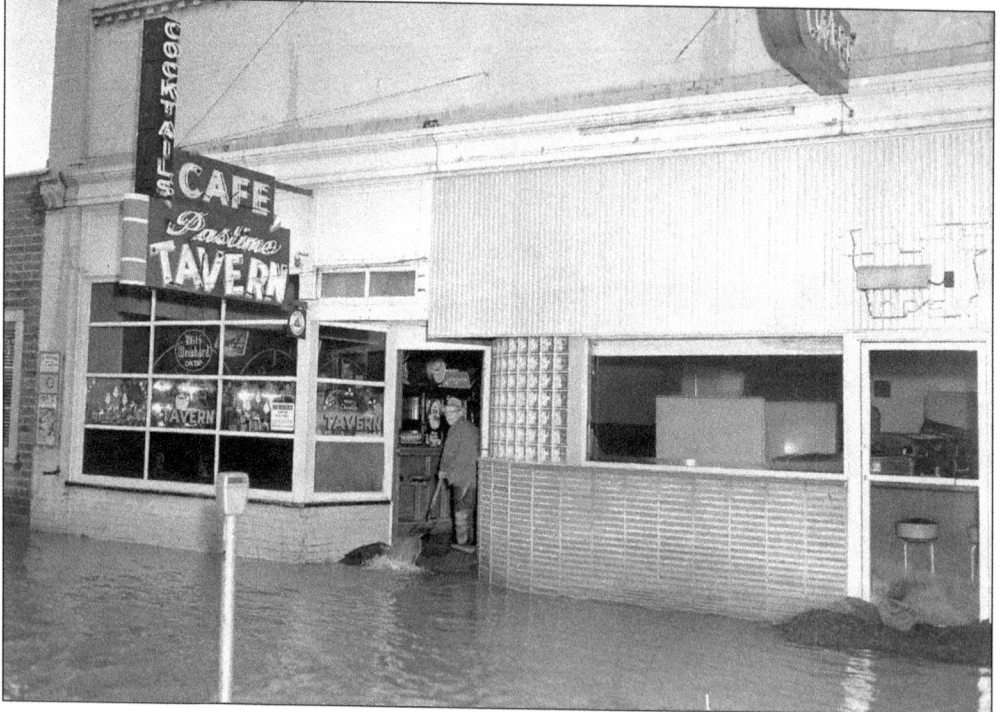

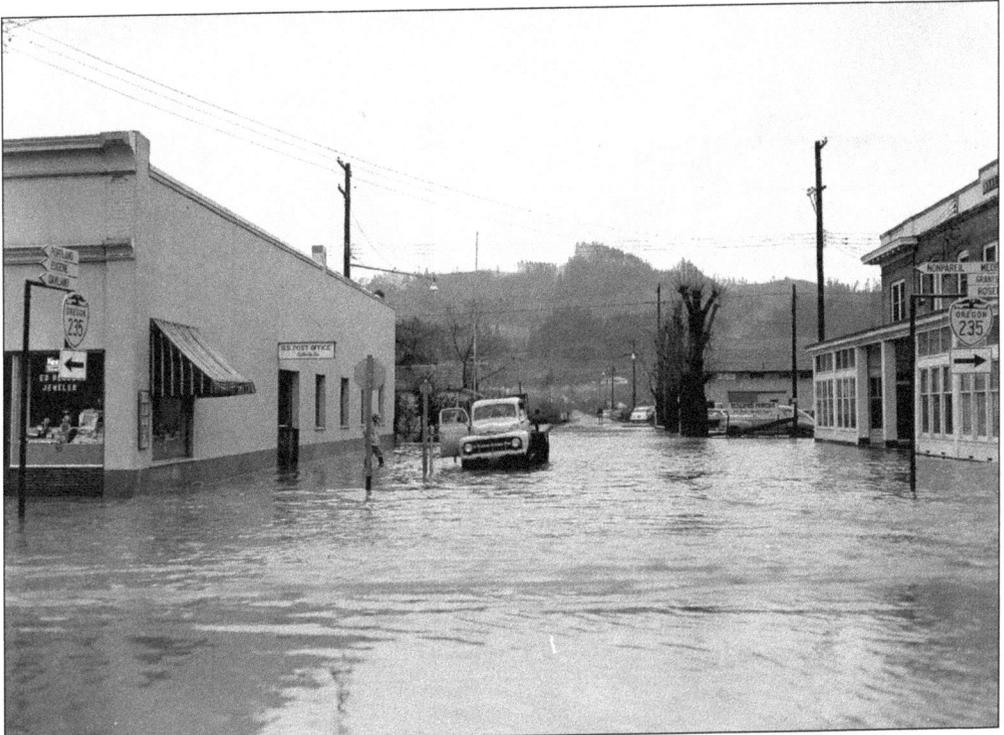

A flooded State Street shows the post office, Sutherlin Hotel, a stranded pickup, and a brave soul wading. Below is a close-up of the hotel's plight. (Both DCM.)

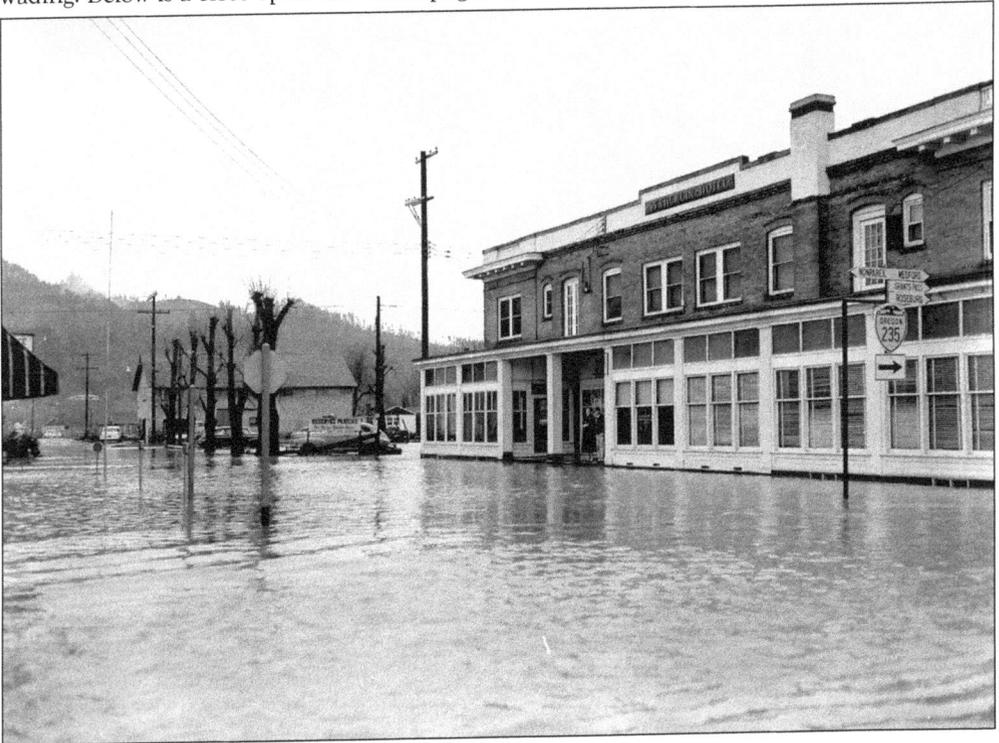

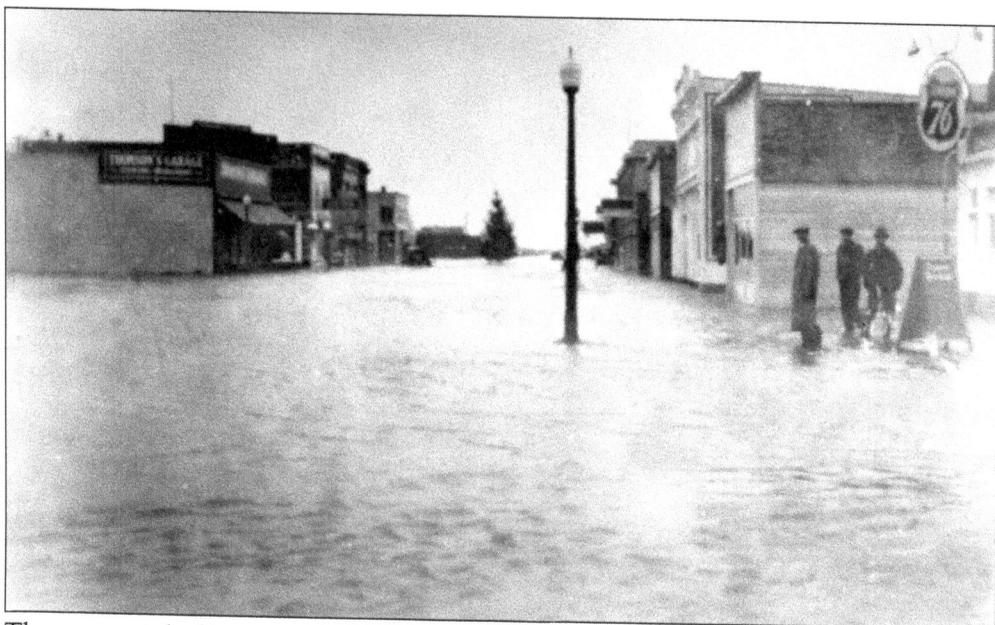

The camera is looking east at a badly flooded Central Avenue from Calapooia Street. This photograph was taken on January 2, 1933. (DCM.)

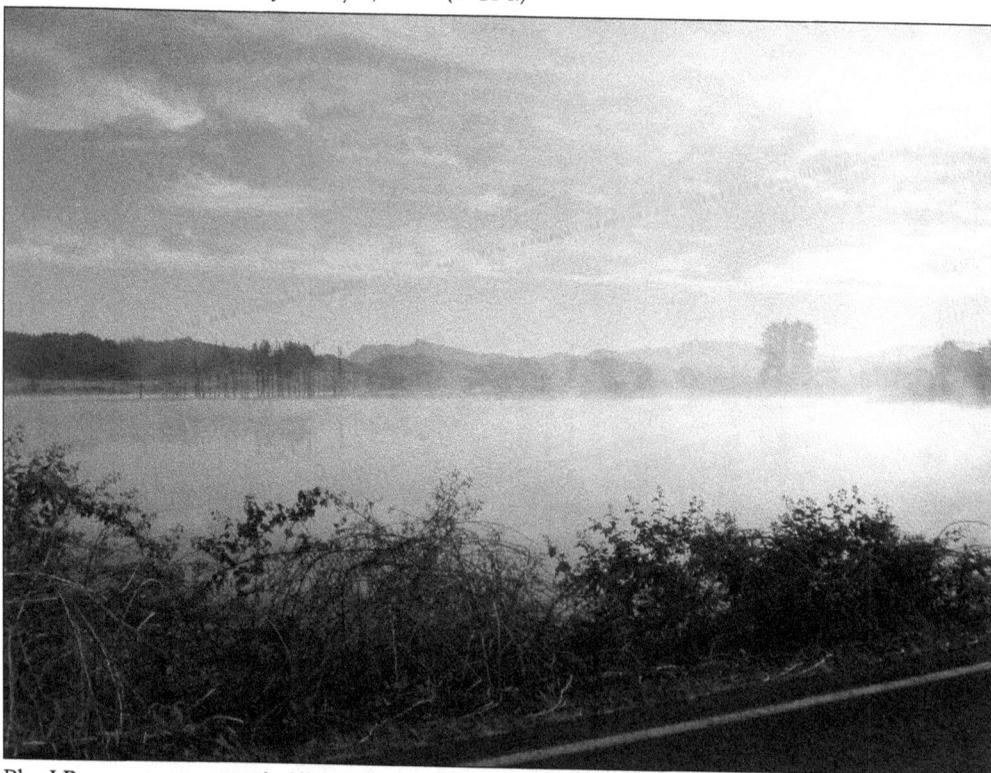

Plat I Reservoir is an earth-fill dam constructed on Sutherlin Creek about 3.5 miles east of town. All or part of a number of family farms were condemned "by right of eminent domain" to provide the 247 acres needed. Compensation was below actual value. Some farmers were able to buy inferior land and remain in the area. Others were forced to move away. (Tricia Dias.)

Seven

PASTIMES AND SIMPLE PLEASURES

Every age has a different way of unwinding. Baseball was the pastime of choice for most of Oakland and the Sutherlin, Umpqua, and Cole Valleys. There were fierce rivalries between town and company teams. The games were usually played on Saturday or Sunday afternoon, with the whole family in attendance. Picnic lunches were shared, and children made the most of the relaxed atmosphere.

Picnics, hiking, river rafting, swimming, horseback riding, and assorted youth activities also helped to bring joy into lives—and still do. And let's not forget Sunday drives in the country. The Umpqua Valley is actually not one valley but a thousand valleys, and the Sutherlin area abounds in lots of opportunities to explore the road not taken. Recently, Highway 138/38, which has its eastern terminus in Oakland and Sutherlin, was officially designated the Umpqua River Scenic Byway. This is the only Oregon scenic byway that is located all in one county.

The Sutherlin airport has become the Industrial Park, but if one listens closely on a still summer morning, the sound of an early biplane engine as it comes in for a landing with a nervous student at the control can still be heard. The schooling of amateur pilots at the airport continued well into the 1980s. Aerial tournaments were held there as far back as 1910.

Drill Teams, marching bands, and other parade-type events were routine activities for schoolchildren, especially if they wanted to be part of the in crowd. Scouting and church-affiliated youth groups kept children occupied and focused their minds on service for others. The older residents had their service organizations as well: Odd Fellows, Lions, Lady Lions, Rotary, Jaycees, Jaycettes, veterans' organizations, Eagles, and so on.

In more modern times, Sutherlin can proudly boast of its summer festival schedule, which includes the Sutherlin Rodeo Stampede in July and the world-famous Blackberry Festival in August. Scattered throughout late spring, summer, and early fall are a variety of local events that attracts many visitors—and the weather can't be beat.

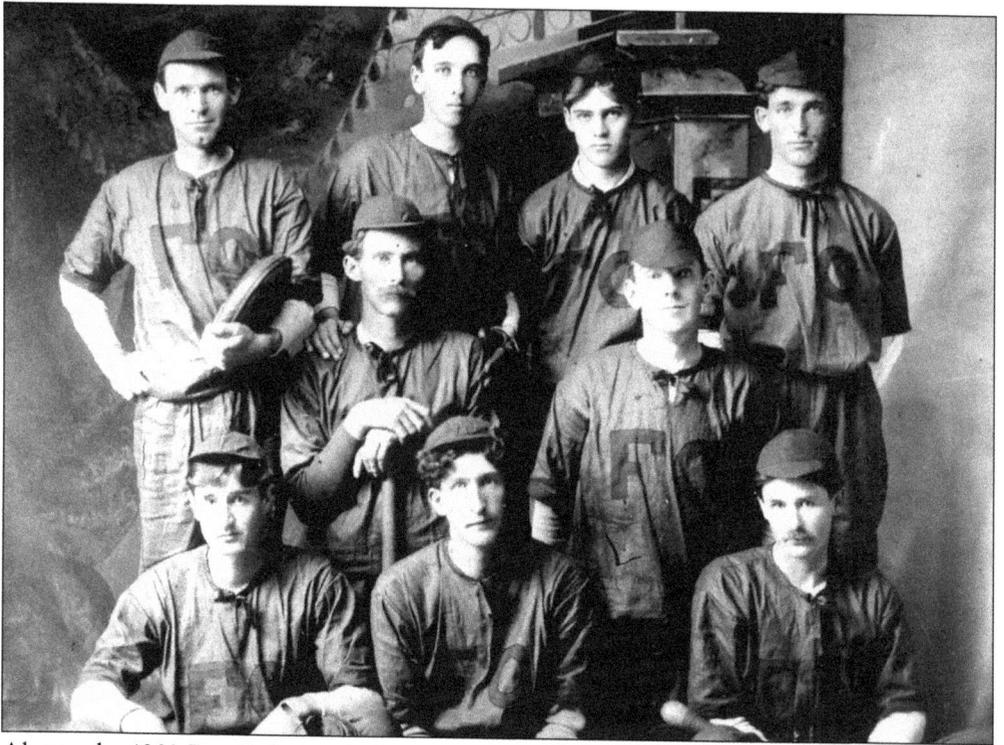

Above, the 1902 Fair Oaks baseball team members are, from left to right, (first row) Albert Cockeram, John Abeene, and Ward Cockeram; (second row) Bob Benton and Walter Hunt; (third row) Bert Hunt, Giles Hunt, Bill Baird, and King Hogan. The Cockerams were brothers. Photographed at Peter Adams's ranch, the 1905 team members (below) are, from left to right, (first row) George Neal, Arthur Smith, George Chenoweth, and Ava Manning; (second row) Walter Hunt, Jim Clay, Giles Hunt, Bill Bard, and Jess Lyons. (Both DCM.)

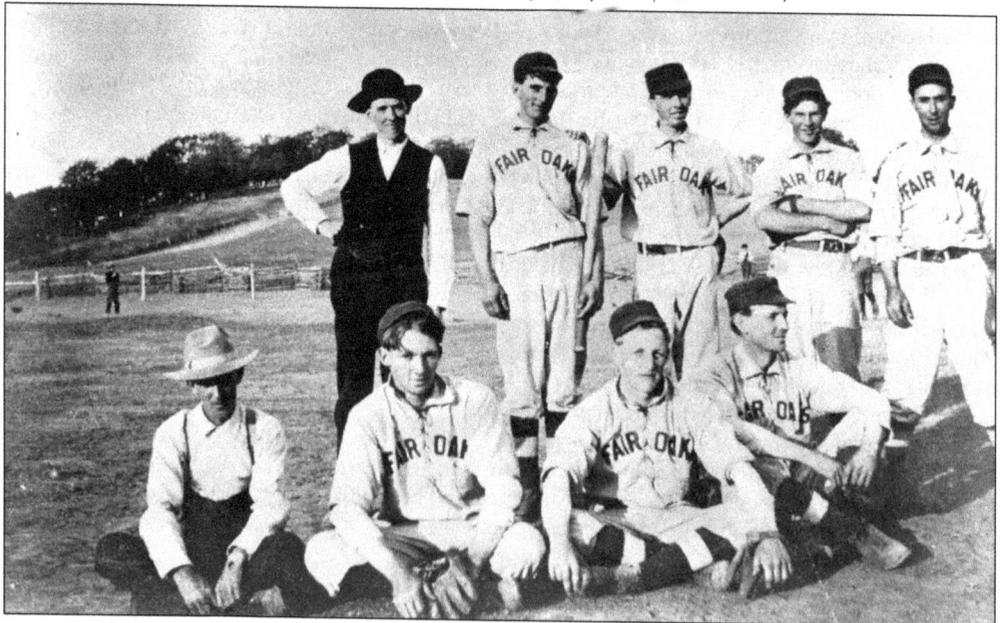

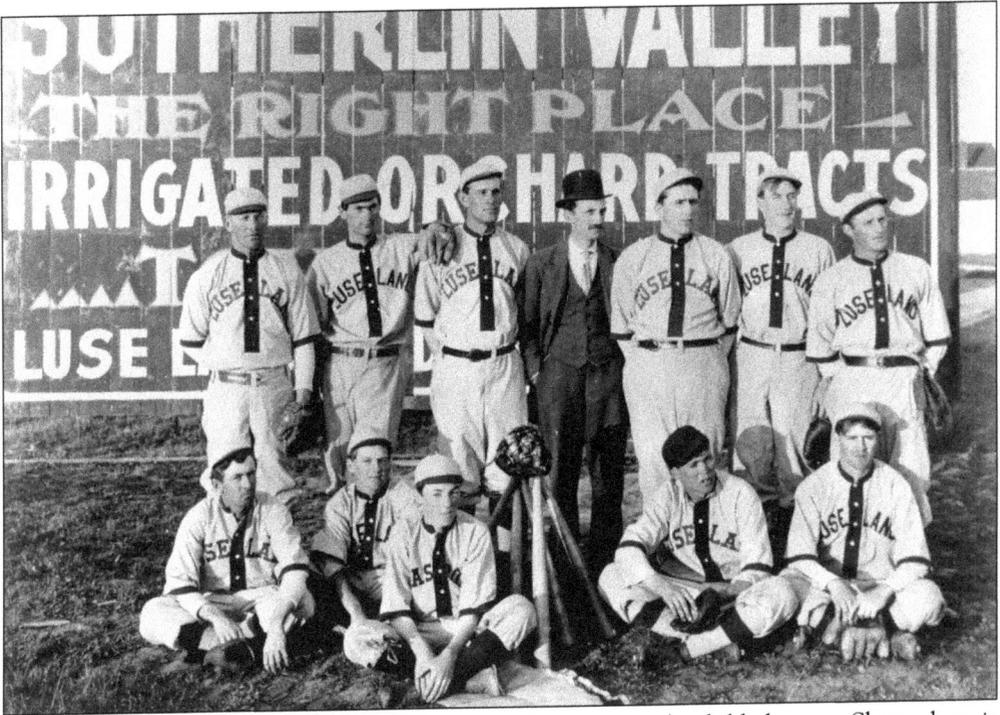

Not only the towns had friendly rivalries, but local businesses also fielded teams. Shown here is the 1911 Luse Land Company baseball team. The image was taken in Sutherlin. (DCM.)

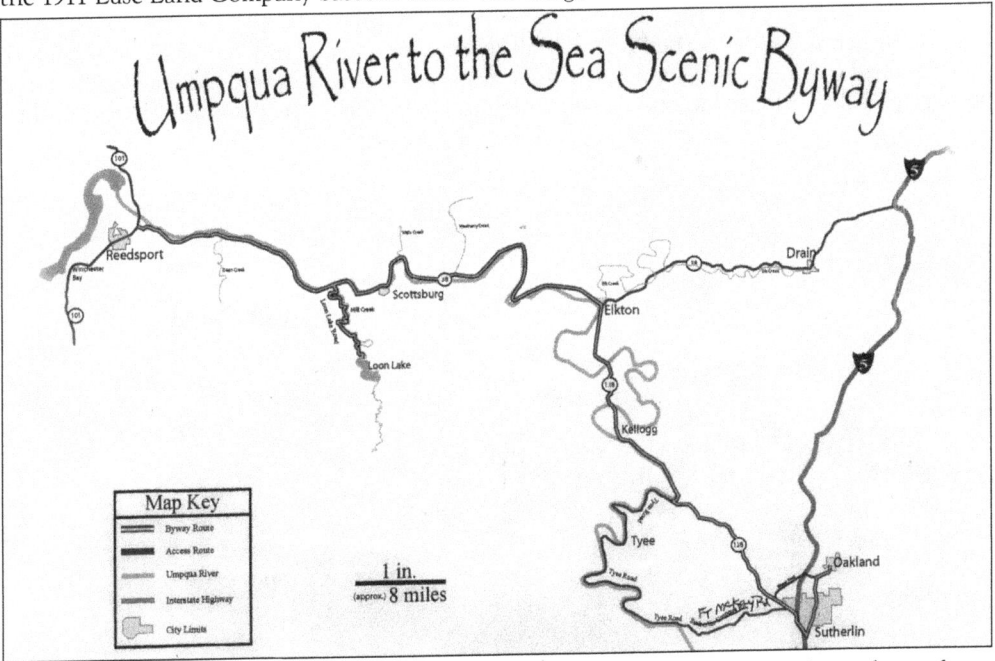

In the fall of 2008, after four long years, the hard work of many dedicated members of two committees, and a 10-minute presentation, the Oregon Transportation Commission officially designated Highway 138/38 as the Umpqua River Scenic Byway. The dedication was held at 2:00 p.m. on September 18, 2009, in Scottsburg Park. (Umpqua River Scenic Byway Committee.)

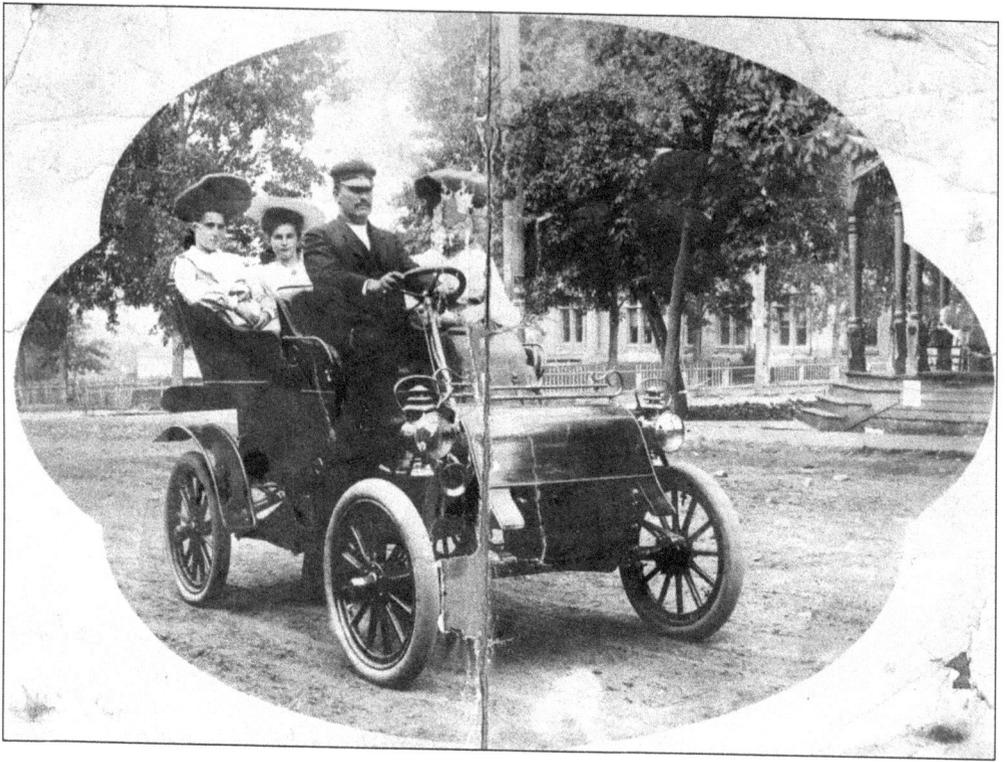

John R. Sutherlin, Fendel Sutherlin's son, had the first automobile in Douglas County (above). Photographed on June 1, 1903, John R. was residing in Roseburg at the time. The automobile in the photograph below belonged to one of the Sutherlins. His mother is the passenger. (Both DCM.)

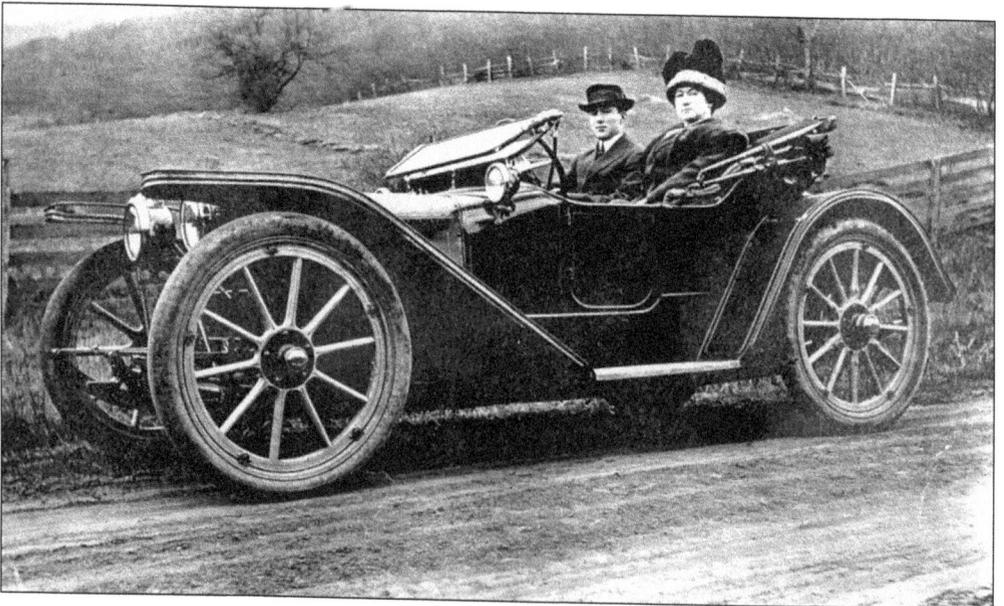

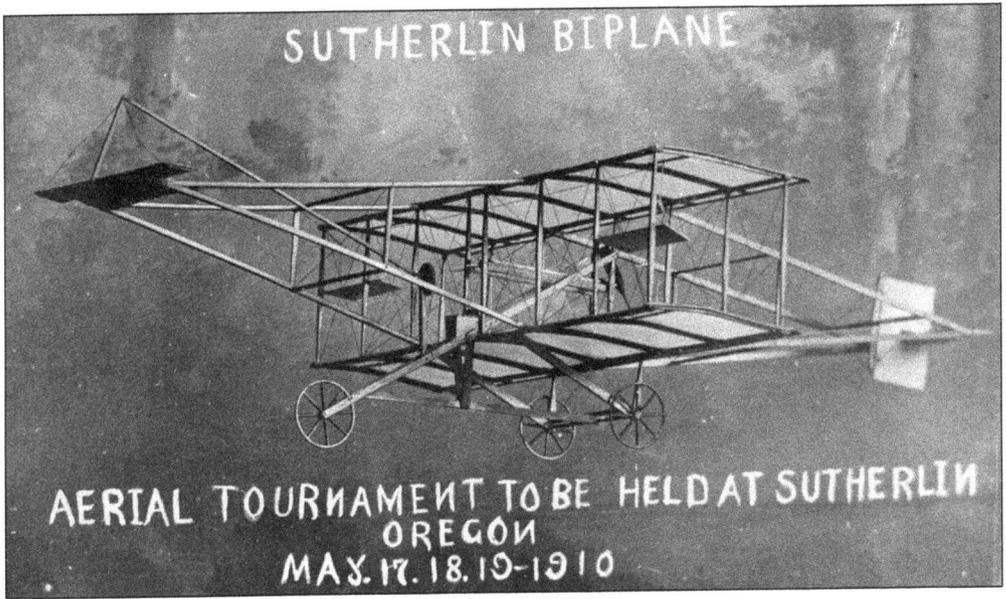

The advertisement above for the Sutherlin Aerial Tournament to be held at the Sutherlin airport on May 17 through 19, 1910, seems to contradict the image below that purports to show the first airplane flight in Sutherlin as occurring two years later. (Both DCM.)

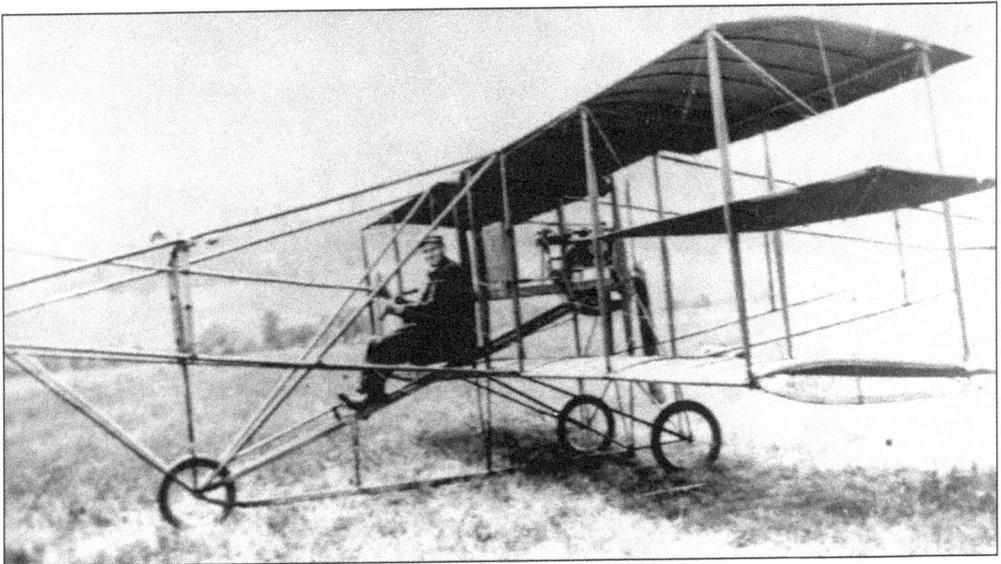

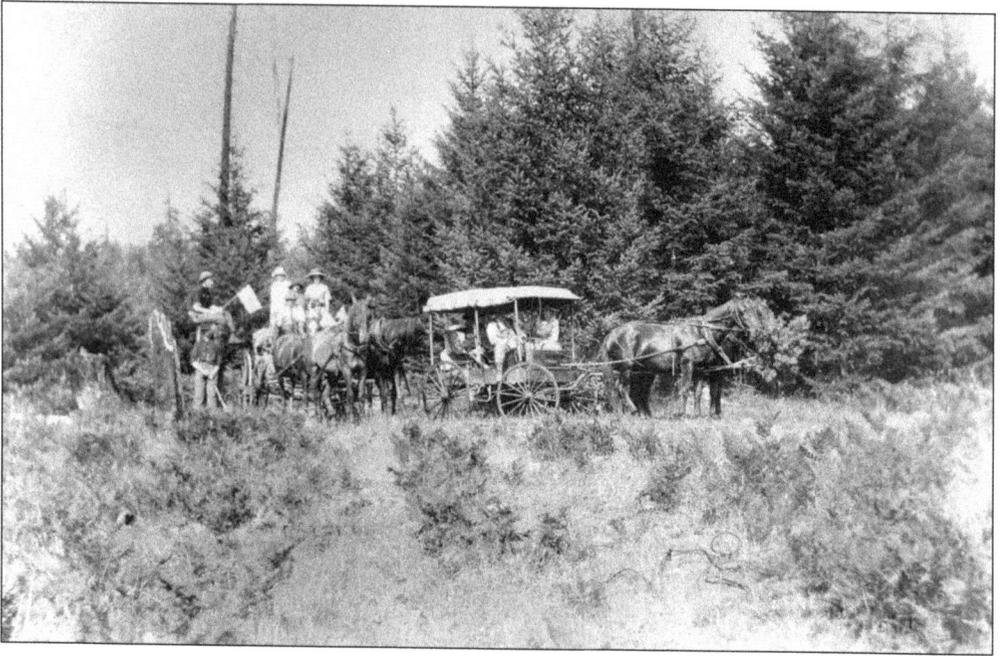

Picnics could be formal or informal, at home or at a special place. The group in the hack and wagon in the 1913 image above are obviously on their way to a special place—perhaps to Hall's picnic ground (as seen in the 1910 image below). Virgil Chenoweth watches from the stump while Giles Hunt stands below him. (Both DCM.)

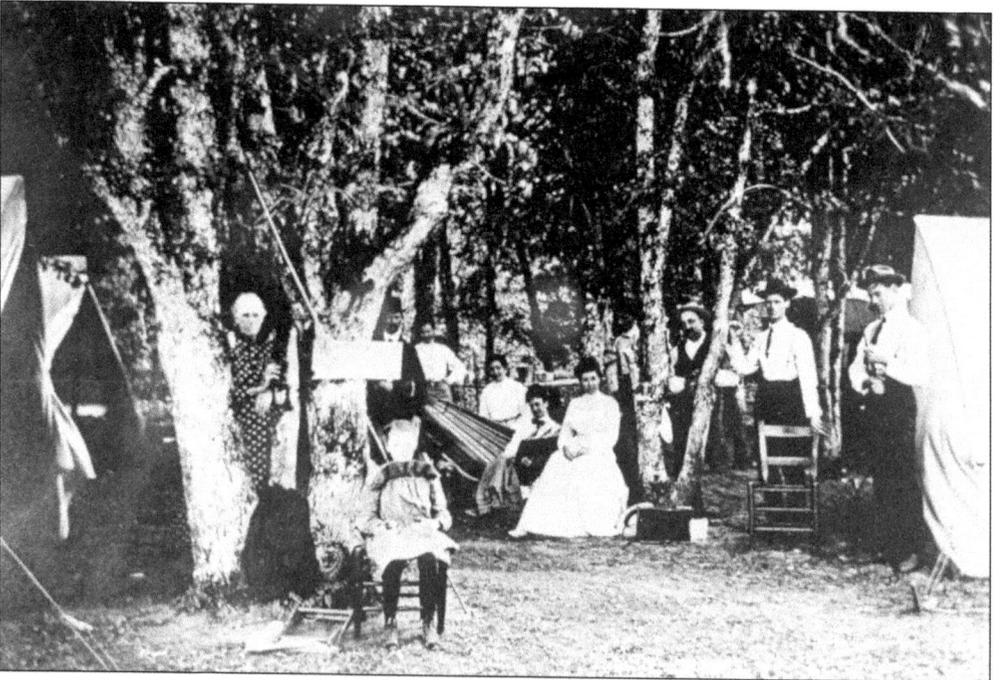

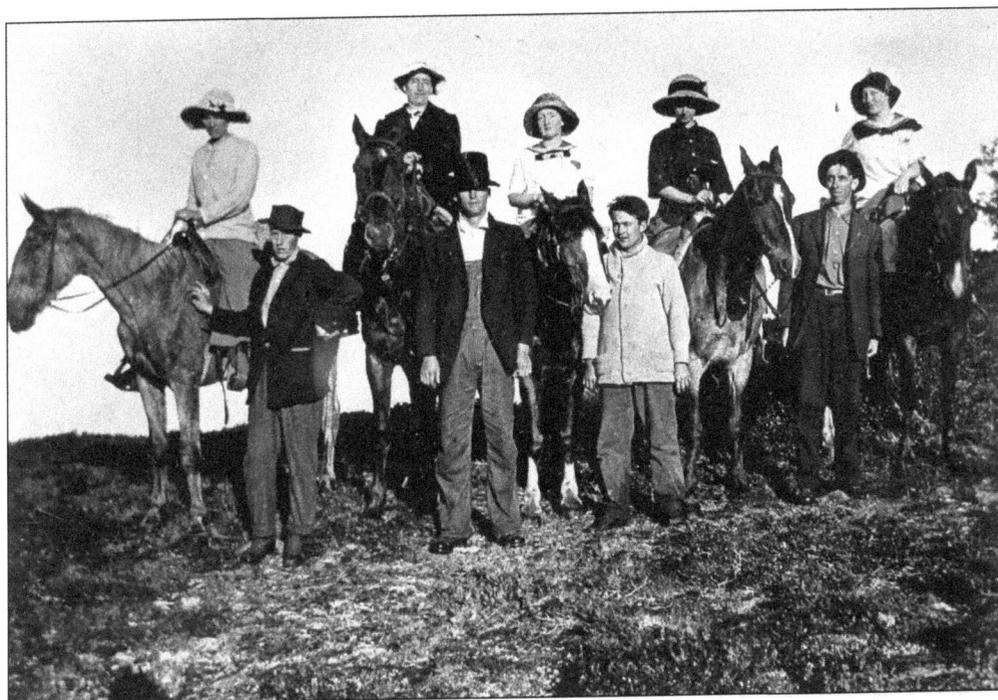

Above, a group
of riders scale
Mount Scott.
At right, the
Jaycettes enjoy
their 1955
picnic in the
woods. (Above,
DCM; right,
Kitty Murphy.)

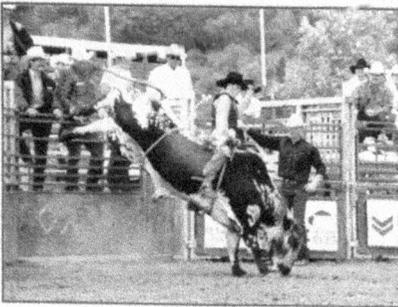

Sutherlin Stampede Assn. Inc.

P.O. Box 1211
Sutherlin, Oregon 96479

STOCK CONTRACTOR: Diamond X. Rodeo Co.

BULL: #41 Bucket of Blood
RIDER: Ben Tatone RESULTS: Bucked off (no score)
FROM: Roseburg, OR.

RODEO: Sutherlin Stampede Rodeo, Sutherlin, OR.

DATE: August 6th & 7th, 1994

PHOTO BY: Joe Lichtscheidl

The free Sutherlin Rodeo Stampede is held the third week in July. When the Timber Days celebration was discontinued, the stampede parade expanded to include the town's timber heritage (above). The flyer to the left is calling for entrants and support. (Above, Tricia Dias; left, Carol Swesso, S100.)

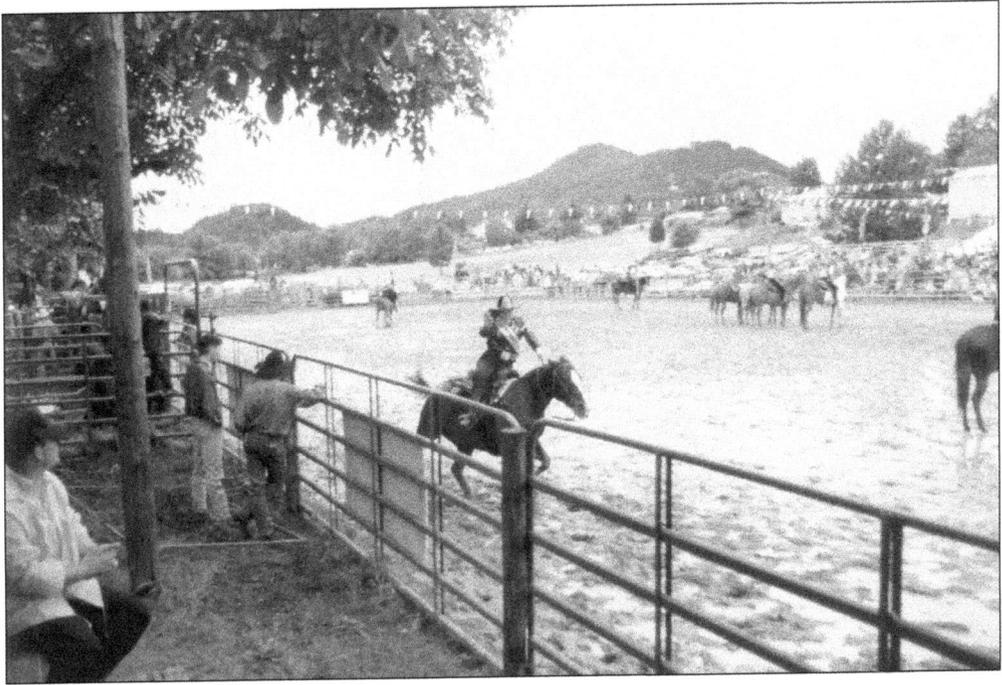

The 1993 Sutherlin Stampede Rodeo Queen, Shelley Hamilton, takes a spin around the arena. Below, the 2007 Sutherlin flag team springs into action. (Above, Sutherlin Stampede Rodeo; below, Tricia Dias.)

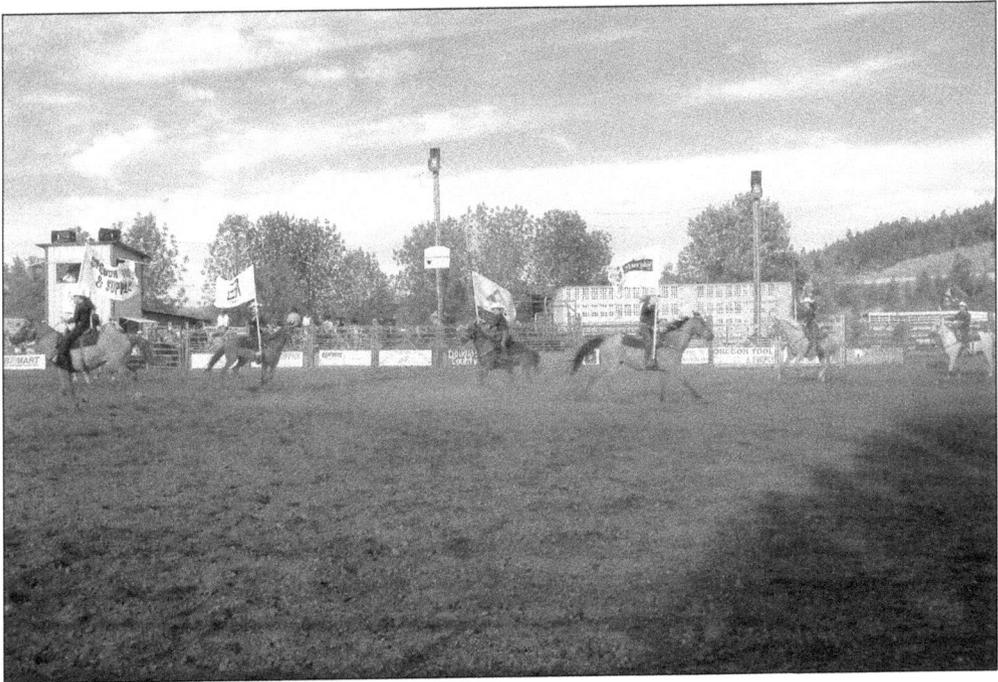

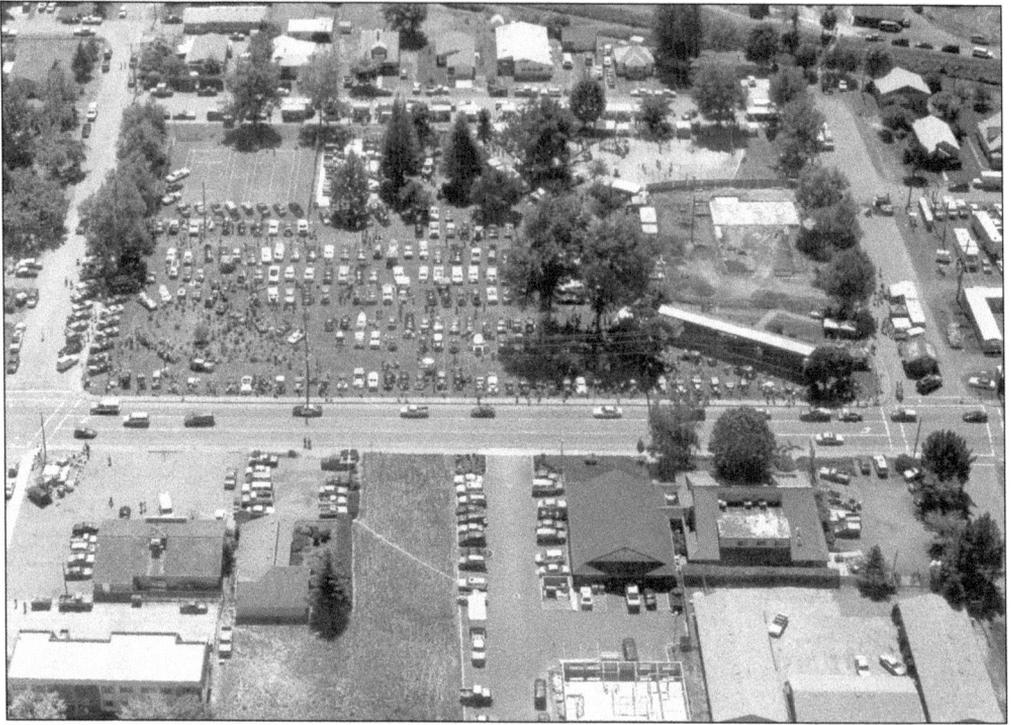

The annual Blackberry Festival is held the third weekend in August. The 1999 aerial shot (above) of Central Park and the Timber Days grounds also shows the empty space where the original clapboard community center was. It has since been replaced by an up-to-date handicap-accessible facility of which the city is deservedly proud. Below, the festival's BMX races are getting ready to start. (Both Bertha Egbert, S100.)

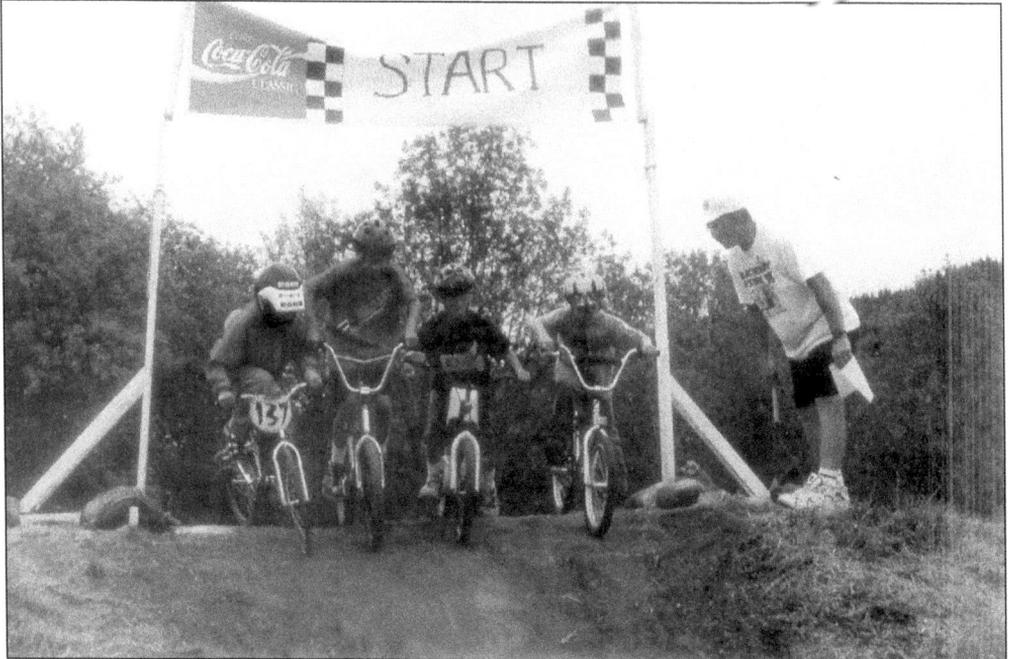

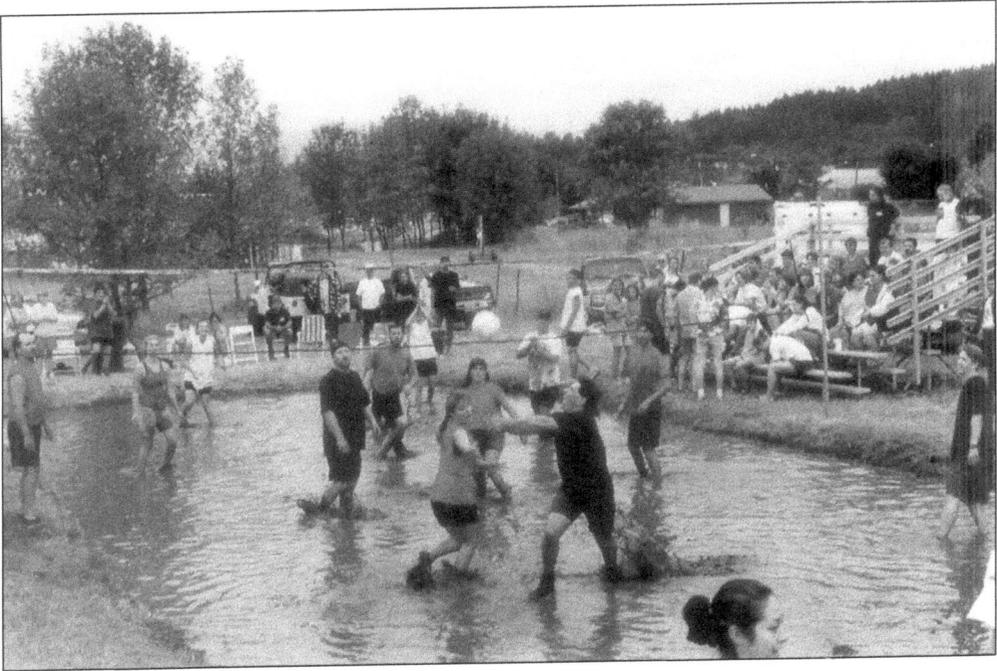

The mud volleyball game is in full swing on the old Timber Days grounds. West of town, races (below) were being held at the old Sutherlin airport, now the city's Industrial Park. (Both Bertha Egbert, S100.)

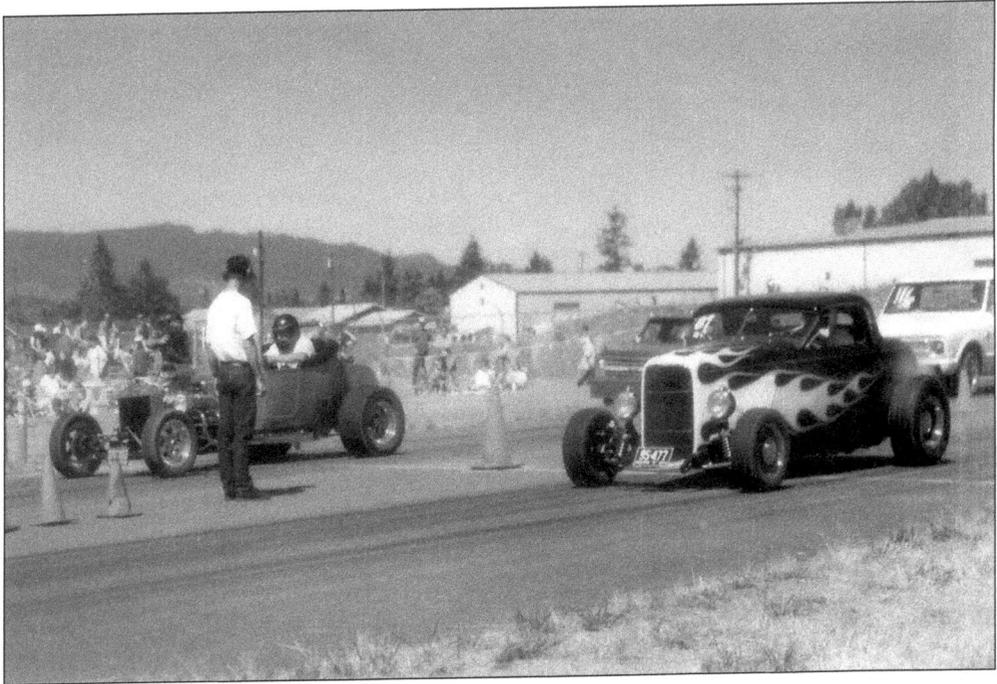

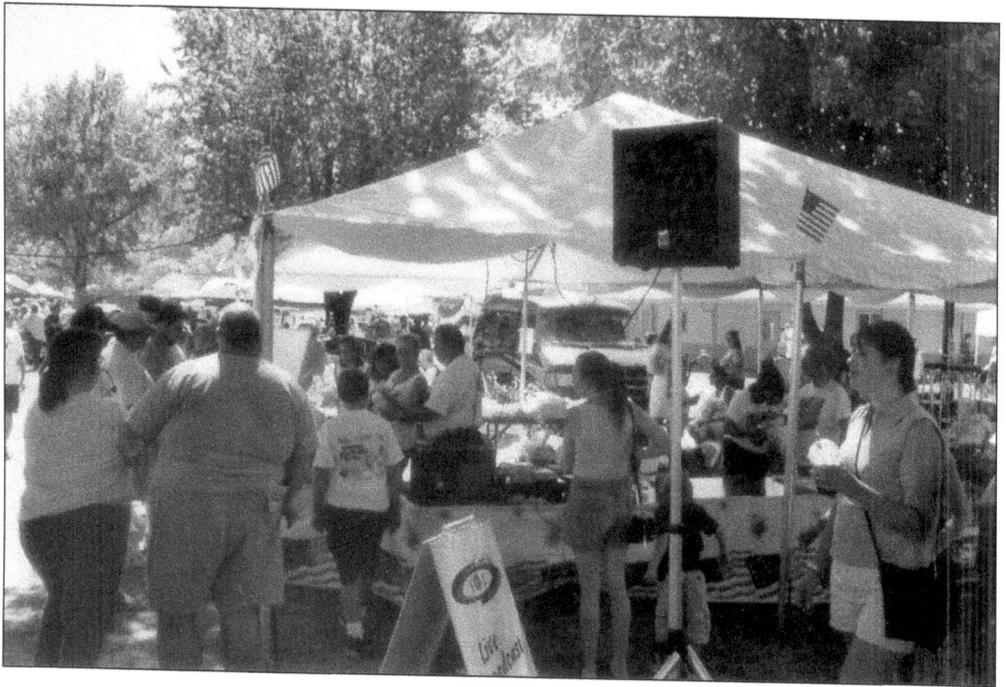

The Blackberry Festival is a grand time for one and all. There's a plethora of booths, including those for food, local craftsmen, artists, authors, service organizations, and local businesses. And there are contests galore. Two of the all-time favorites are the blackberry recipes and the chili cook-off. The main booth (above) and the awards booth (below) are always hopping. And there's always something to do or see for the crowd. (Both Bertha Egbert, S100.)

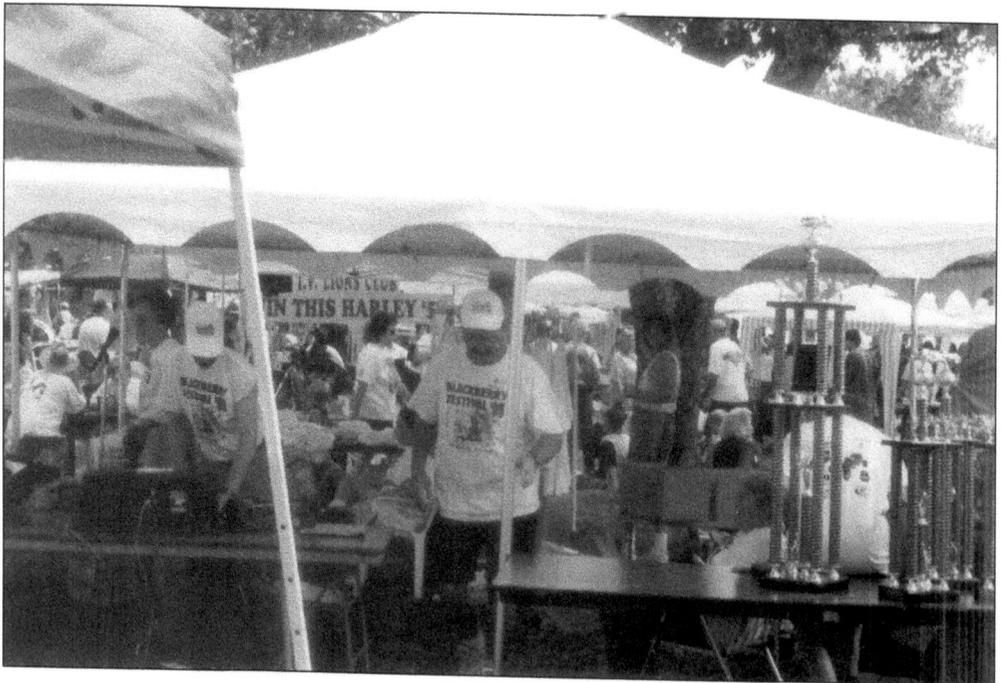

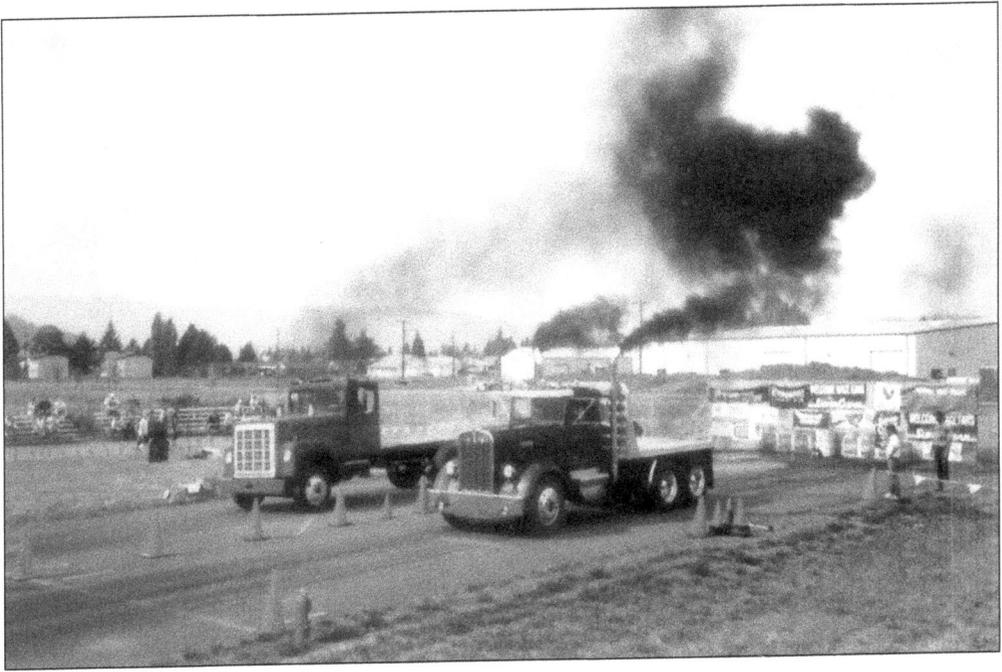

Above is a truck drag race. Below, visitors to the Oregon Lions health screening van get their health checked. (Above, Bertha Egbert, S100; below, Tricia Dias.)

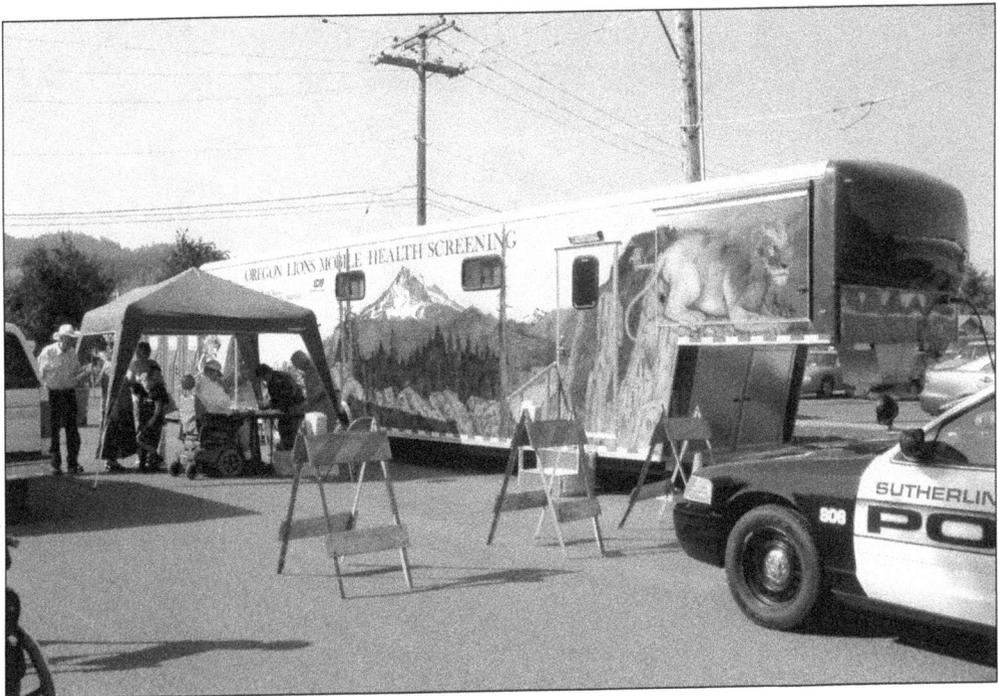

The Junior Chamber of Commerce, better known as the Jaycees, had a lovely booth for a mid-August event: a dunking booth. Here, John Murphy is about to be dunked. (Kitty Murphy.)

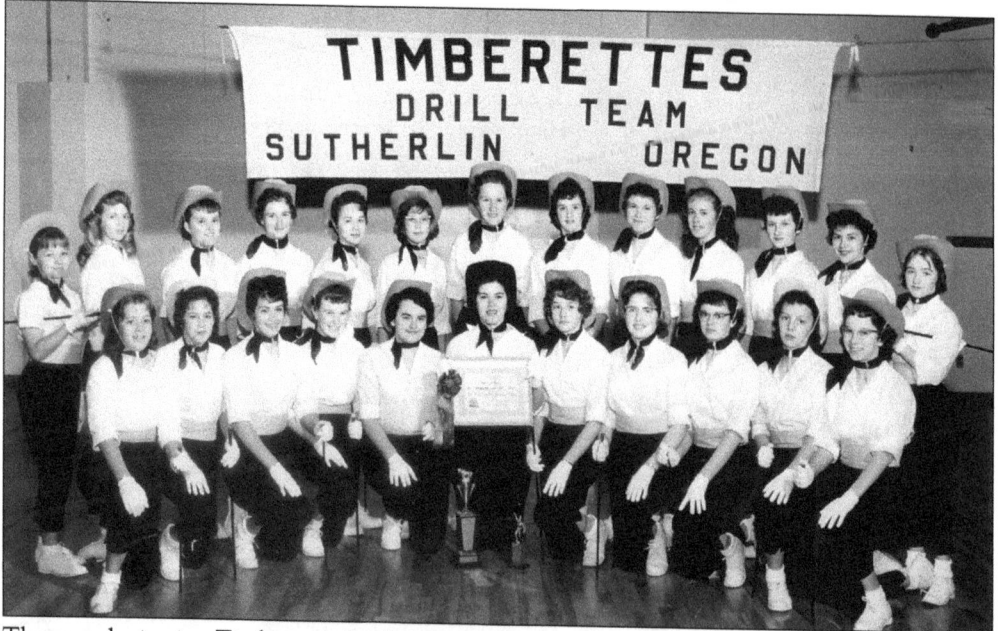

The award-winning Timberettes Drill Team (comprised of girls aged 12 through 18) consists of, from left to right, (first row) Charlene Forney, Susan Lane, Penny Rhondo, Linda Kenwisher, Lyndia Moodie, Nancy Moore, Mary McGinty, Frances Ahern, Diana King, Sandra Ashcraft, and Karen Chandler; (second row) Georgia Kremer, Cynthia Boyd, Edith Moodie, Kathy Hubbel, unidentified, Phyllis Bowler, Bonnie Findley, Nancy Brown, Barbara Henebeck, Jackie Frost, Susan Mayo, Janet Parazoo, and Kathy Norris. (Diana King Cox.)

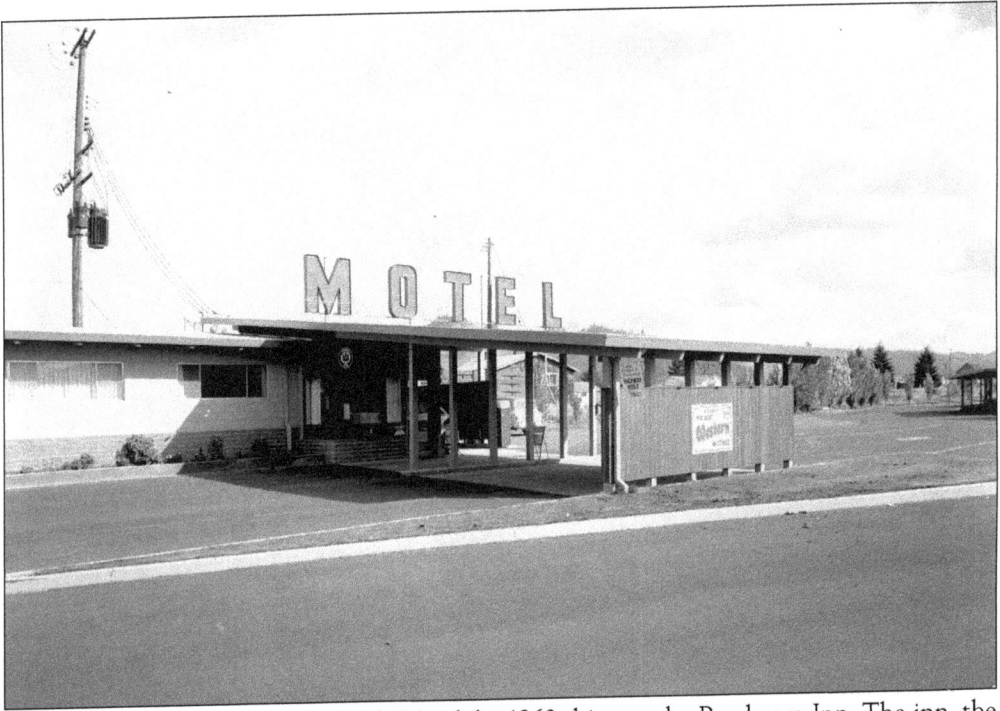

Originally known as the Four Winds Motel, by 1960 this was the Ponderosa Inn. The inn, the lounge (above, right), and the pool (below, center) were the centers of recreation for visitors and residents alike. The pool was available to the locals for an afternoon swim. In addition to a horseshoe of single-level rooms by the pool, there was a two-story section of rooms and a small gift shop and visitor's center just northeast of the office. (Both DCM.)

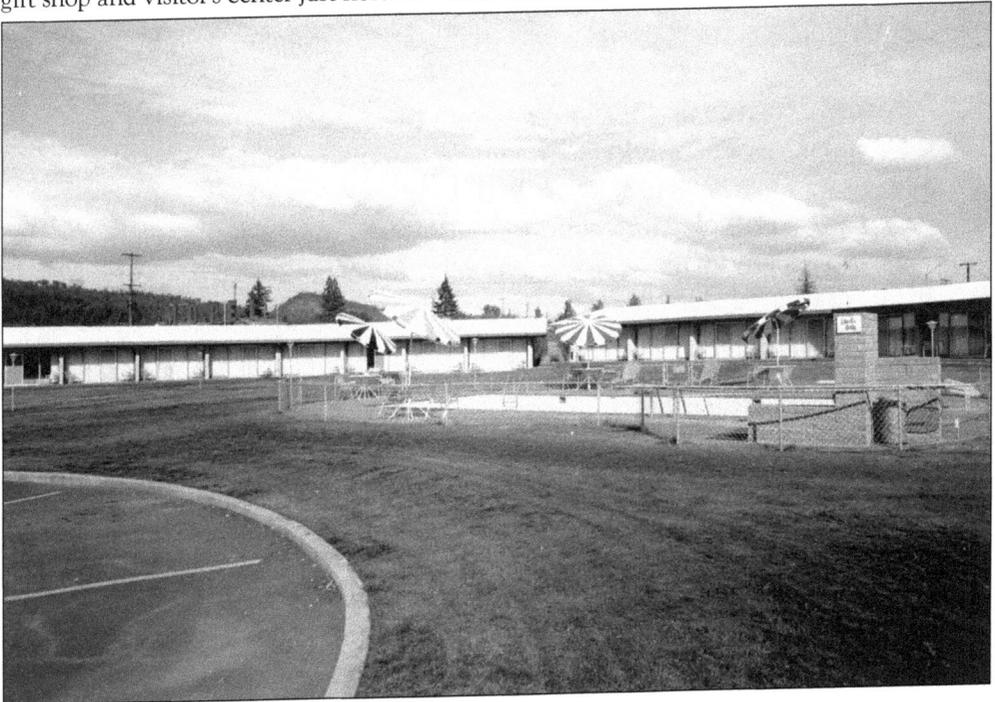

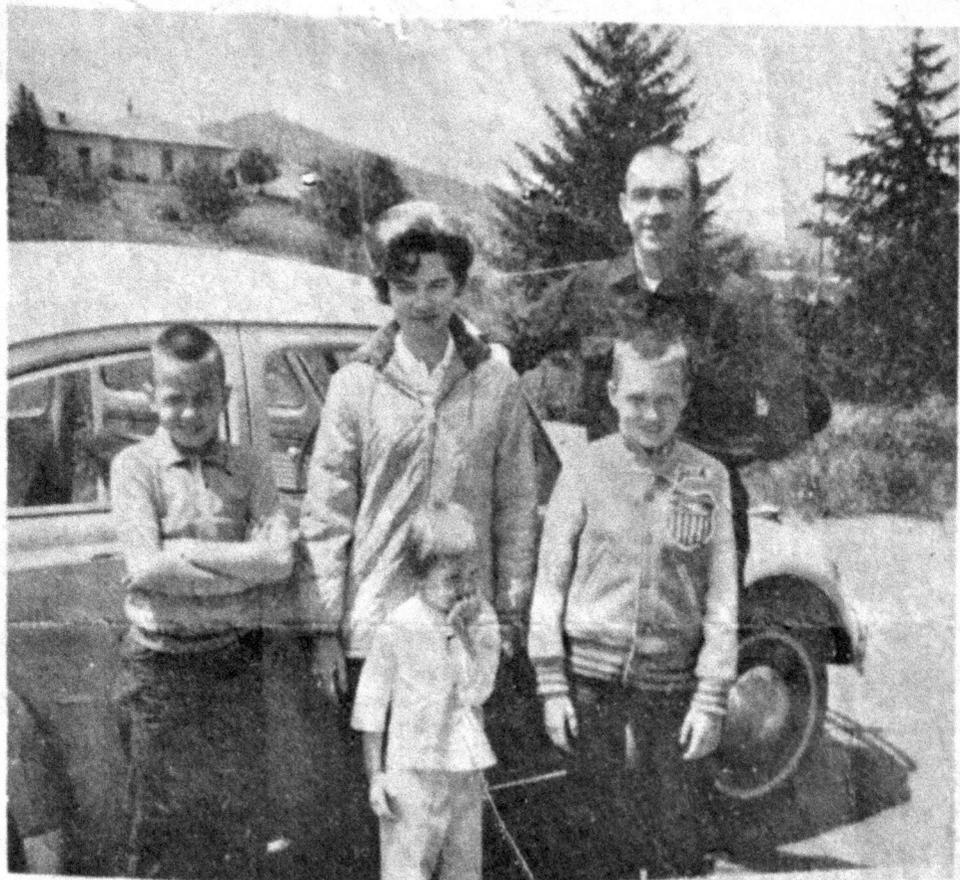

Mr. and Mrs. Jack Culver Jr., and their children, left to right, Jerry, Dana and Jacky, all loaded up and ready to leave for the New York World's Fair last Friday noon. Jack and Jacky will participate in log rolling exhibitions during the Fair this summer. They will be away nearly four months. Housing has been arranged for the family on the Fair grounds this summer and the two log rollers will give exhibitions on the spinning logs each day during the Fair. Mr. Culver is well known throughout the Northwest for his log rolling ability in competition in Timber Carnivals.

Why would the owner of a successful meat market want to participate in log rolling contests, let alone encourage his son to do so? Not only did Jack Culver and his son Jacky do it, but they even spent the entire summer at the New York World's Fair to do so. It was a family vacation. Both Jack and Jacky were well known in the northwest for their ability, as they routinely competed in timber carnivals throughout the region. (Dana Culver.)

Eight

A BOUNTIFUL VALLEY

The natural resources of Sutherlin Valley include timber, minerals, lakes, streams, ponds, and forests, to name a few. In the late 1800s, James Rice, W. H. Crouch, and friends discovered the Bonanza Mine. With the formation of the Sutherlin Quicksilver Mining, Refining and Development Company, the economy of Sutherlin improved. This mine began operating about 1932. The decline in prices caused its closure in 1961. During its operating life, it was the most productive mine in the state. It produced about 97 percent of the total mercury in the country.

The valley also has its share of nickel mines and placer gold (deposited gold obtained by panning, sluicing, or hydraulics as opposed to tunnel vein mines).

F. W. Mundy drilled for oil near Oakland as early as 1909. The oil well in Whitmore (now Union) Gap around the clay pit area went down 310 feet in July of that year. Core samples reportedly contained gas and oil indications. A bore was sunk to quite a depth, but drilling tools were lost in the hole, and the drillers moved to another site—Leeper Dome, one of the oddly shaped hills near Rochester bridge on the Calapooia in the western end of Sutherlin Valley. Other projects included the Sutherlin Oil and Development Company of 1923.

On Cooper Creek 2 miles east of the city, another earth-fill dam was constructed in 1960. This also was to be a source of irrigation water, a means of flood protection, and a recreation site. The Cooper Creek reservoir covers 160 acres and is channeled through a timber-covered chasm. It supplies fishing, wading, boating (including a launch site), drinking water, toilets, and picnic facilities through the County Park system. There is a year-round caretaker on site.

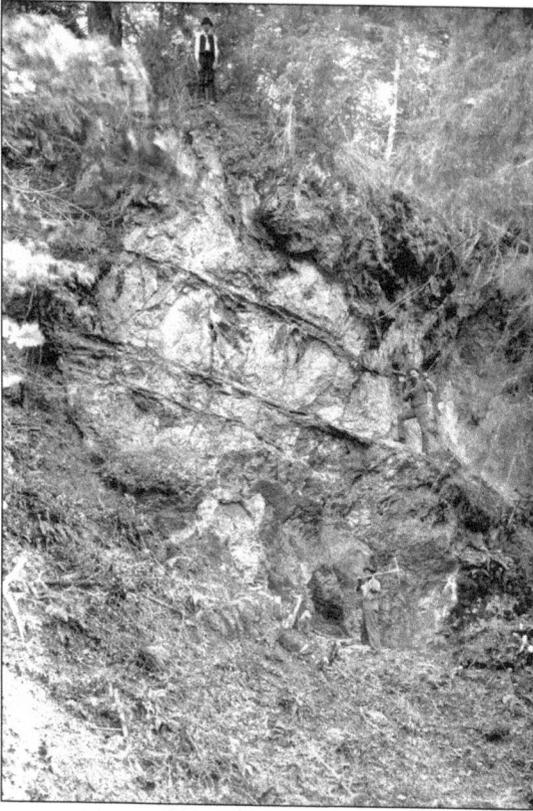

The most abundant deposits of mercury ore in Douglas County (which leads Oregon in the total amount of mercury mined) are found along the eastern edge of the Coast Range Province near Sutherlin (in Nonpareil). In the late 1800s, James Rice, W. H. Crouch, and friends discovered the Bonanza Mine. (Both DCM.)

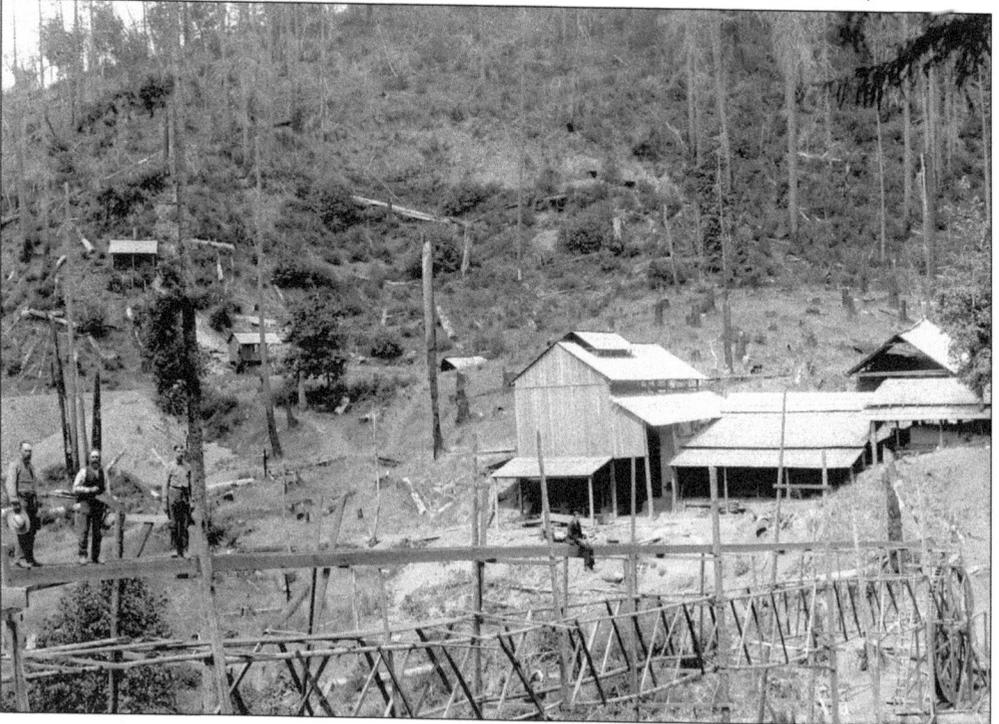

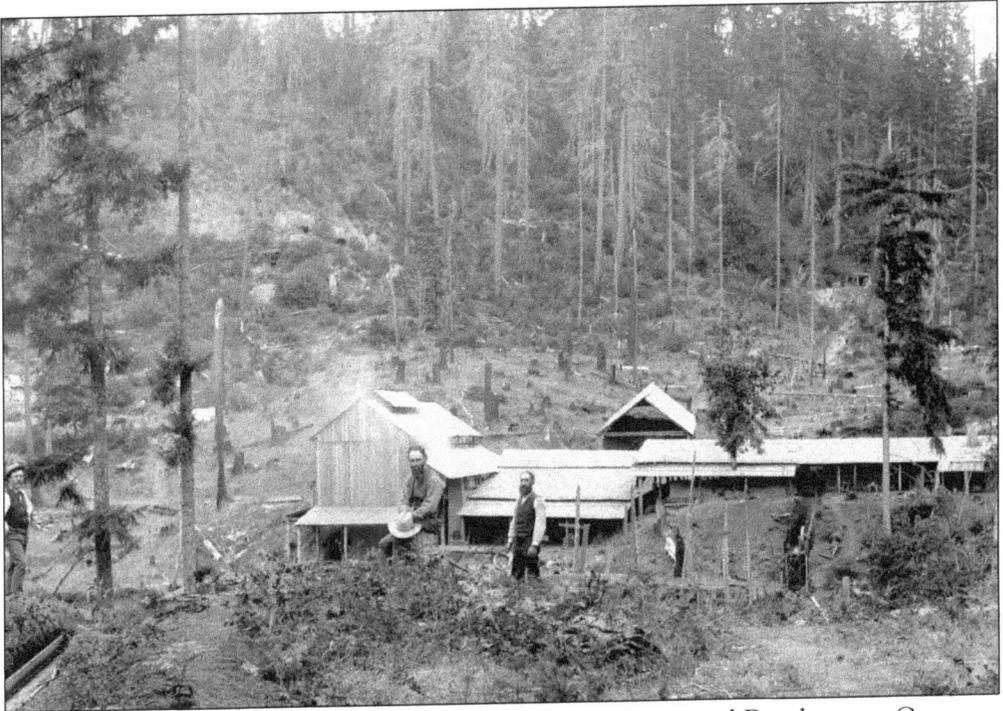

The formation of The Sutherlin Quicksilver Mining, Refining and Development Company helped to improve the economy of Sutherlin. The mine (seen below in 1960) began operating about 1932, but the decline in prices caused its closure in 1961. During its operating life it was the most productive mine in the state. It produced about 97 percent of the total mercury output in the country. (Both DCM.)

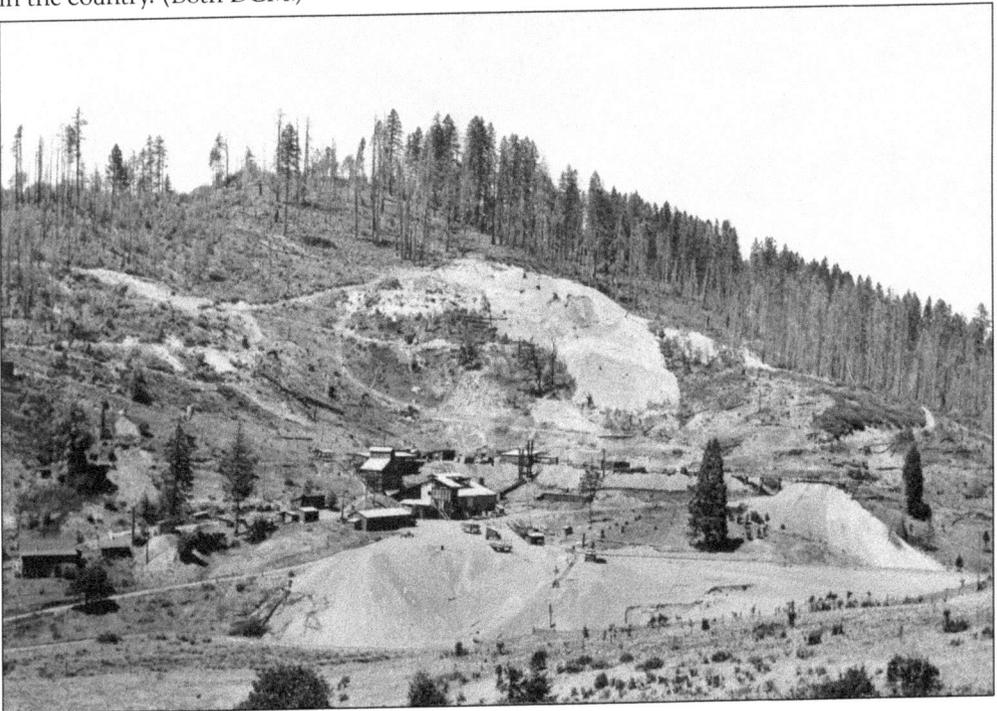

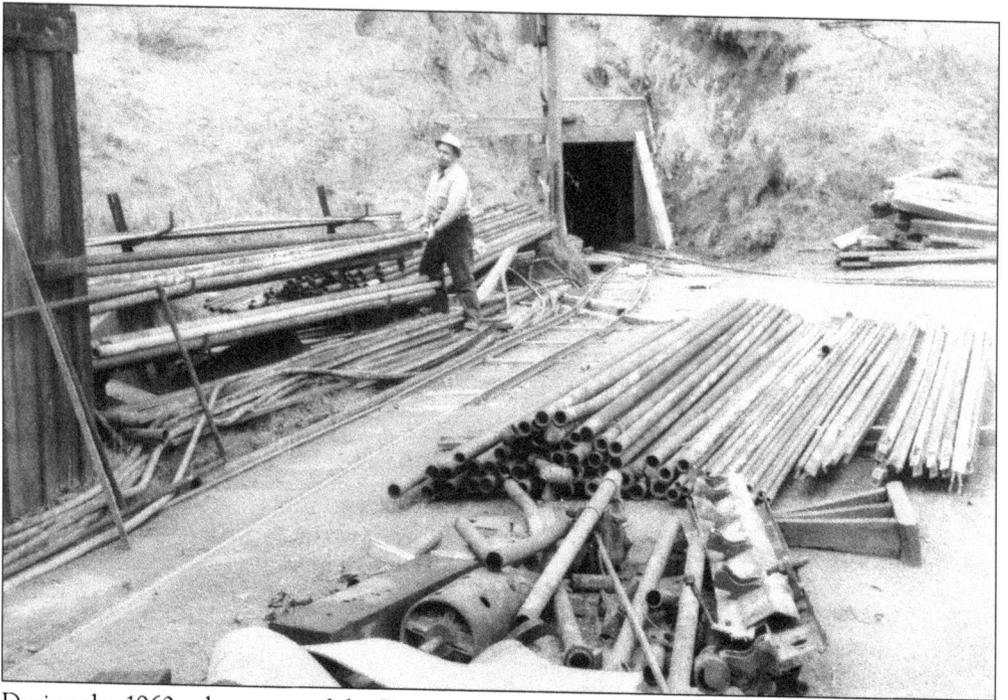

During the 1960s, the owner of the Bonanza Mine was Cliff Bryden and Associates. The 1961 photograph above shows the railroad tracks, tunnel entrance, rail stacks, piping, and machines. Below, the smelter, sawmill, blacksmith shop, waste dumps, and railroad tracks are visible. (Both DCM.)

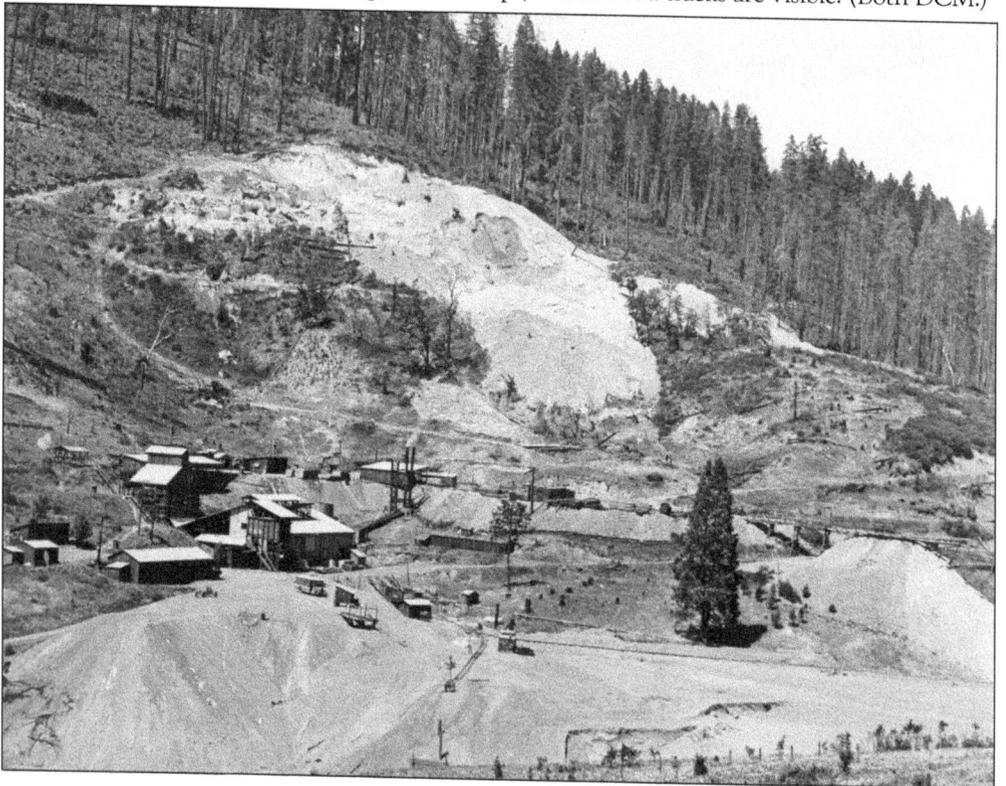

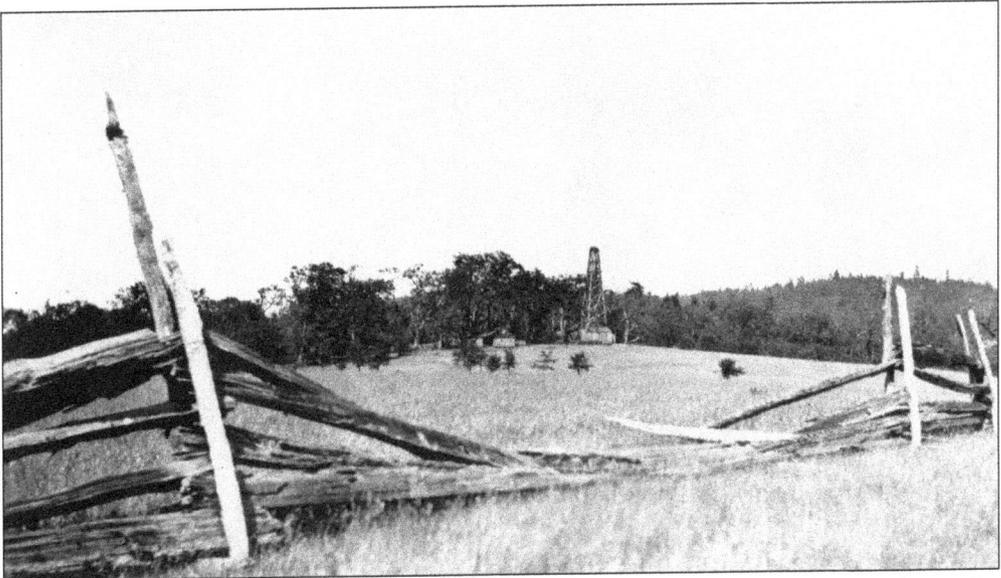

The oil well in this 1920 view of Leeper Dome, west of Sutherlin, can barely be seen due to the trees. Thankfully for the pristine nature of the valley, no oil was ever found there. (DCM.)

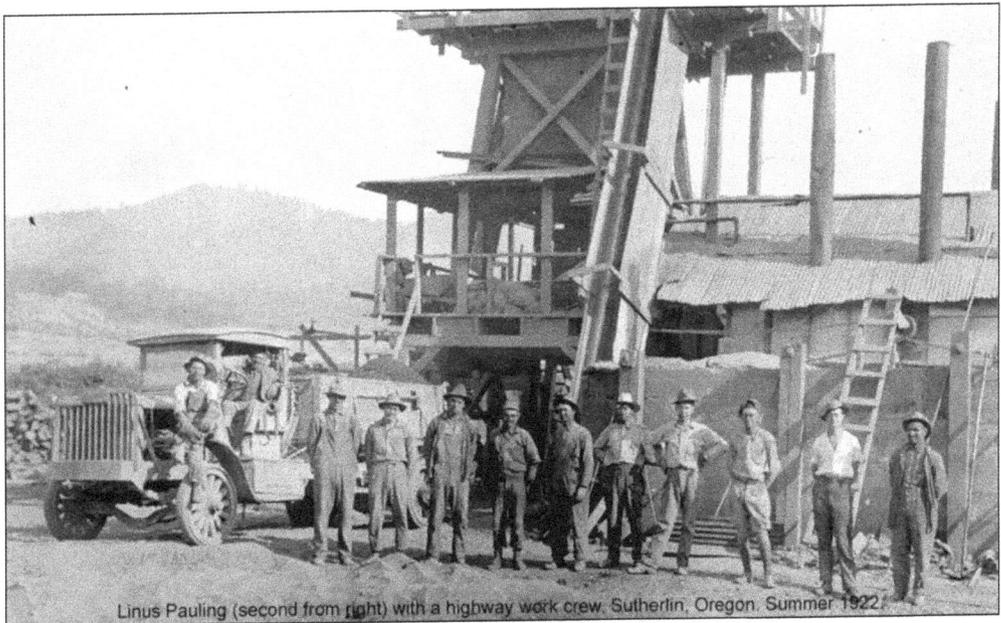

Linus Pauling (second from right) with a highway work crew, Sutherlin, Oregon. Summer 1922.

Born in Portland, Oregon, on February 28, 1901, Linus Pauling (second from right) had not yet won the 1954 Nobel Prize in chemistry, nor had he started the country taking megadoses of vitamin C. At this time, he was just another college student working summers as a member of the 1922 highway crew in Sutherlin. Did his time in this bountiful valley have anything to do with his future success? (S100.)

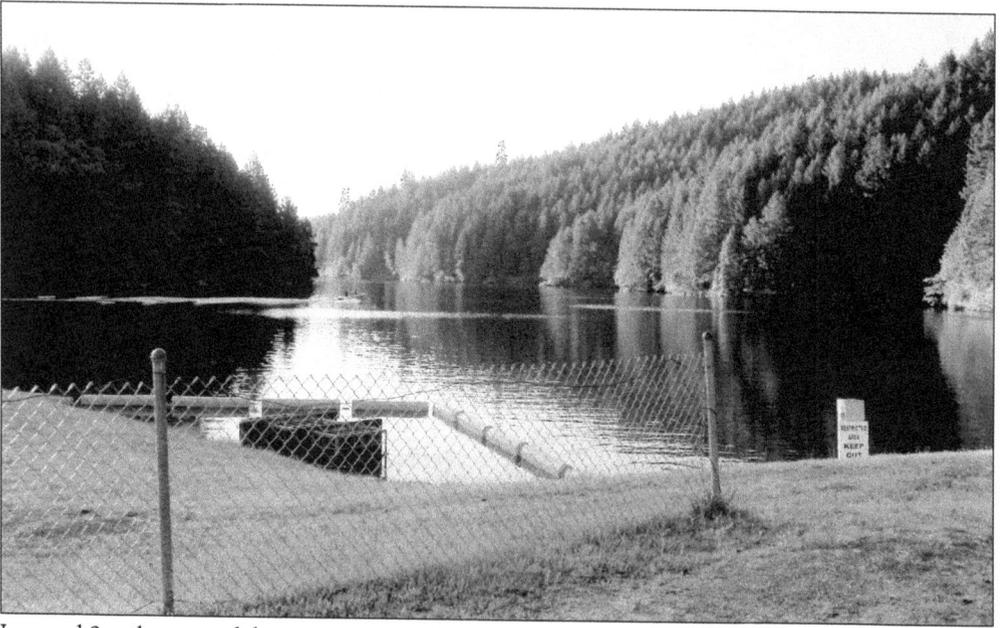

Located 2 miles east of the city, Cooper Creek County Park is a reservoir. Its earth-fill dam is a source of irrigation water, a means of flood protection, and a recreation site. It covers 160 acres and is channeled through a timber-covered chasm. Fishing, wading, and boating are some of the activities available. The amenities include drinking water, toilets, and picnic facilities. A year-round caretaker is on site. (Tricia Dias.)

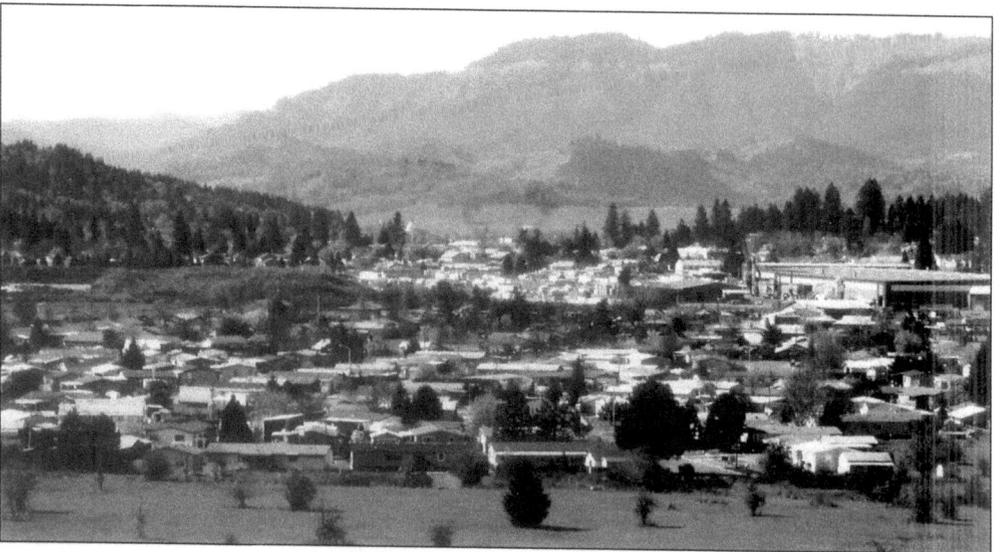

The flag is flying high and wide over exit 136 off Interstate 5. Sutherlin has come far, and the town has continued to grow west. It's a proud city. Its people are made up of pioneer descendents, retirees, the second- and third-generation early 1900 settlers, and those who came when timber was king. It's a relatively peaceful town with lots going on, especially in the summer. (Carol Swesso, S100.)

Nine

ORDINARY PEOPLE, EXTRAORDINARY LIVES

By definition, the early pioneers were not ordinary people. They were people with a dream and the determination to do what it took to see it through. Like fire strengthening steel, so too did hardship strengthen the will and character of the early settlers. These were thoroughly independent people whose descendents, for the most part, have inherited that trait and their tenacity.

Two of the Sutherlins were related by either blood or marriage to two of America's best-known patriots: Benjamin Franklin and Abraham Lincoln. John Hunt's nephew, C. Giles, was an early philanthropist.

Loring Wood was a visionary. He had a series of five dreams, from their details he constructed his fabulous archway. It became the entrance to his Oregon Woods Camp, which was Oregon's first motel. The camp was formerly located on old Highway 99 at what is now exit 135 off Interstate 5. Within the compound, Wood erected the tallest teepee in existence as a gift shop. He also built exact replicas of the U.S.S. *Constitution*, affectionately called "Old Ironsides," and the *Mayflower*, among other items. He took these on tour to California. The ships went as far as Washington, D.C.

Sutherlin produced many lovely ladies, among them a winner of the Miss Oregon contest who went on to compete for the Miss America title.

The town has been blessed with dedicated police and fire personnel. The police department consists of both unpaid reservists and full-time, paid officers. It has grown from a force of two to its current strength of 13 certified officers.

Currently the Sutherlin Fire Department is run by Douglas County Fire District No. 2, which also covers the Calapooia station on Highway 138 east of Interstate 5.

The Fair Oaks Rural Fire Department, east of the city of Sutherlin, is entirely composed of unpaid volunteers. When the alarm rings, everything stops as they prepare for the unknown. Their job is dangerous, but they are dedicated.

These are just some of the people who make up Sutherlin's past, present, and future.

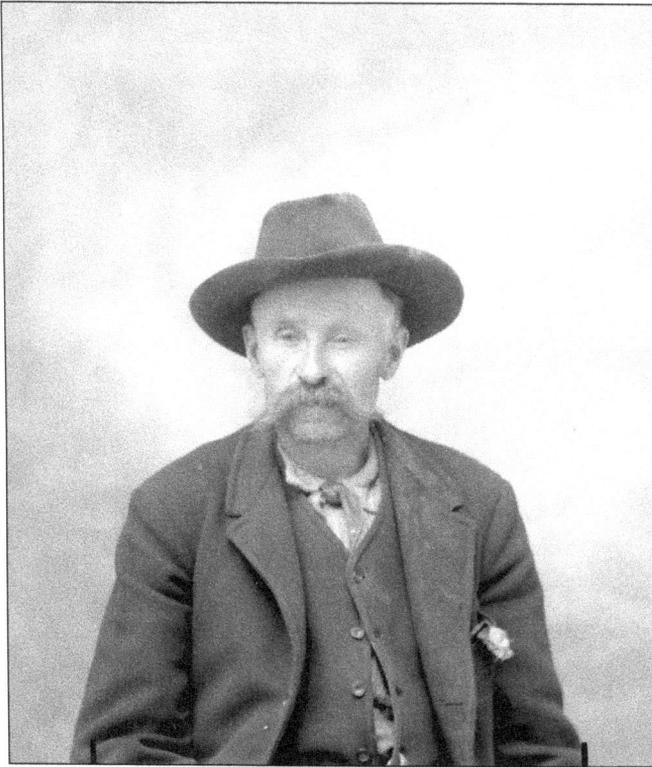

John Franklin Sutherlin's father, Fendel Sutherland, changed the family name to Sutherlin. He was Benjamin Franklin's first cousin. (DCM.)

C. Giles Hunt, who established a trust fund to help nonprofit organizations, is shown here, seated in a rocker before the fireplace in his log house that has since burned down. (DCM.)

110

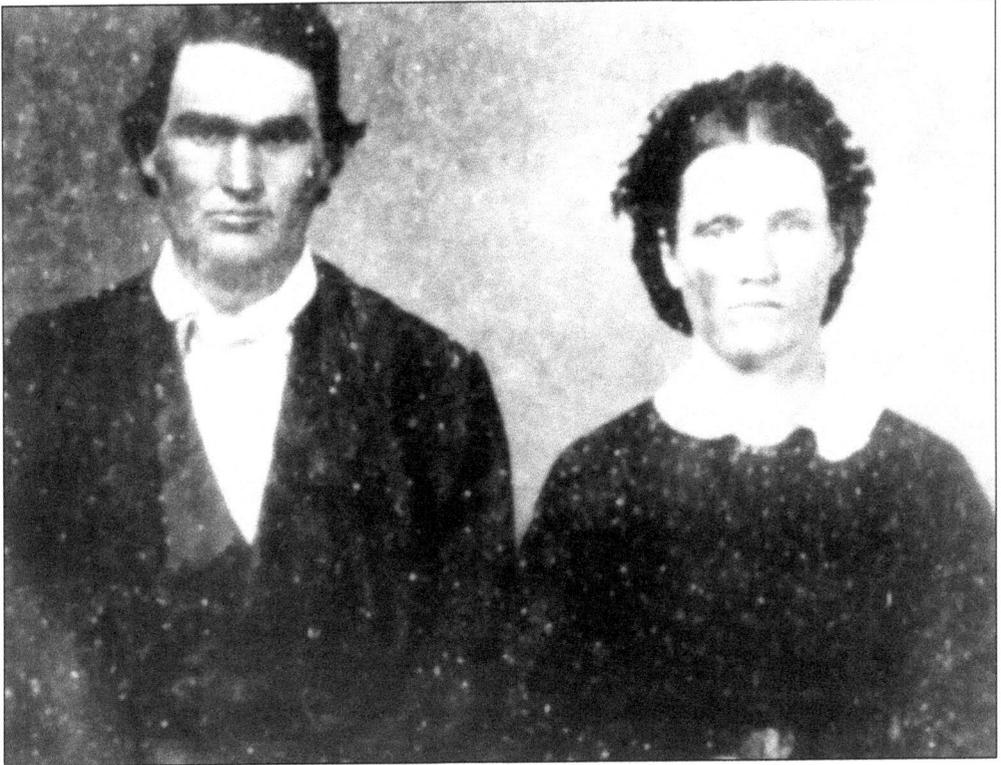

John P. Sutherlin (son of John Franklin)
married Polly Anne Brown (above). Polly's
mother, Sarah Hanks Brown, was Nancy
Hanks Lincoln's niece and Abraham
Lincoln's (right) first cousin. If Mary
Todd Lincoln hadn't refused to move any
farther west, Lincoln might have become
governor of the Oregon Territory; instead,
he became the 16th president. John P.,
Polly Brown Sutherlin Eubanks, and
two of their young children are buried
in the Sutherlin family plot, which is
now part of the Valley View Cemetery.
(Both Ronald and Loretta Quant.)

William Andrew Taylor Lucy Jane Sutherlin
b. Nov. 24, 1856 d. Oct. 5, 1948 b. Feb. 12, 1861 d. Oct. 3, 1948
m. Nov. 7, 1880 Lincoln's 2nd cousin

Lucy Jane Sutherlin (Lincoln's second cousin) married William Andrew Taylor (above left) on November 7, 1880. Their daughter, Jessica Amy (Lincoln's third cousin), married Seymore Clark Quant (below) on June 24, 1903. (Both Quant family.)

Fourth cousin, Andrew Clark Quant, married Faye McCarty (second and third from the left in the back row, above) on August 30, 1952. The little boy in front with his hand on his head is Ronald Quant. Ron and Loretta Quant and their daughter and granddaughters are all genealogy buffs. The photograph below was taken on June 22, 2010, at the Sutherlin Visitor's Center. From left to right are (first row) K'Lynn Brentano and her parents, Loretta and Ronald Quant; (second row) granddaughters Nicole (age 15), Stephanie (age 19), and Jaimee (age 17). (Above, Quant family; below, Tricia Dias.)

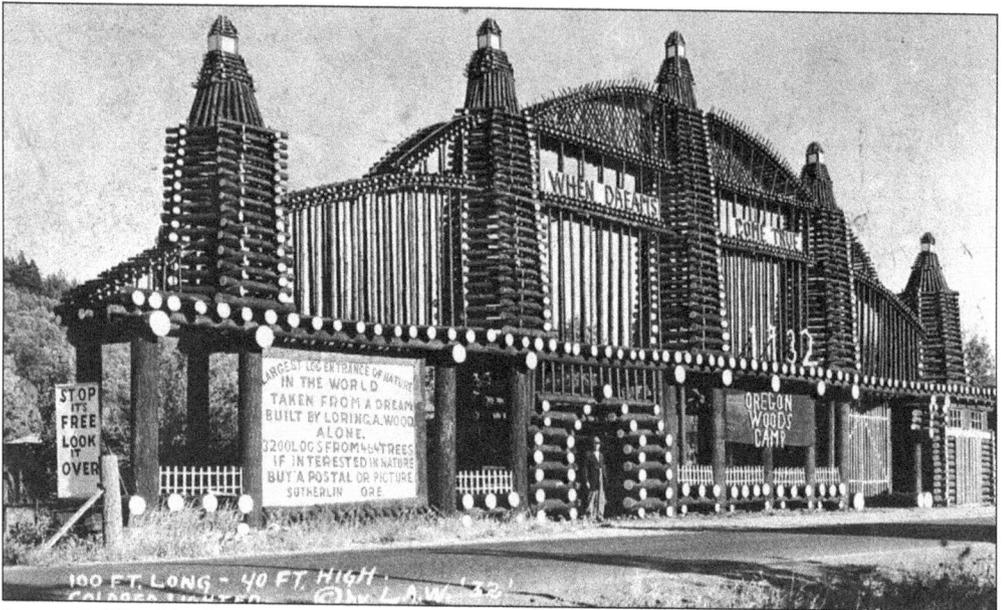

Loring A. Wood built a 100-foot-long, 40-foot-wide archway (above) using 3,200 logs from 464 trees after a series of dreams. It became the entrance to the Oregon Woods Camp. Within the compound, he erected the tallest teepee in existence, at 110 feet, as a gift shop (below). (Both DCM.)

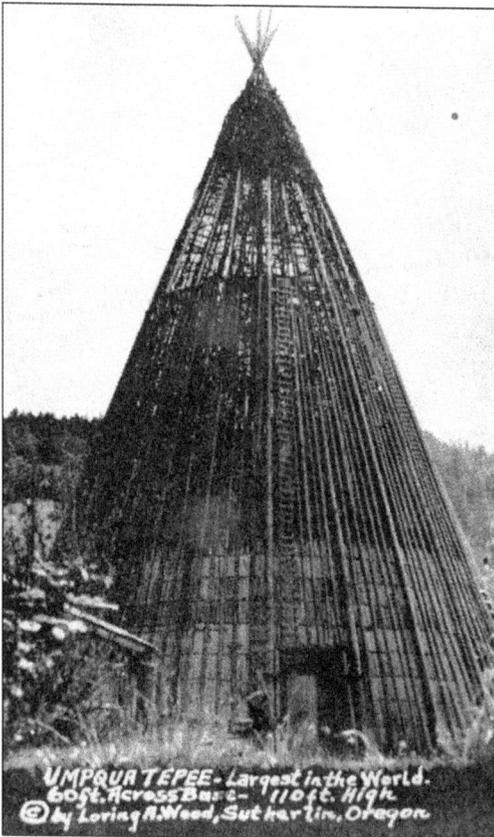

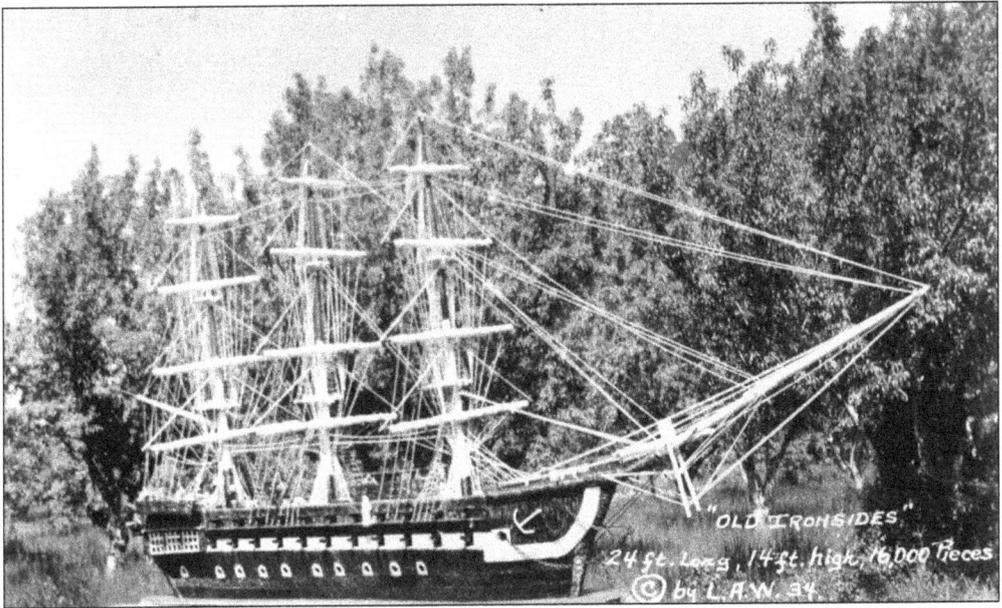

When the U.S. Navy's Old Ironsides was shown in Portland in the summer of 1934, Loring A. Wood got permission to go aboard. His model (above) used 14 different types and more than 20,000 pieces of wood. From a picture of the *Mayflower*, Wood built a 5-foot by 4-foot model (below) using a total of 1,317 ash, myrtle, and wild grape pieces in the hull and sails, in only 10 days. His models and replicas, modeled and fashioned without specifications, caused Wood to be acclaimed by Ripley and others as the country's most unique artistic genius. (Above, DCM; below, Wayne Hall.)

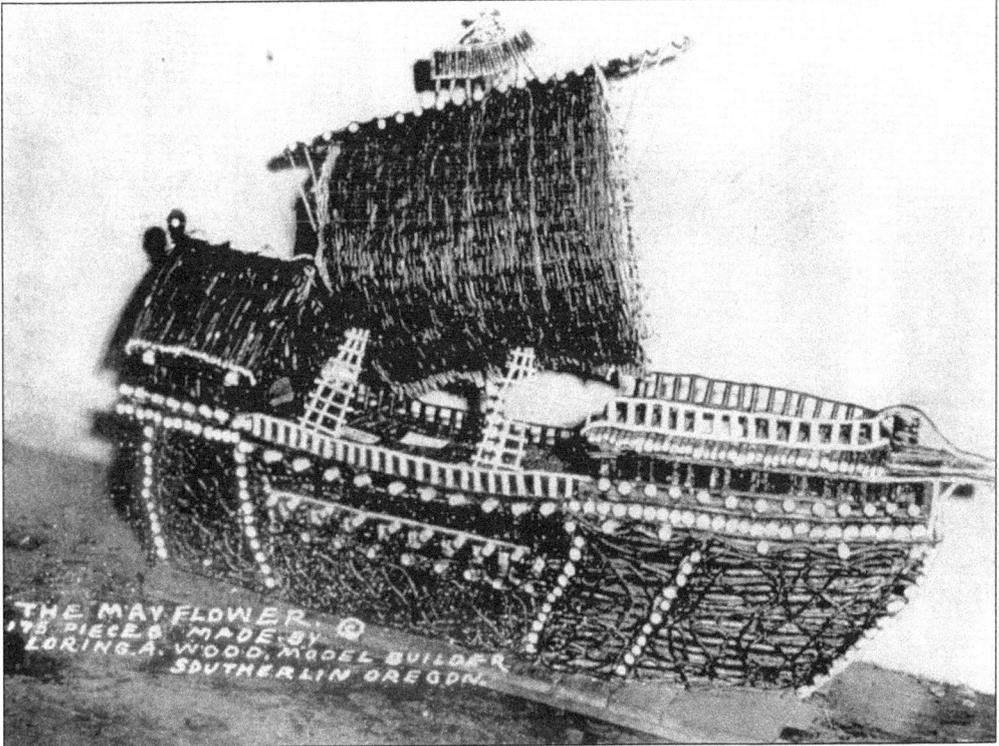

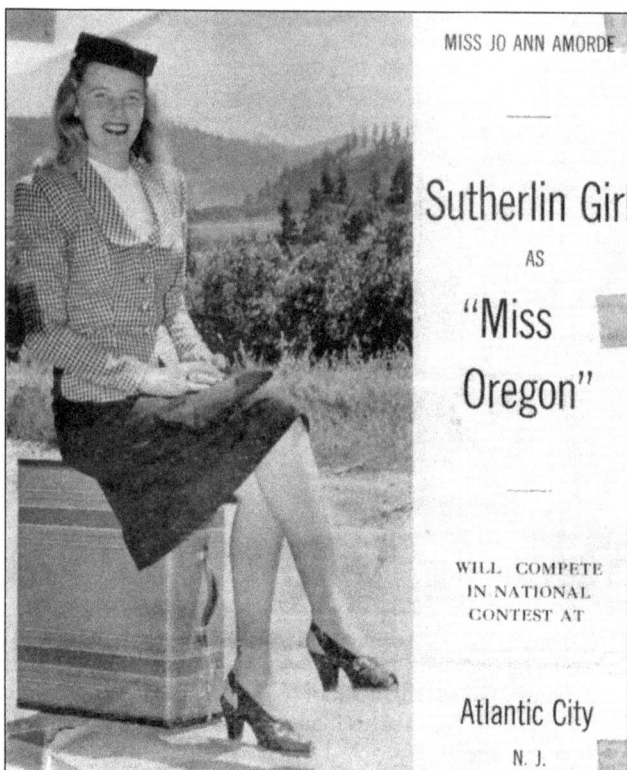

MISS JO ANN AMORDE

Sutherlin Gir

AS

"Miss

Oregon"

WILL COMPETE
IN NATIONAL
CONTEST AT

Atlantic City

N. J.

Miss Jo Ann Amorde of Sutherlin was crowned Miss Oregon and is pictured here on her way to the Miss America pageant in Atlantic City, New Jersey. (Joyce Botticchio.)

This group of Sutherlin ladies gathered together in 1910. The occasion was Donald Wood's birthday. Pictured are, from left to right, (first row) Chris Backman, Harriet Riggs, and unidentified; (second row) Mrs. Merriman, Donald Woods (in his highchair), Mrs. Comstock, and Mrs. Jesse Cooper; (third row) Mrs. Meecham, Mrs. Will Haynor (whose husband was the first newspaper editor), Mrs. Wood, Mrs. Weaver (the minister's wife), and two unidentified; (fourth row) Grandma French, unidentified, Mrs. Parker, and four unidentified. (DCM.)

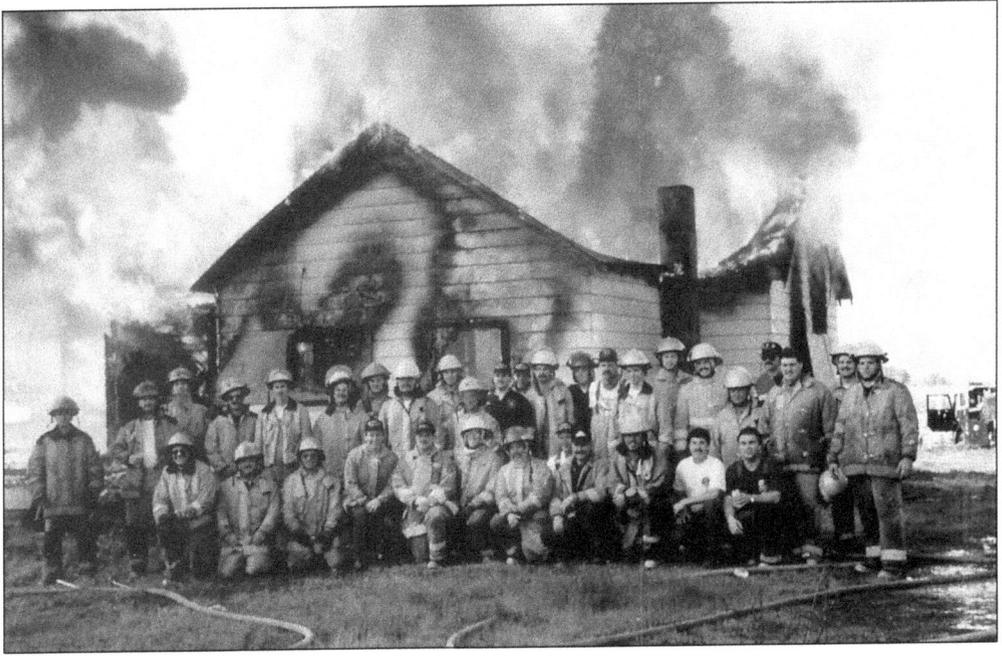

The Sutherlin Fire Department is seen above in a training exercise when it was still being employed by the city. The Fair Oaks Rural Volunteer Fire Department (shown below in 1977) is still an independent all-volunteer organization. (Both Sutherlin Fire Department.)

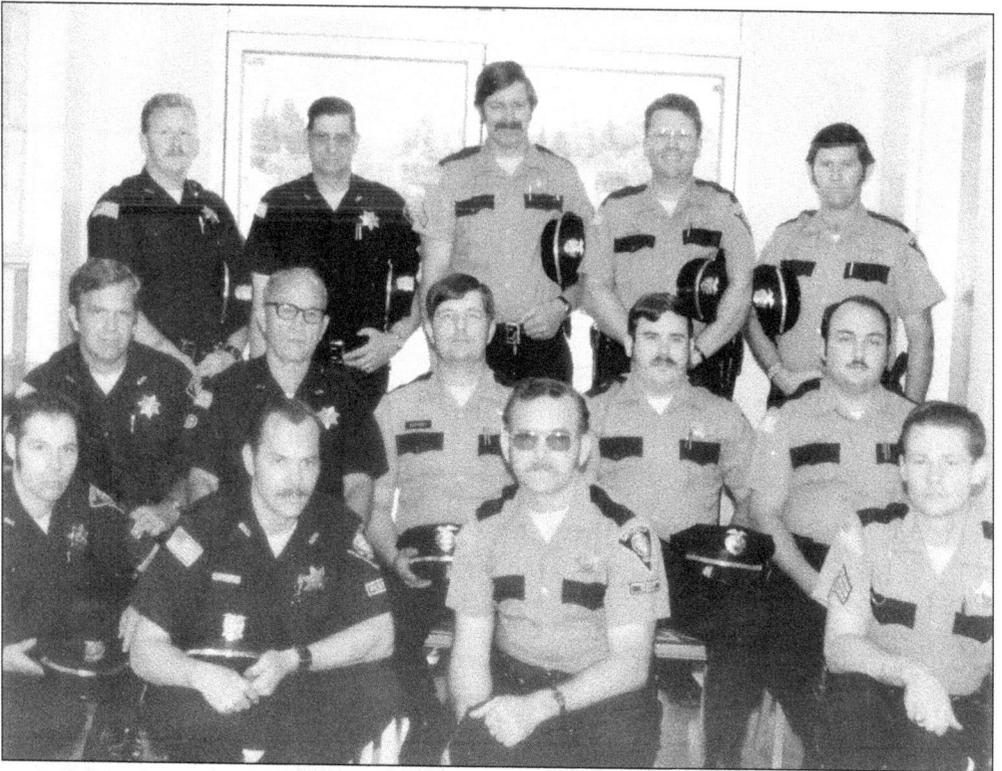

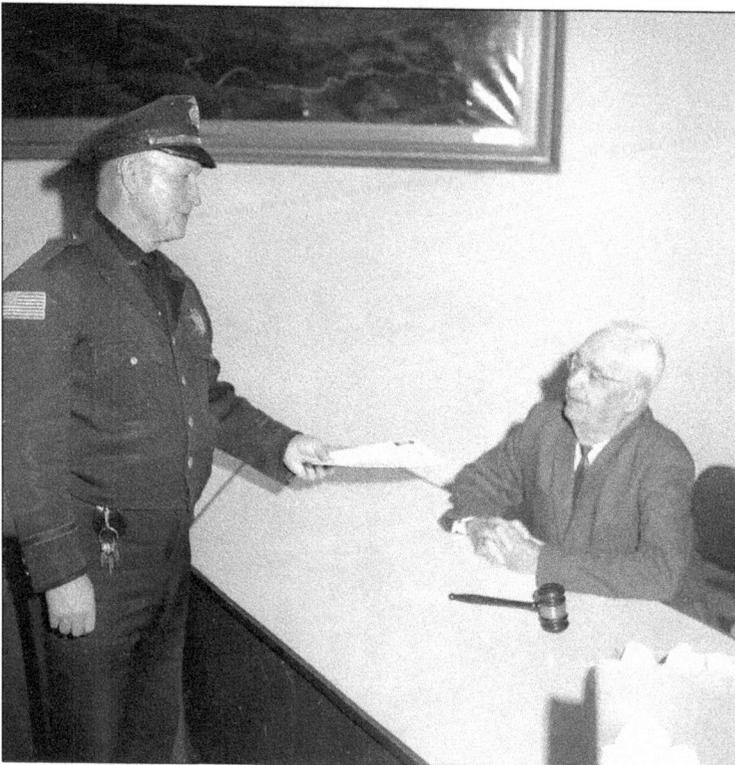

The 1970 Sutherlin Police Force, both reserve and full-time, is shown above. At left, Police chief Cecil Holley explains something to Judge Bill Crowell. At the time, Judge Crowell owned one of the town's liquor stores, and on Monday mornings was often trying some of his best customers. (Both Pauline Wells Holley.)

Ten

THEN AND NOW

When researching history, the biggest problem is visualizing what the town looked like then, when one can only see what it looks like now. Many fascinating places that were integral to the life and society of the time being studied no longer exist or were moved.

Sutherlin is very lucky to have the historical State Street bank to use as a reference for so many of the vintage images of the old business district. In addition, because of the narrowness of the valley, the unchanging contours of the valley's prominent hills can also be used to locate where things were. It's a treasure hunt that delights history buffs and interested newcomers.

Sutherlin is also blessed with many nonagenarians whose memories fill the gaps between then and now. So, sit back and enjoy.

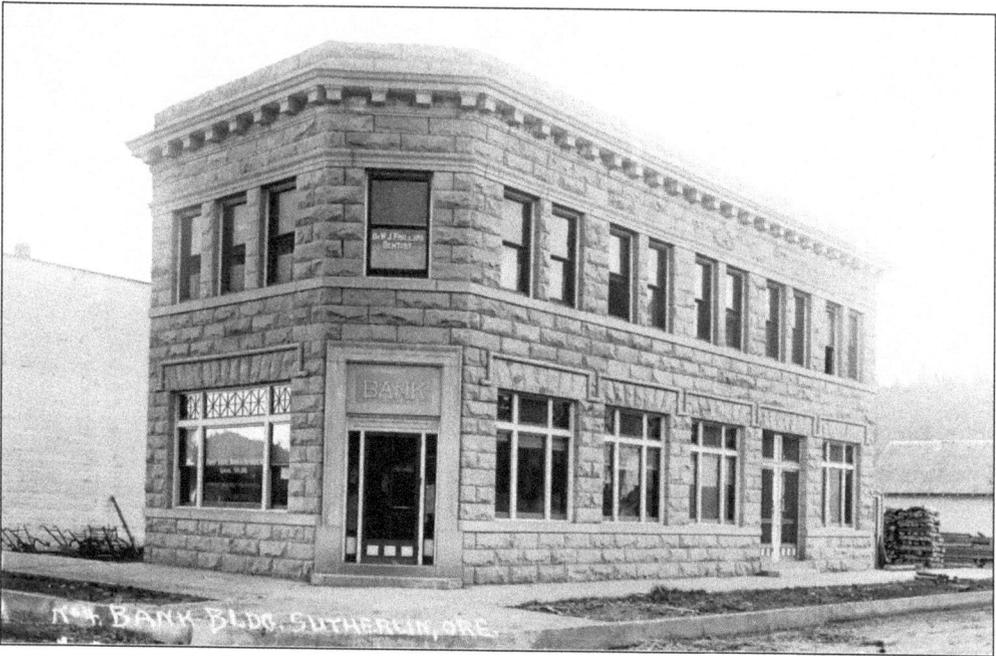

Constructed in 1910 at a cost of $10,000, this was among the first of 10 banks in Douglas County. The quarried stone was loaded on flatcars, transported to Sutherlin, and transferred to a temporary spur laid on Central Avenue from the main line to the construction site. Because a locomotive was not permitted to travel to the bank's location, a team of horses hauled the flatcars. Above is as an early postcard of the bank, and below is how that corner looks in 2010. (Above, DCM; below, Carol Swesso, S100.)

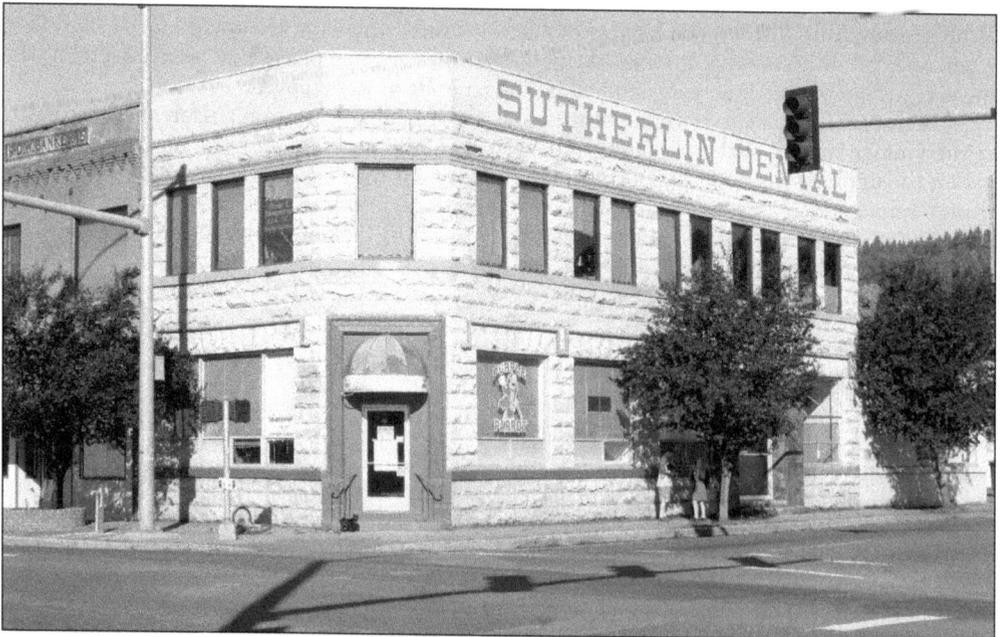

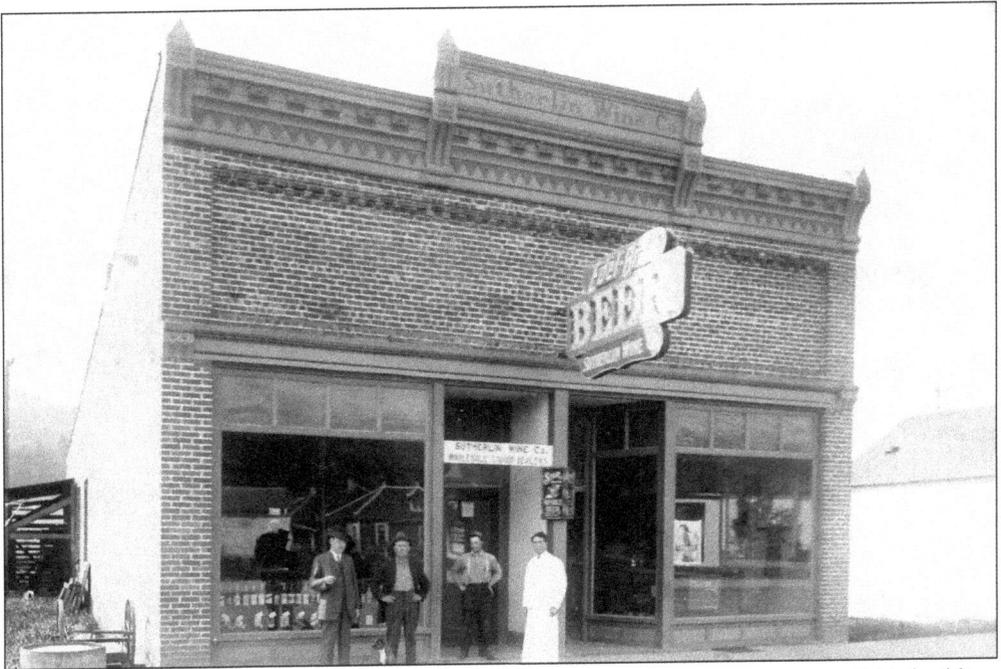

It would seem that the valley has been in the wine business for quite some time. This building has gone through many incarnations; the last one, Vera's Lounge, has recently closed. (Above, S100; below, Carol Swesso, S100.)

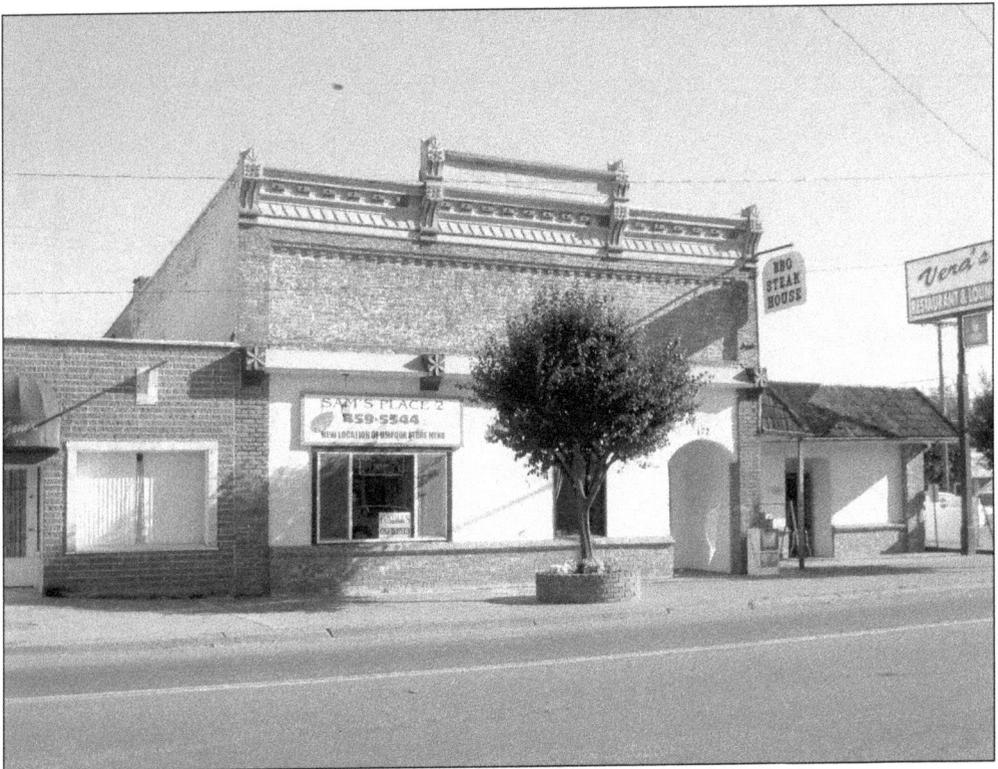

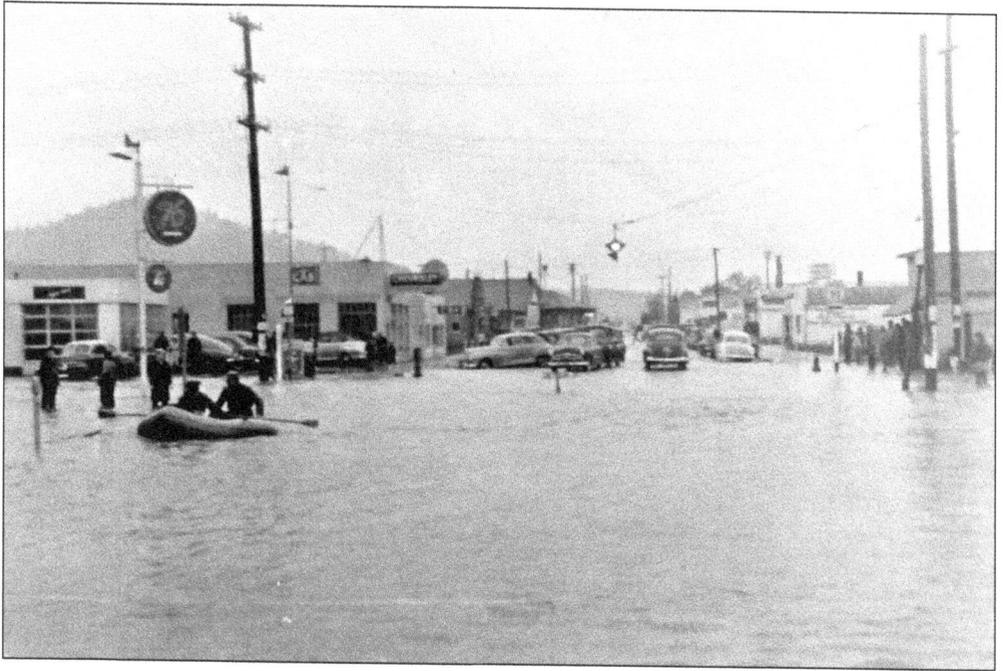

In 1945, rowboats were all the rage on Central Avenue at Calapooya Street (above). If it wasn't for the contours of the hill in the background, the 2010 photograph below couldn't be recognized as the same place. (Above, DCM; below, Carol Swesso.)

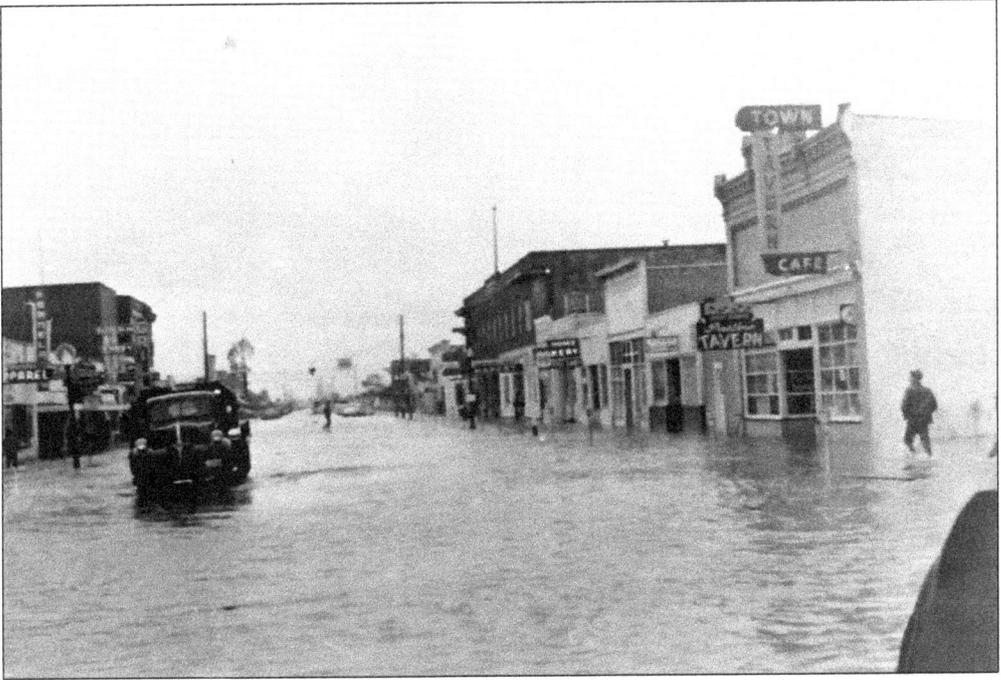

Here is the same flood, same place, and same recognition problem as on page 122. This time the camera is looking east. Aren't the trees in their boxes (below) lovely? (Above, DCM; below, Carol Swesso.)

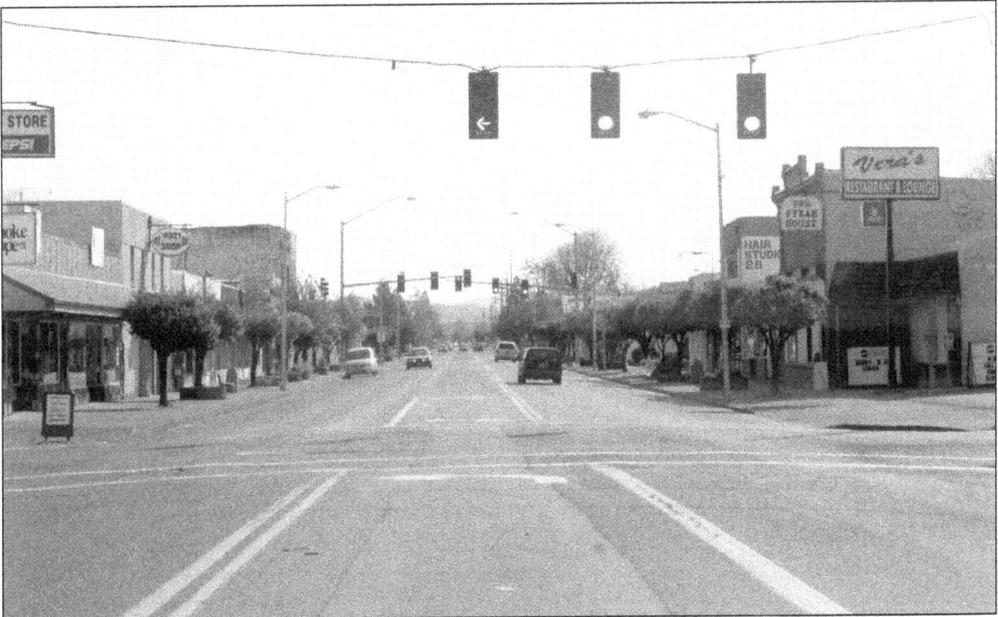

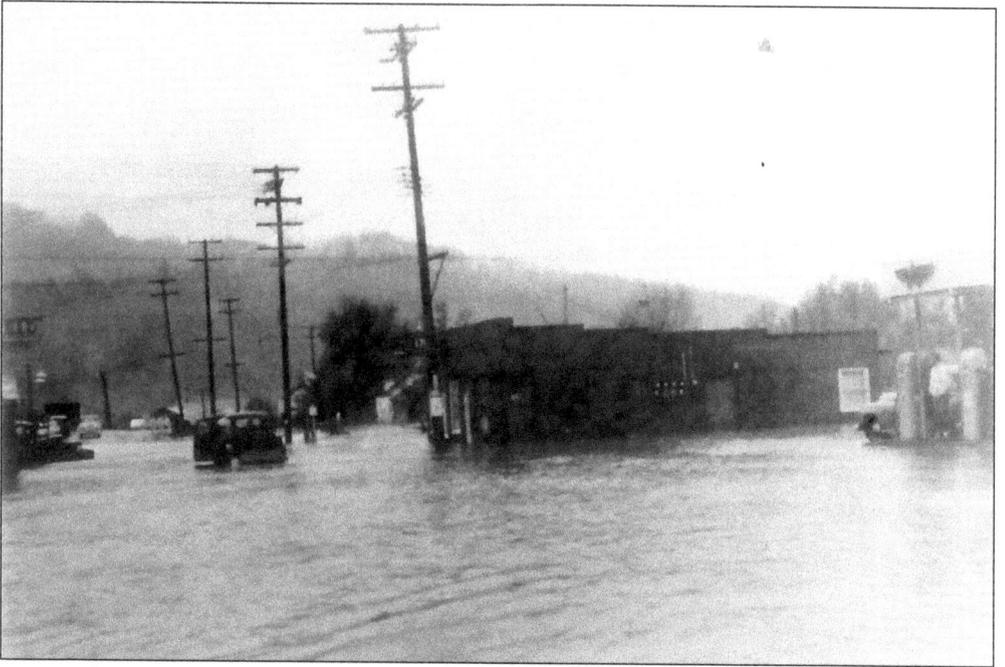

Finally, turn around and look down Calapooya (old Highway 99 South). Once again, the topography aids in identifying the area. Gone is the gas station on the corner (below), instead there's JJ's Sports Bar and an old rock shop—oh yes, and a traffic light. (Above, DCM; below, Carol Swesso.)

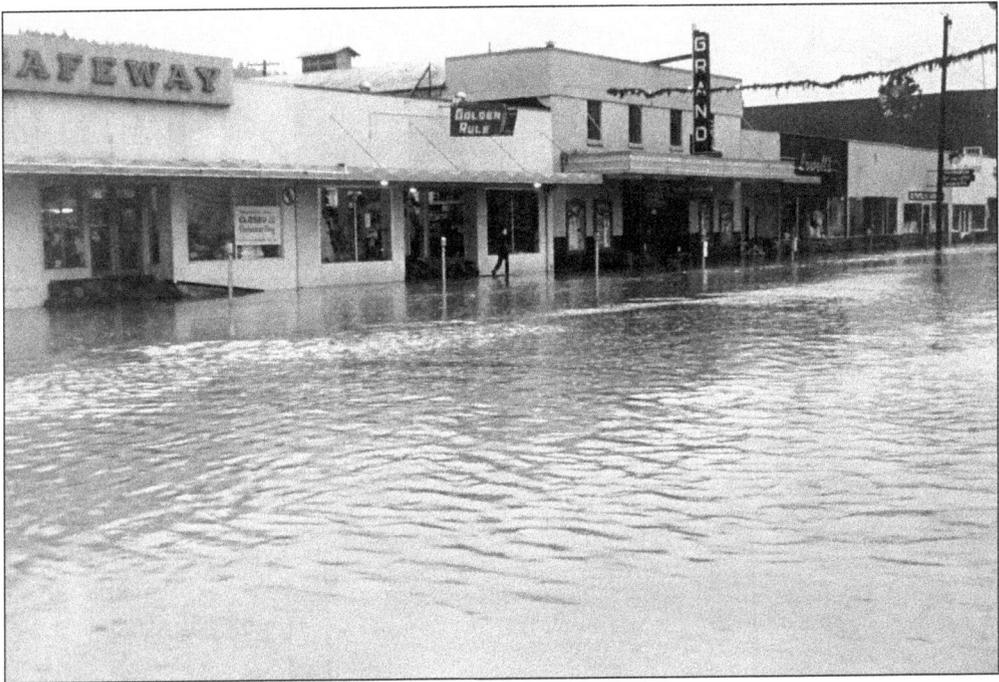

Ten years later, here comes another doozy. Sandbags are all the rage (above). There were even parking meters on the street. All of that was swept away by the flood, and look at what it left behind (below). (Above, DCM; below, Carol Swesso.)

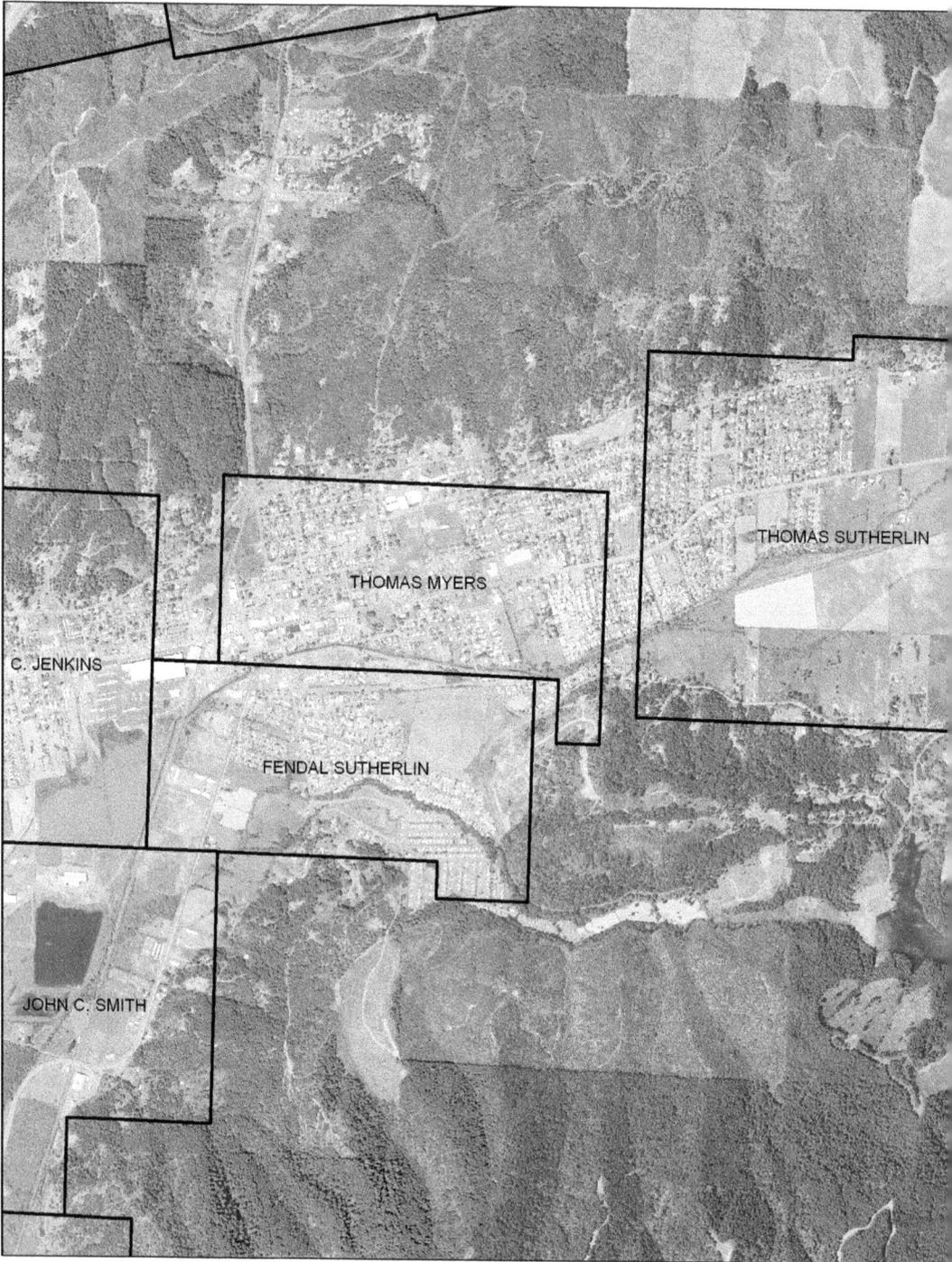

THOMAS SUTHERLIN

THOMAS MYERS

C. JENKINS

FENDAL SUTHERLIN

JOHN C. SMITH

126

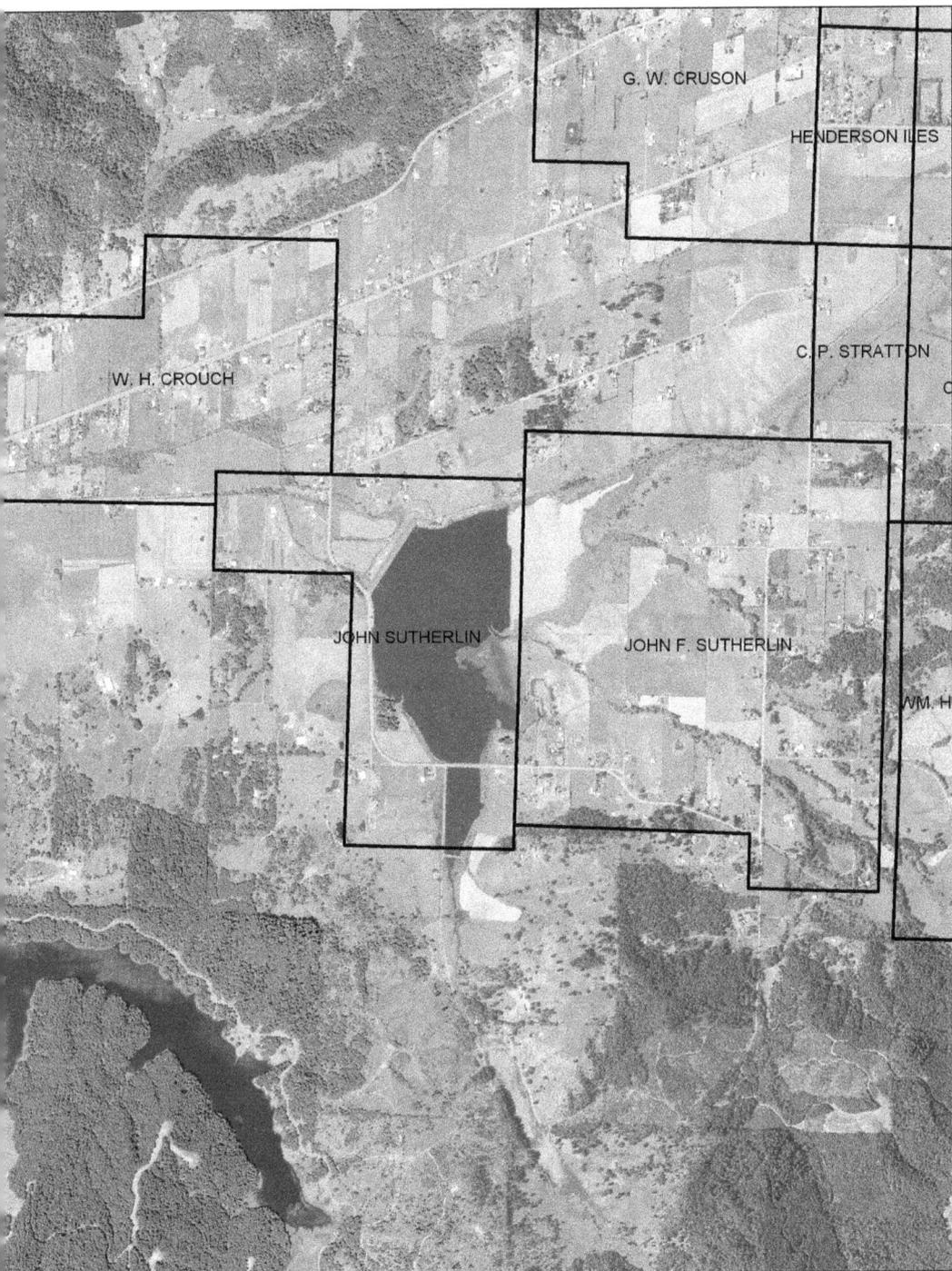

This 2009 aerial view of Sutherlin has been overlaid with the Donation Land Claims of 1850, a true blending of the past and the present. With such a beginning, who knows what the future will bring. (Douglas County Surveyor Department.)

Visit us at
arcadiapublishing.com